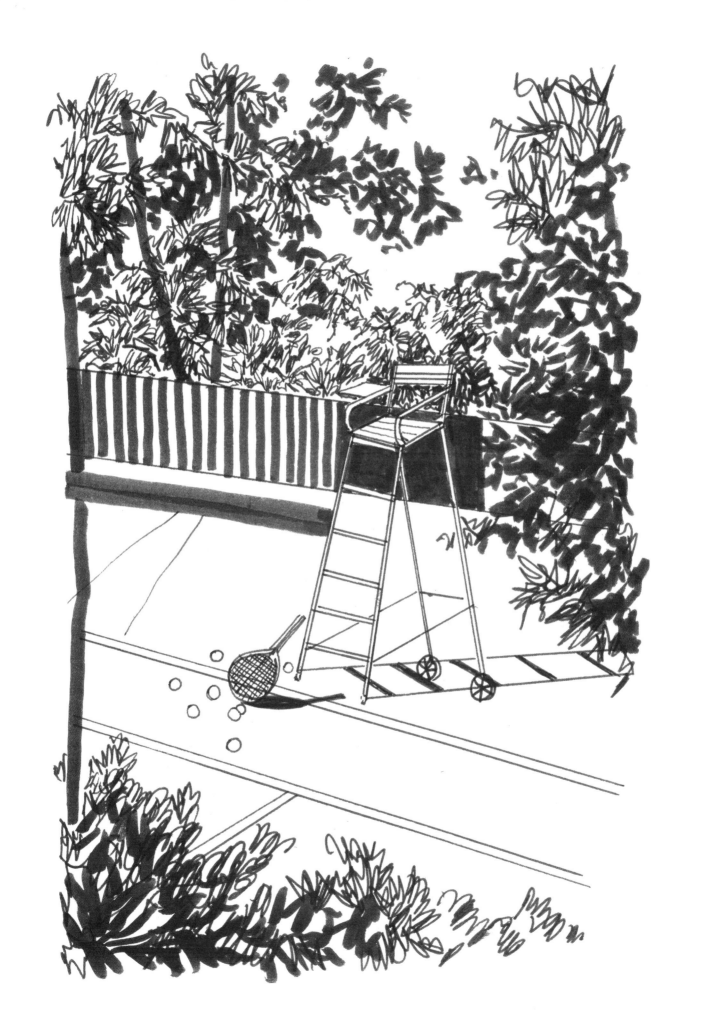

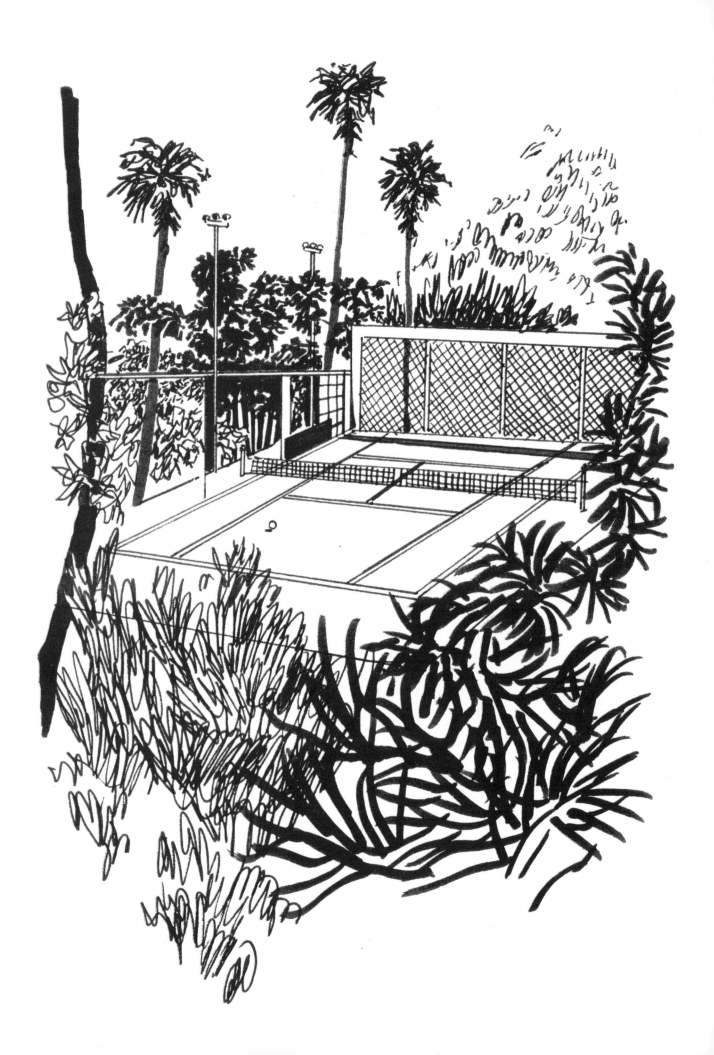

Courtship

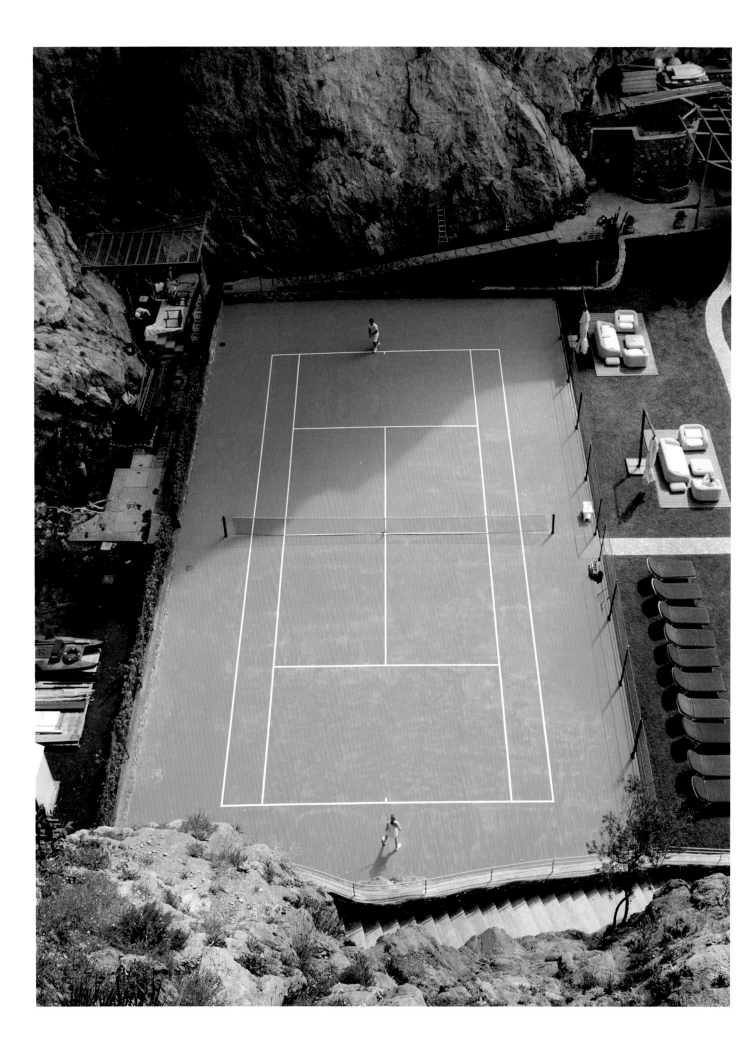

Edited by
Laura Bailey

Photography by
Mark Arrigo

Courtship

For the Love of Tennis

RIZZOLI
NEW YORK

New York · Paris · London · Milan

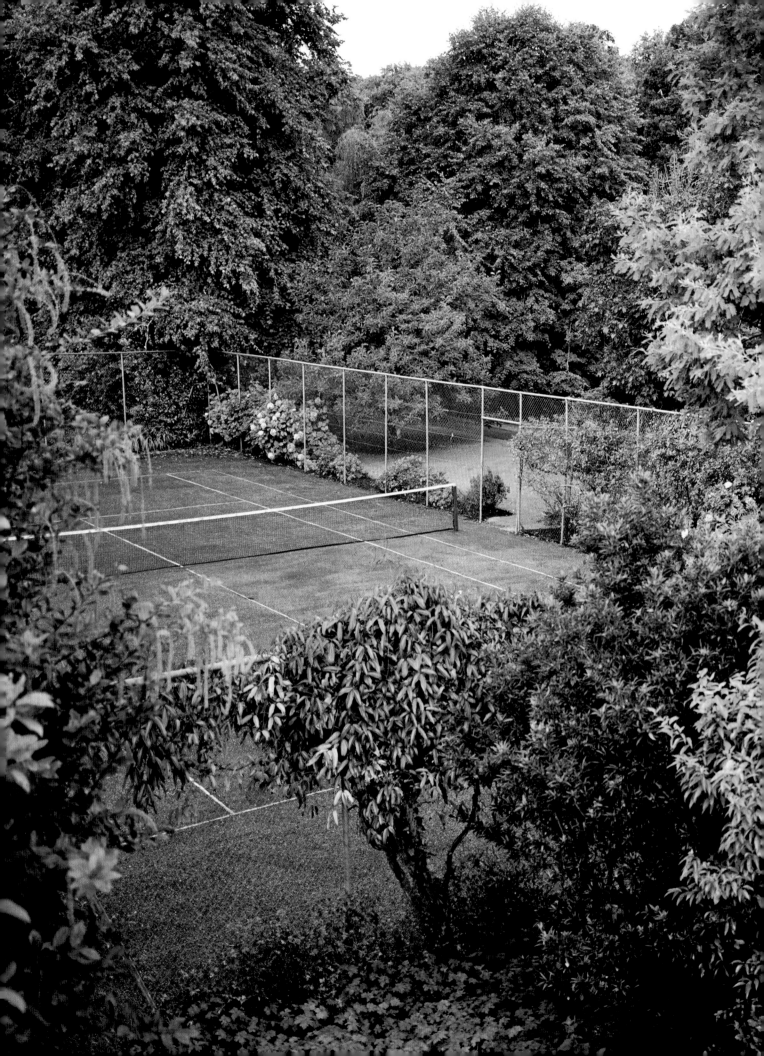

Contents

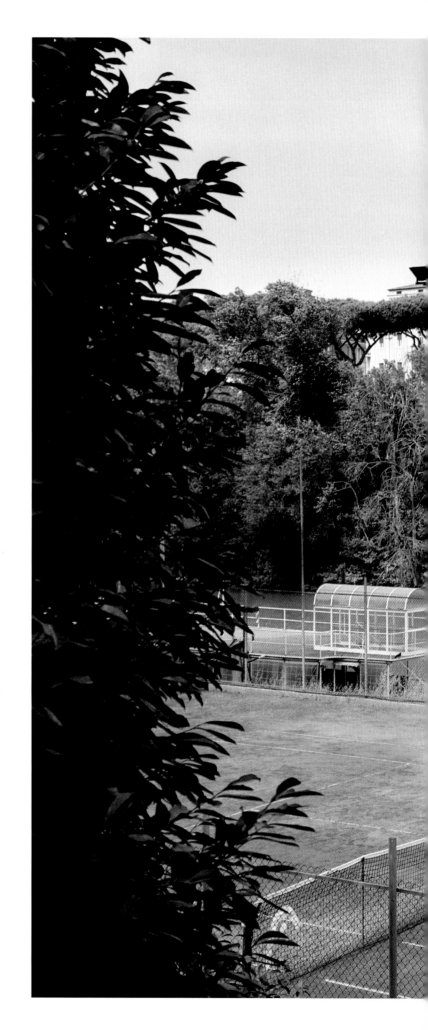

SSD Lazio Tennis, Rome
FOLLOWING SPREAD: Sticklinge Tennis
Court, Lidingö, Sweden

10

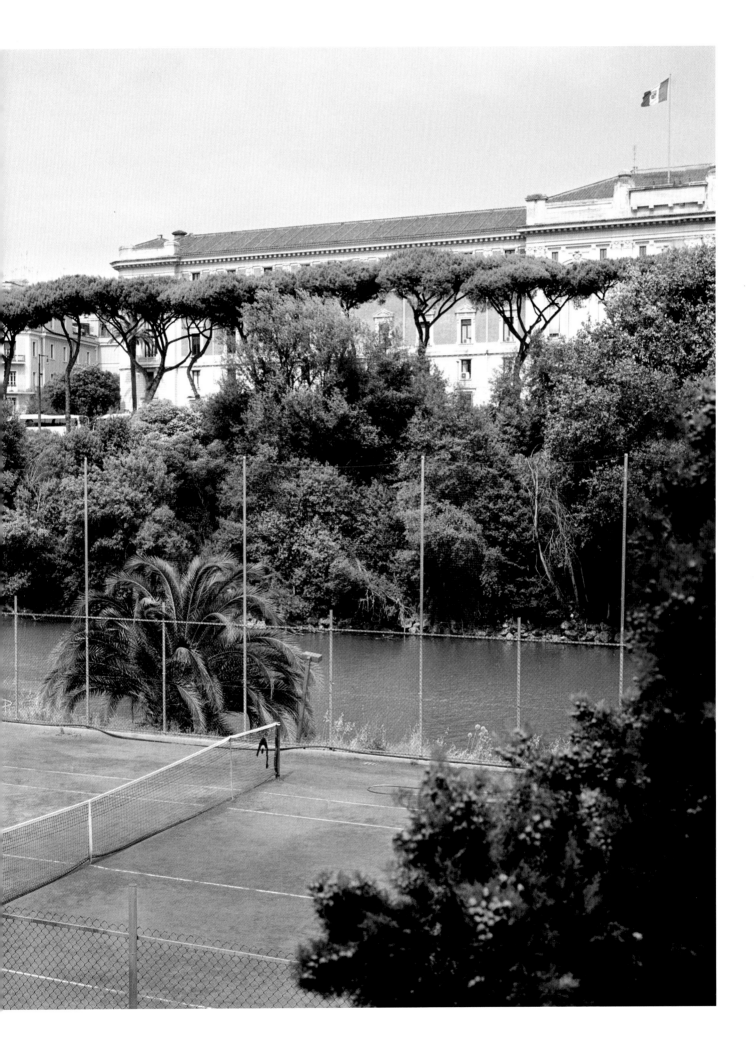

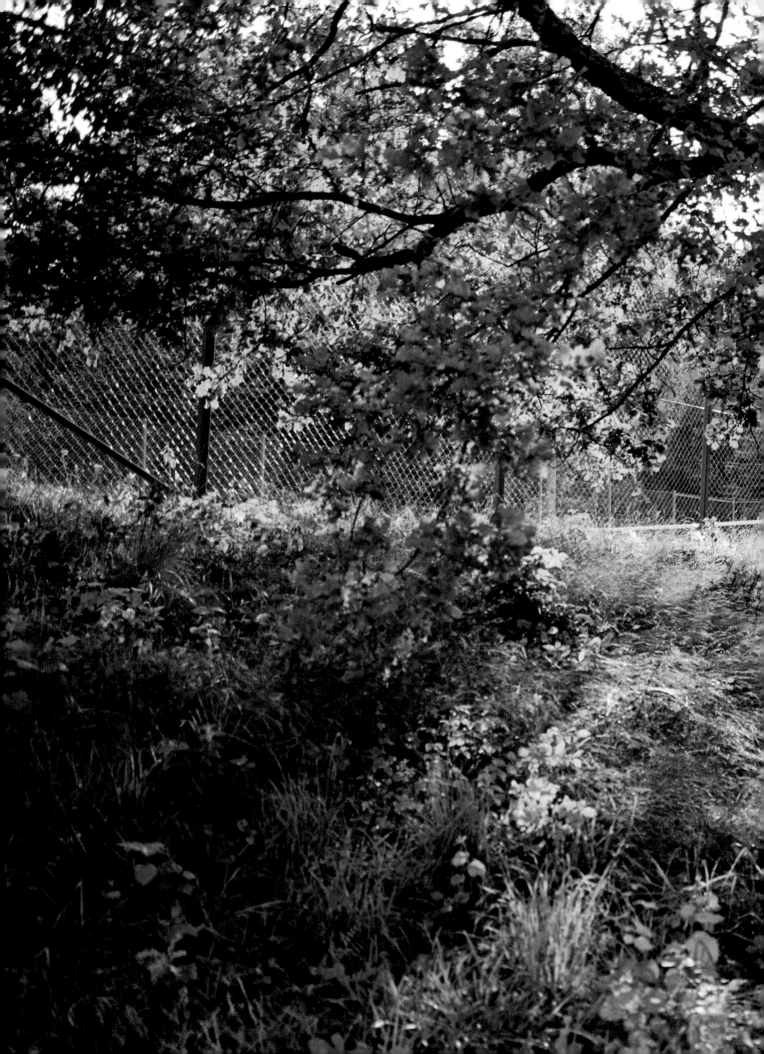

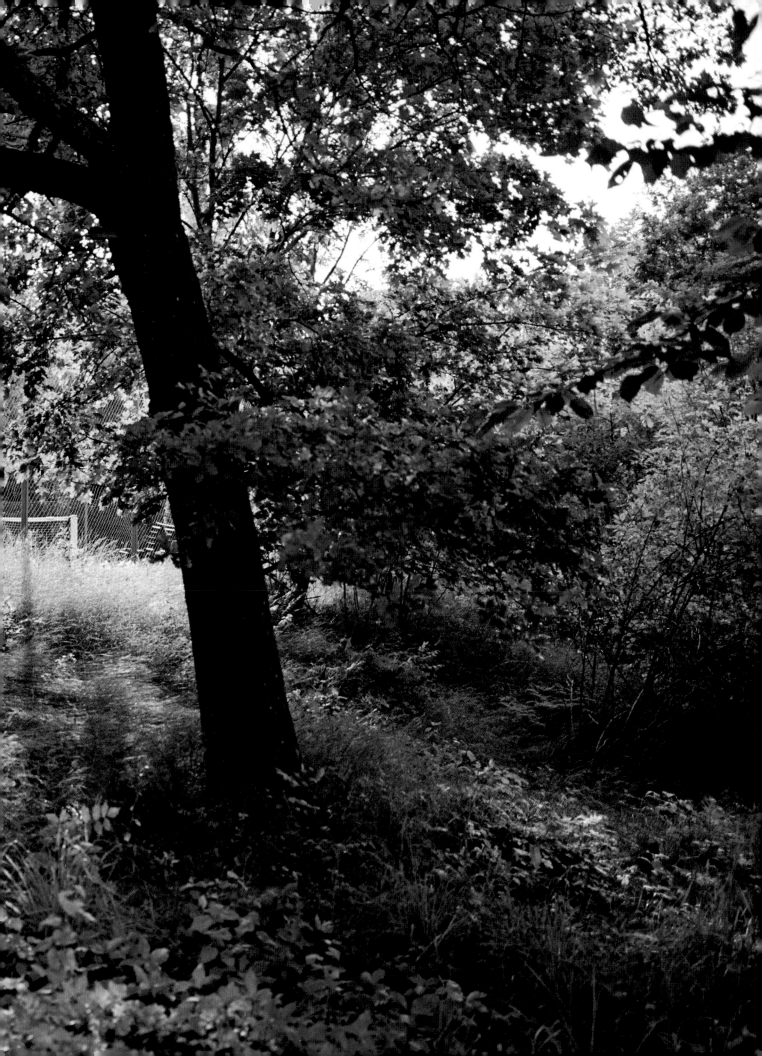

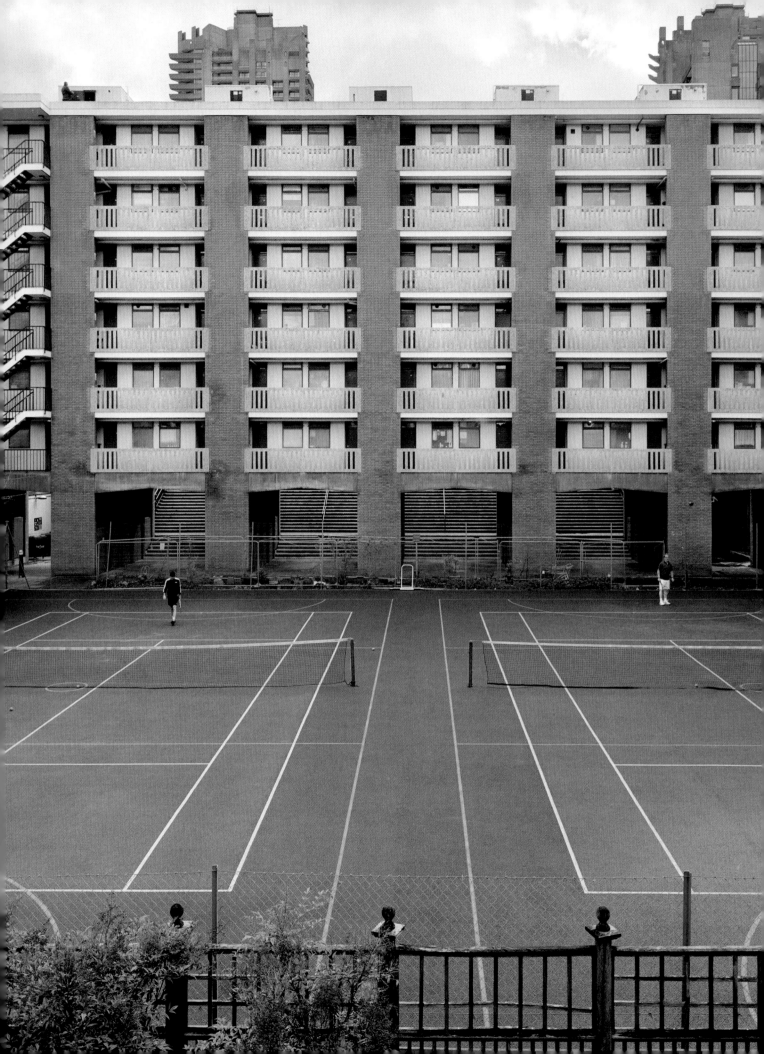

Introduction — *by* Laura Bailey

When, encouraged by my friend and occasional doubles partner Michael Lynton, I committed to turning our spiralling transatlantic conversations about tennis and travel into a book, I immediately thought of photographer and filmmaker Mark Arrigo.

Long-time creative collaborators, Mark and I share a love of photography and adventure as well as an intuitive understanding of how the other works best – and a kind of fearless madness that means we can navigate and even embrace challenges along the way. We are both used to working on big sets with even bigger personalities, so there was something liberating about our quest: just the two of us, on the road, searching and making photographs, often reliant on the kindness of strangers for local knowledge and secret codes.

Both of us are passionate about community and philanthropy, and from the outset we wanted our book to inspire but also to make a difference. Partnering with the LTA Tennis Foundation, we are proud to be able to support their work creating tennis opportunities for disadvantaged children, often in deprived neighbourhoods. The stories we heard and witnessed in the process of making this book have reminded us again and again of the power of sport to transform young lives, as well as the joy and connection a club or court can bring.

For this special project, we stole time, juggling work and family and more. Whether we were trekking across Rome, Warsaw or Prague, or winding our way up a Swiss mountain by train and cable car before slip-sliding skywards in the dark to a haunted motel where we were lucky to get a bowl of soup, something magical always happened – often on court, sometimes on the journey. One day, simply being accidentally allocated a convertible by the car rental company made our trip. In Ireland, it was a breakfast of champions. In Sicily, a room with a view. We travelled in search of the rare and the beautiful, but also those courts that anchor a community and have a story to tell. We sometimes got lost or locked out, but we also encountered extraordinary open-hearted generosity and curiosity, and made friends for life.

We climbed trees and scrambled across rooftops and clifftops and waded into the sea. I sometimes felt we lived a week in a day, we moved so fast and stealthily. This was not a fashion circus.

Mostly, my racquet served as ID enough to access all areas.

And as with tennis, win or lose, we learnt, we explored further. We began again.

OPPOSITE: Golden Lane Tennis Courts, London

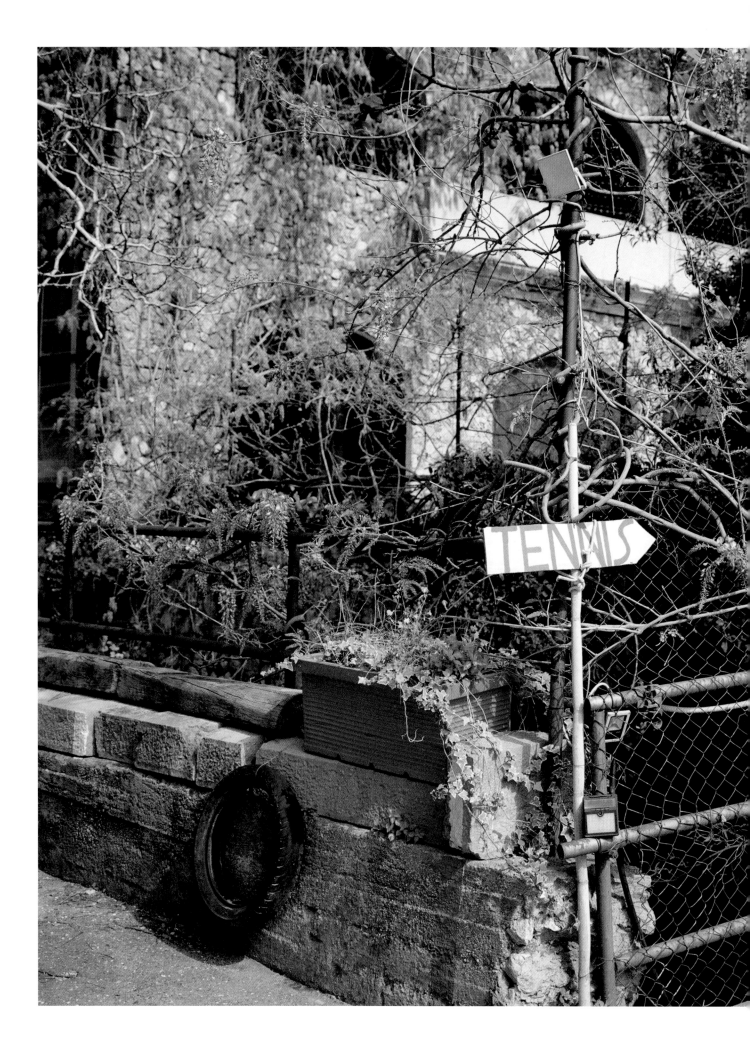

A Note on the Photography

by Mark Arrigo

Photography is both my passion and my profession. Shooting landscapes offers meditation and freedom – a chance to escape the noise and connect to something deeper within myself. Each year I travel somewhere new, whether for a weekend, a week or a month. I leave my laptop at home, delete all social media and messaging apps from my phone and disconnect as much as possible. With just my Mamiya 7 and a backpack full of film, I walk – often without speaking to anyone except to check in to a room for the night or to order food. This is my therapy, a time to clear my mind, explore new places and be in awe at the planet's natural beauty. It awakens something inside me that I try to capture in my landscapes.

When I embarked on this project, I established strict guidelines for its photography. My aim was to transcend mere depictions of tennis courts, capturing instead the sense of discovery and wonder that a player experiences upon finding that new and special court. I made the decision at the outset to shoot every court with the same camera and lens, without deviation. It created a lot of limitations and some missed opportunities, but within this confined space emerged a unique focus. The technical constraints paradoxically offered the photography freedom, and as I captured more courts, I noticed how this specific framing told a broader story. Despite their differences I realised that there is a synergy to the courts, a throughline in what they represent.

This discovery became a key part of the work. Each time I stumbled upon a new court, I was met with something furtive and unspoken, something special that connects them all. This was my own courtship with the landscape, which I feel incredibly grateful to have experienced as it has deepened my understanding of why this game is loved around the world.

OPPOSITE: Clube de Ténis do Jamor, Lisbon

18

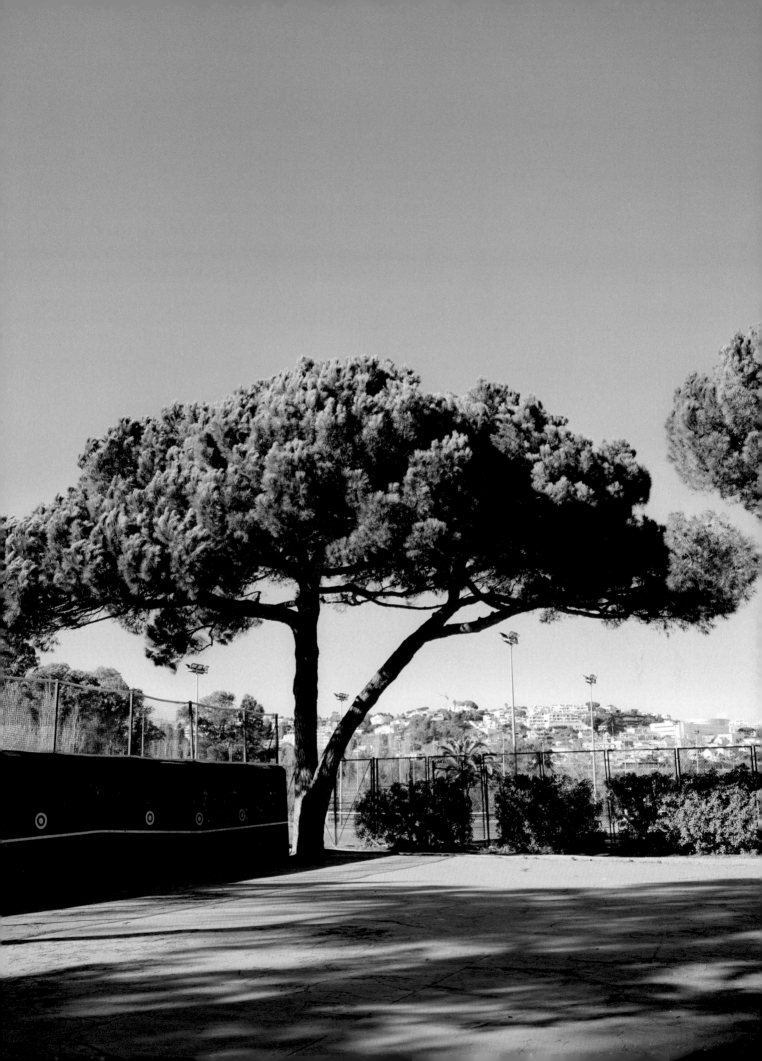

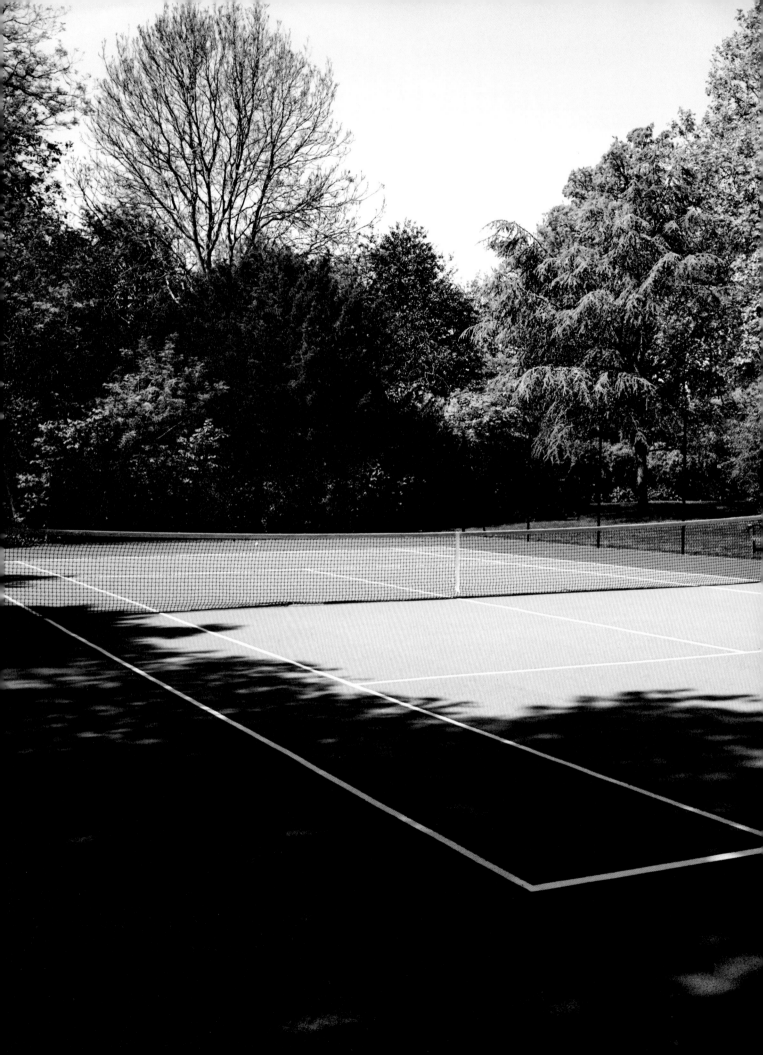

On Tennis *by* Laura Bailey

As I write my tennis love story – with the 2024 French Open playing out distractingly on my kids' computer in the kitchen, not quite out of sight – I realise that I'd rather be playing. I'd pretty much always rather be playing. As I obsessively weave matches and training into the already complex tapestry of life, tennis has become both my anchor and adrenaline hit, a form of meditation and a catalyst for change.

My first style crushes weren't pop stars or actors. That came later with Madonna and Molly Ringwald. It was sport that had an early hold on my heart. I cycled seven miles each way to run on the track at the legendary Iffley Road stadium in Oxford. From the fourteen-year-old Nadia Comăneci's dazzling 'perfect ten' in the 1976 Olympics (around which time I clumsily learnt to cartwheel) to the barefoot, world-record-breaking long distance runner Zola Budd, these were the women who made me want to run faster, try harder and never be afraid to get dirty.

I'd always admired tennis from an awestruck distance, idolising Chrissie Evert in her ribboned pigtails as she shared the women's tennis crown with Martina Navratilova throughout the late 1970s. Next came simultaneous crushes on Stefan Edberg and Gabriela Sabatini. From the Williams sisters to Emma Raducanu, from Carlos Alcaraz to Jannik Sinner, I worship the grace and power of the heroes of the game.

And the style... The good guys and the rebels, the angelic whites, the neon flashes. My little black dresses are more Nike than *Breakfast at Tiffany's*, but I love the kit and the accompanying rituals and lucky charms. The safety of the uniform,

the improvised creativity. My son's 'skater' hoodies, the Lycra layers, the significance of pockets. And the life-changing potential of a locker – and the inevitable accompanying allure of Americana – as well as a newfound ability to condense multiple possible personalities into a couple of shoe bags and an après-sport Chanel beauty counter in miniature form.

As a child, watching Wimbledon on TV soothed my senses and numbed my teenage angst. Even now I have a Pavlovian response to tennis commentary. The voice of John McEnroe in particular induces a hypnotic calm, only heightened by the accompanying thwacks and sighs and grunts of play.

All grown-up, I ran around the world for fashion, chasing my shadow, literally and metaphorically. I increased my sporting repertoire on the side: I learnt to climb and box and kept on running. Along came babies: rough-and-tumble re-learning how to play without a rulebook. But I am an adrenaline junkie, and I missed the thrill of the game, any game.

Suddenly my son grew beanpole-tall and naturally co-ordinated on court. I wasn't ready to be beaten by a ten-year-old, so I picked up a racquet for the first time in years and started messing around with him in the park. Being an all-or-nothing kind of girl, I wanted more, so got in line at my local club, suffering through an awkward trial period in too-new whites. For the first time in a while, I was the new girl – and the youngest – in a weekly class full of strangers. I almost never missed it, unexpectedly made new friends when I claimed a full dance card, and started to steal odd hours for random games. Tennis gradually became the only constant in my

week, grounding and focusing me in a way I didn't even know I needed. I am present. Point to point. The balletic learning arc of every match became my own private party in a new world where I could start over and nobody knew my name.

I like winning. And learning to be a gracious loser. I loved teaching my kids the same. The community force is strong in tennis, and I accidentally on purpose fell in deep, drawn to both the solo mission and the conspiratorial camaraderie. The whispers of addiction, the allure of the gear, lucky socks, sweatbands. The hustle and the flirt and the interrogation. The extreme intimacy of the duel counterbalanced by mystery and anonymity. Calculated risk and psychological detective work within safe spaces. Revelations within rules. It all plays out on court. Tennis has stretched my body and mind, gifted me team spirit at home and abroad. I play with teenagers and extremely athletic pensioners, movie stars and moguls, models and mamas. I play with beautiful boys and some of the most extraordinary women I have ever met. I joined a club when I could have just gone to the pub, and I discovered elastic, magical time when I thought I had none to spare. And I found inspirational coaches who not only toughened me up but made me laugh and stopped me saying 'sorry'.

For our book, I wanted to share more than my love of the game; I wanted to celebrate and support diverse tennis communities at all levels, as well as the thrill of the quest for a hit on the road. Matchmaking via a secret court in the Cotswolds in the village with no streetlamps, or the one in Amalfi that could have been dreamt up by Fellini.

I lived in New York City for most of my twenties and never picked up a racquet. That hurts. A long-distance runner since childhood, I believed I was happiest solo sprinting on the West Side Highway or timing laps around Central Park. Back to the future and it's a stormy April night in Manhattan, and I'm in town for less than twenty-four hours. My one and only night is, inevitably, a late one. At 8 am my friend Michael Lynton (whose shared quest for adventure and courts and community all over the world inspired this project) pulls up to my Lower East Side hotel, and we head south over the Brooklyn Bridge towards the fabled Heights Casino club. When friends ask me about how my photo-shoot trip went, I can only remember the feeling of seeing the city that was once my home through entirely new eyes. And the score.

Paris, my second work home, is different now – I even take a week off in June with my favourite tennis gang to watch the French Open, and play all over the city, from the roof of the Montparnasse station to the secret court where I whisper because it feels like a church.

When I took my son to Wimbledon for the first time, I bribed him to wear a jacket and zipped up my favourite Chanel. We were fully committed – to souvenirs, strawberries and cream, and Andy Murray. Lucky Luc fell fast asleep on some actor's shoulder wearing my jumper inside-out while rain stopped play. The sweetest London reverie: tennis, my true love match.

Sport can save your life. This book is a thank-you letter of sorts – to the drama teachers and running coaches who believed in me as a troubled teen, and to the international tennis family who have gifted me so much joy. And to my son, who still scribbles me an 'IOU 10 games because I know it makes you the happiest' every birthday when I know he'd rather be playing football. I love my new nightlife. Tennis changed everything, brought me home and set me free.

OPPOSITE: Campden Hill Lawn Tennis Club, London
FOLLOWING SPREAD: Springfield Park Tennis Courts, London

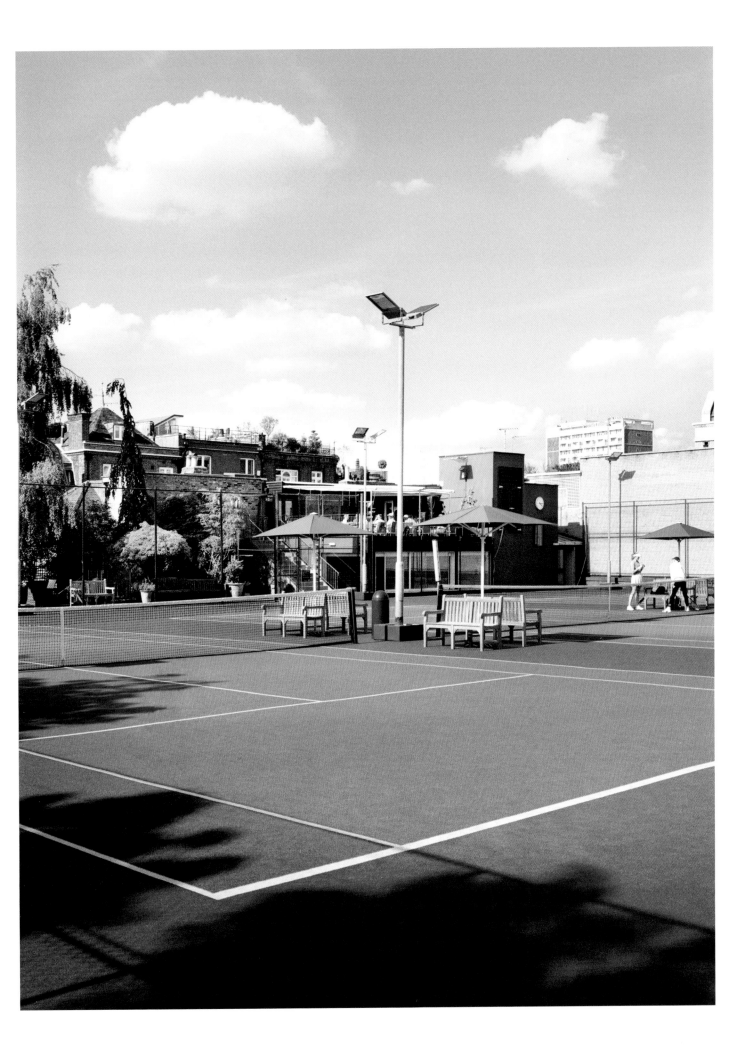

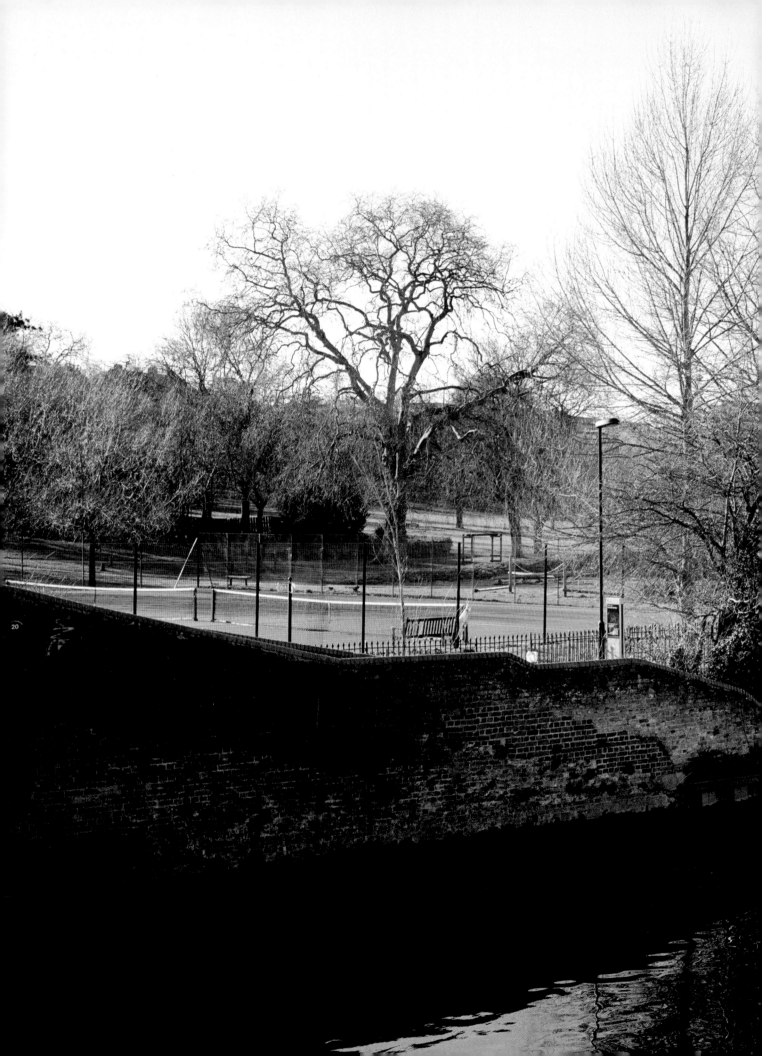

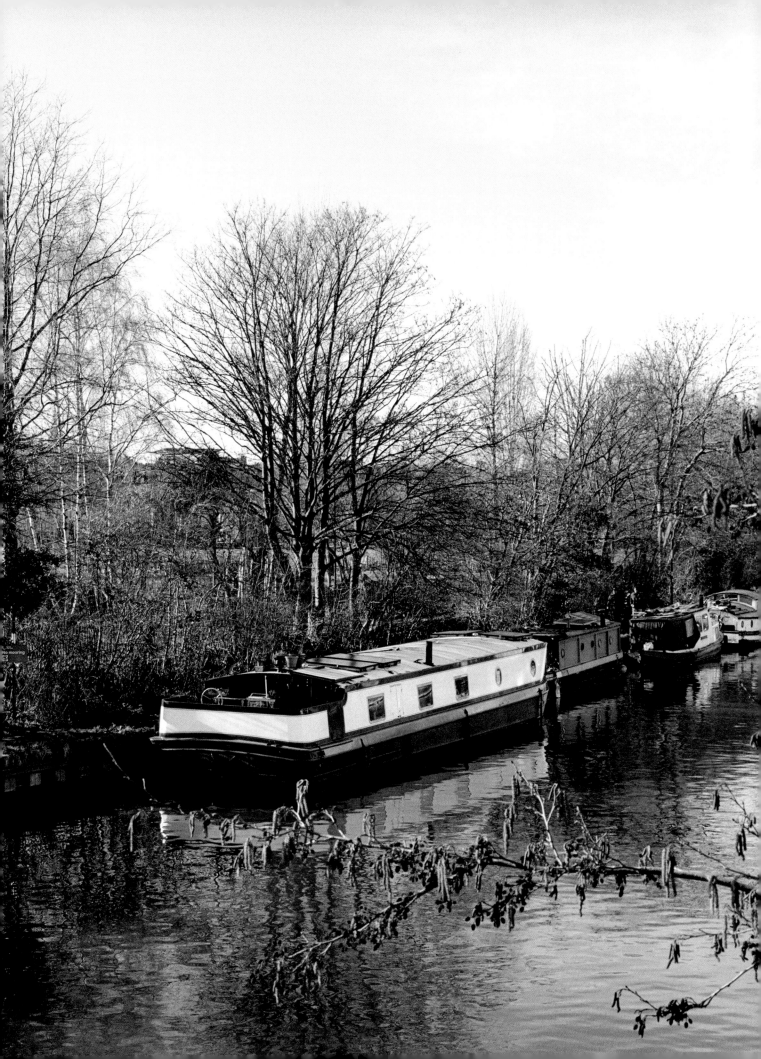

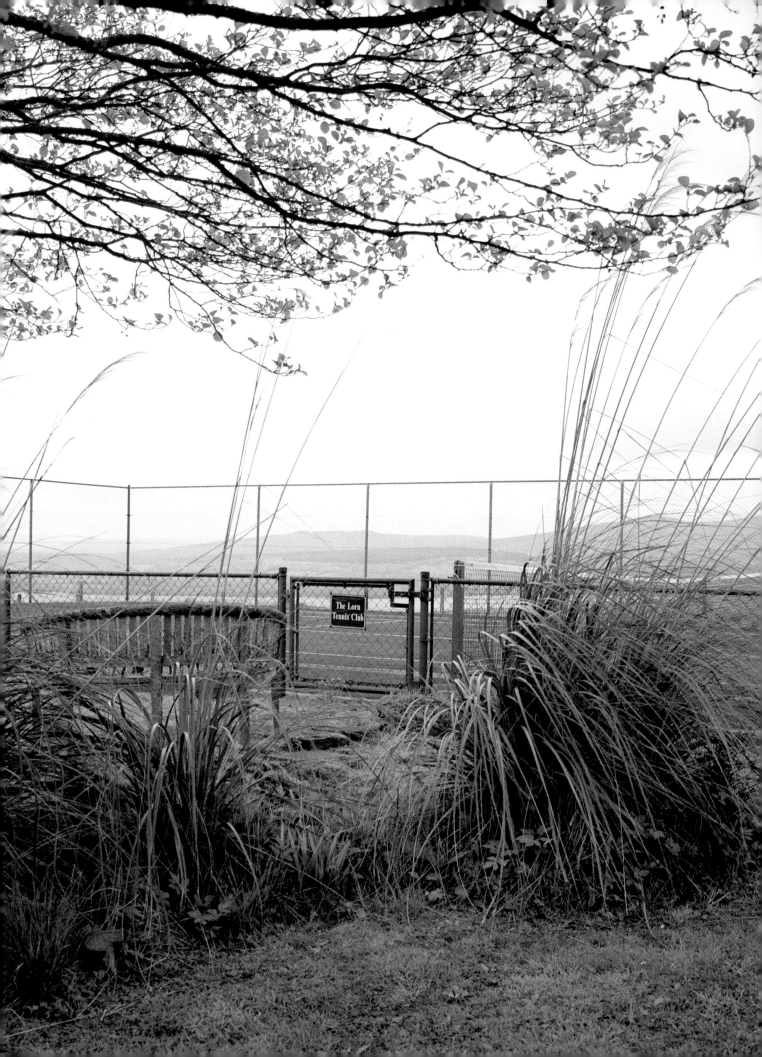

The Lorn
Tennis Club

OPPOSITE AND FOLLOWING SPREAD: Loch Lomond, Scotland

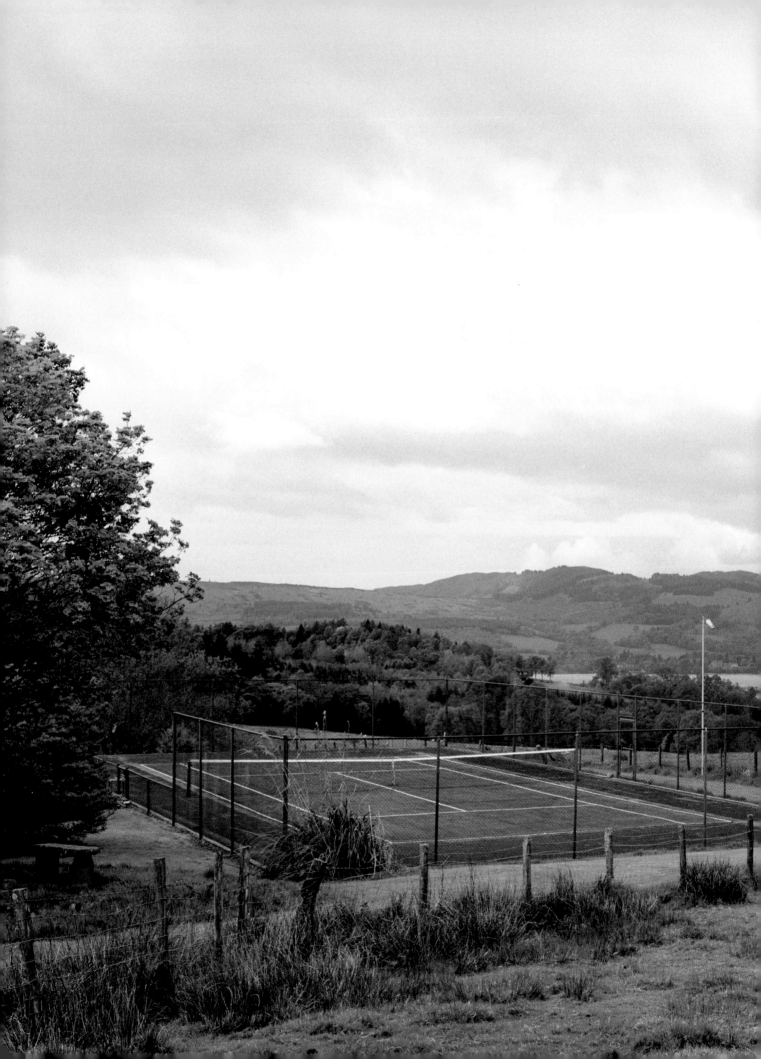

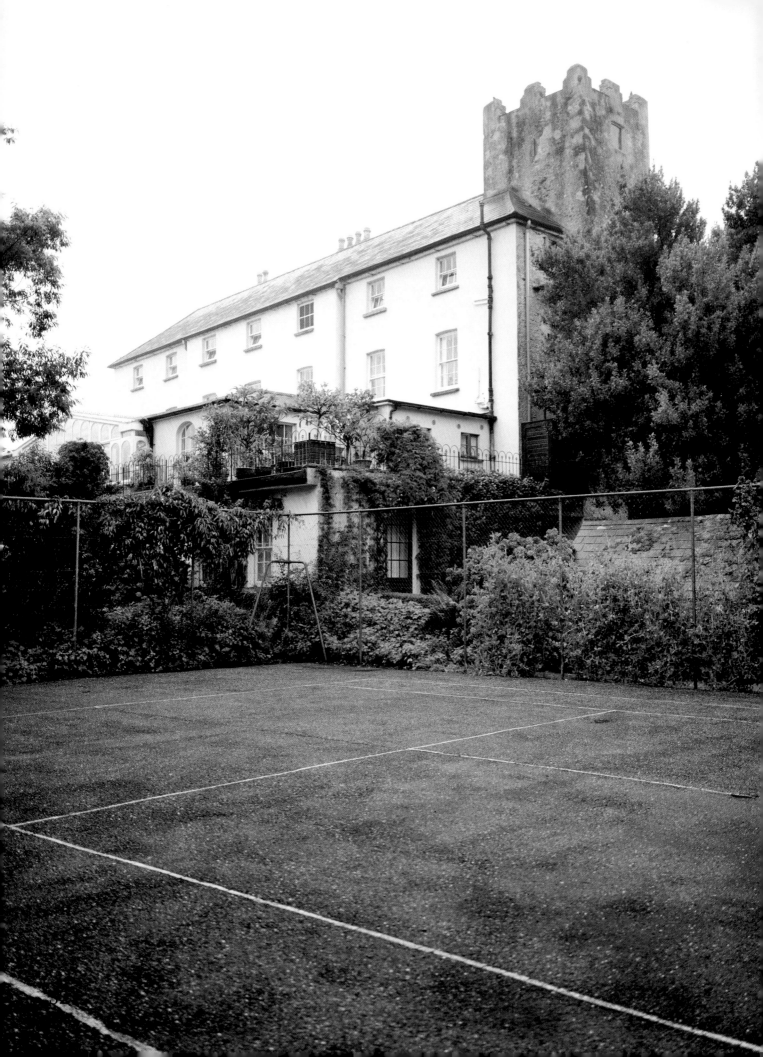

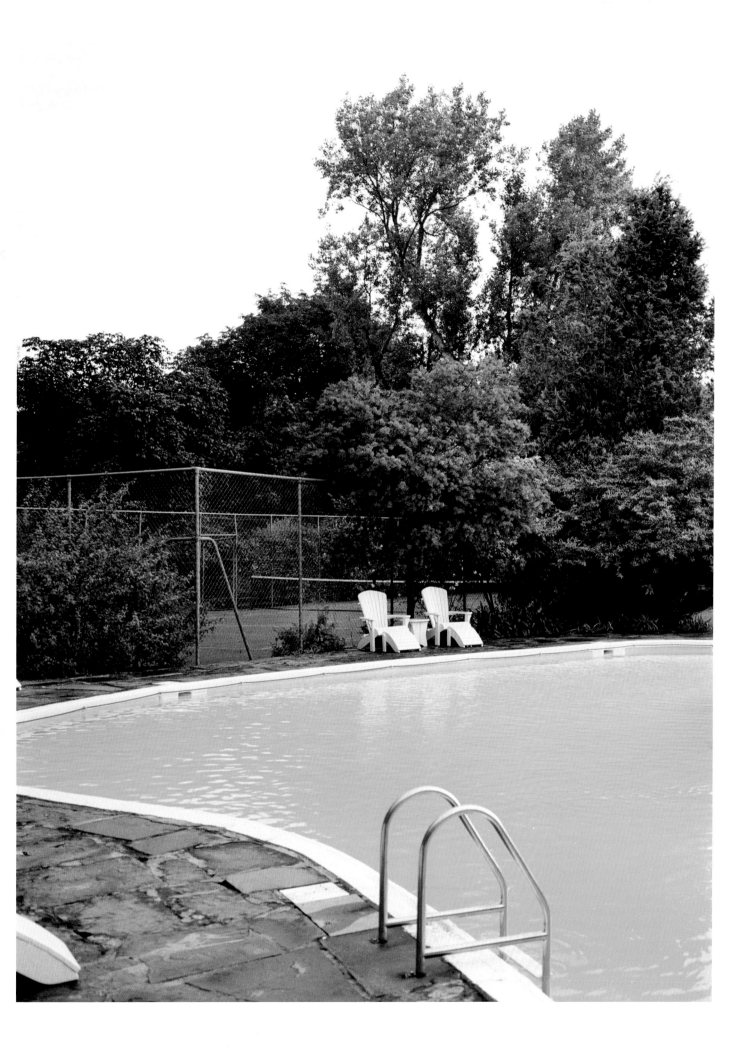

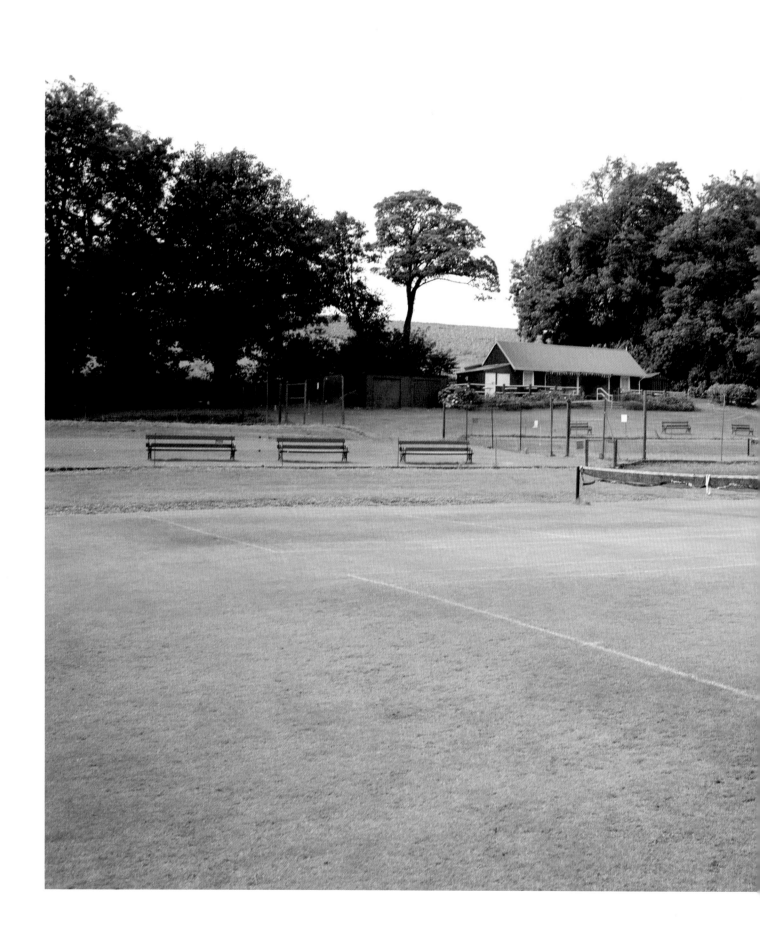

Argideen Vale Lawn Tennis and
Croquet Club, Timoleague, Ireland

OPPOSITE: Copenhagen, Denmark
FOLLOWING SPREAD: Kinsale Tennis Club,
Snugmore, Ireland

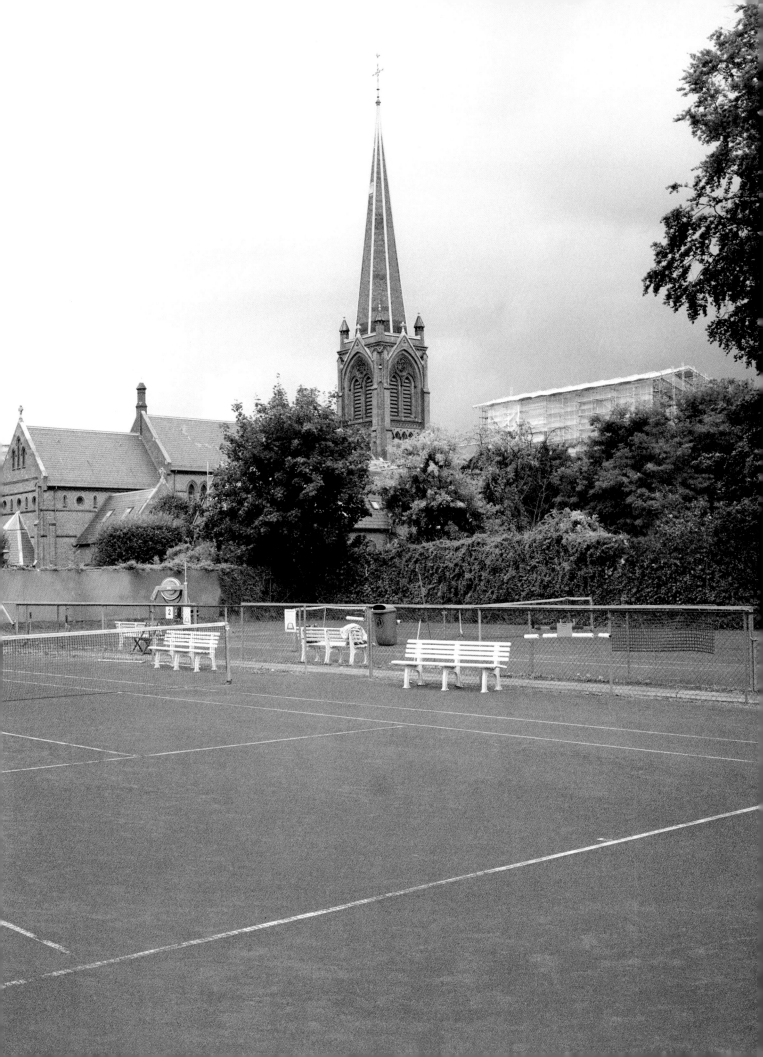

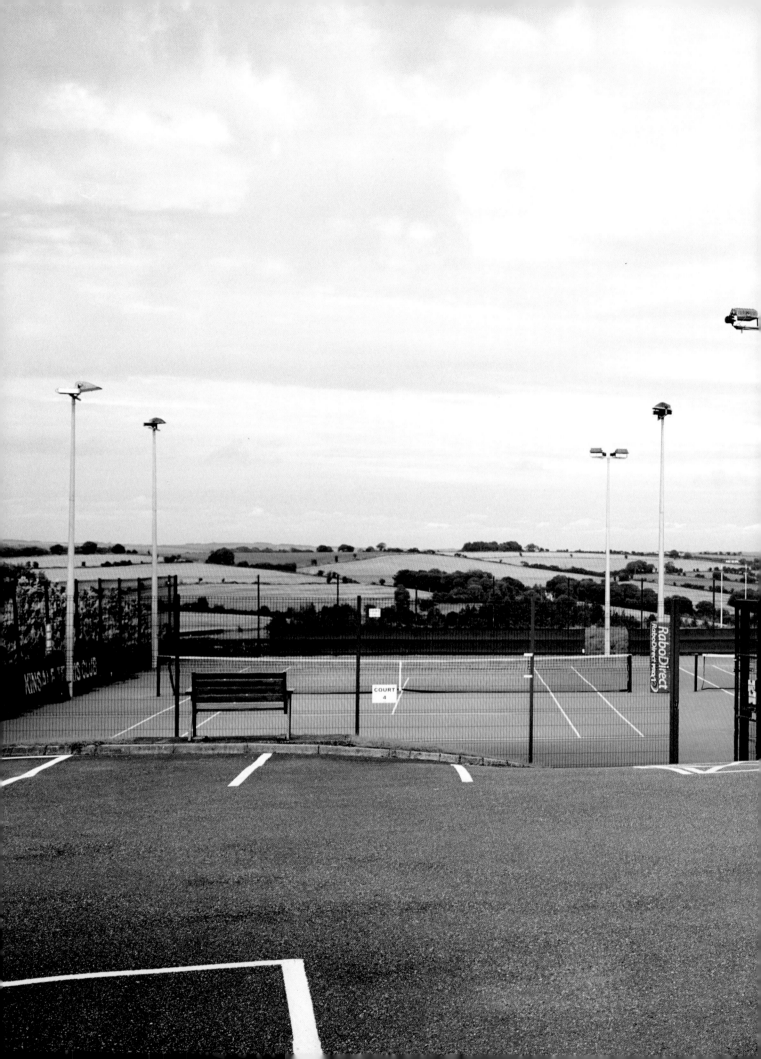

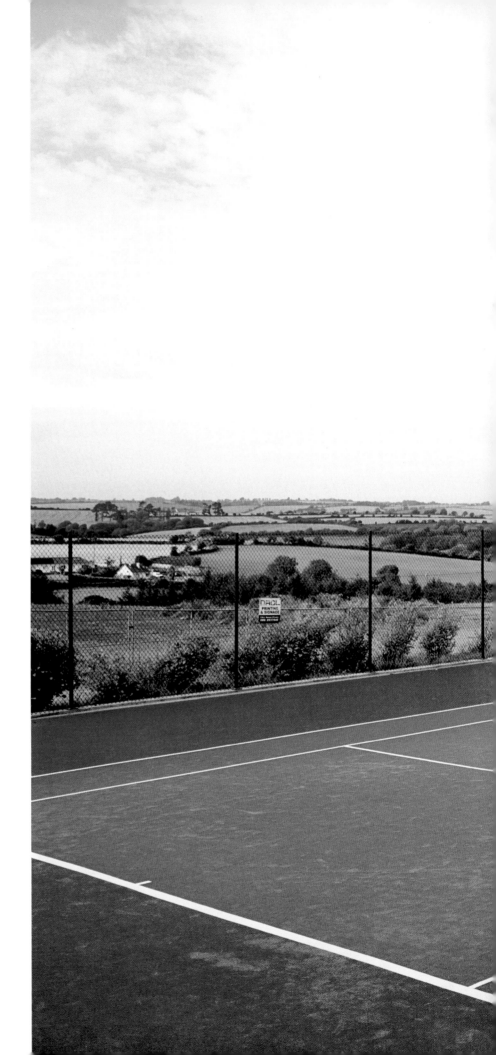

42 Kinsale Tennis Club,
Snugmore, Ireland

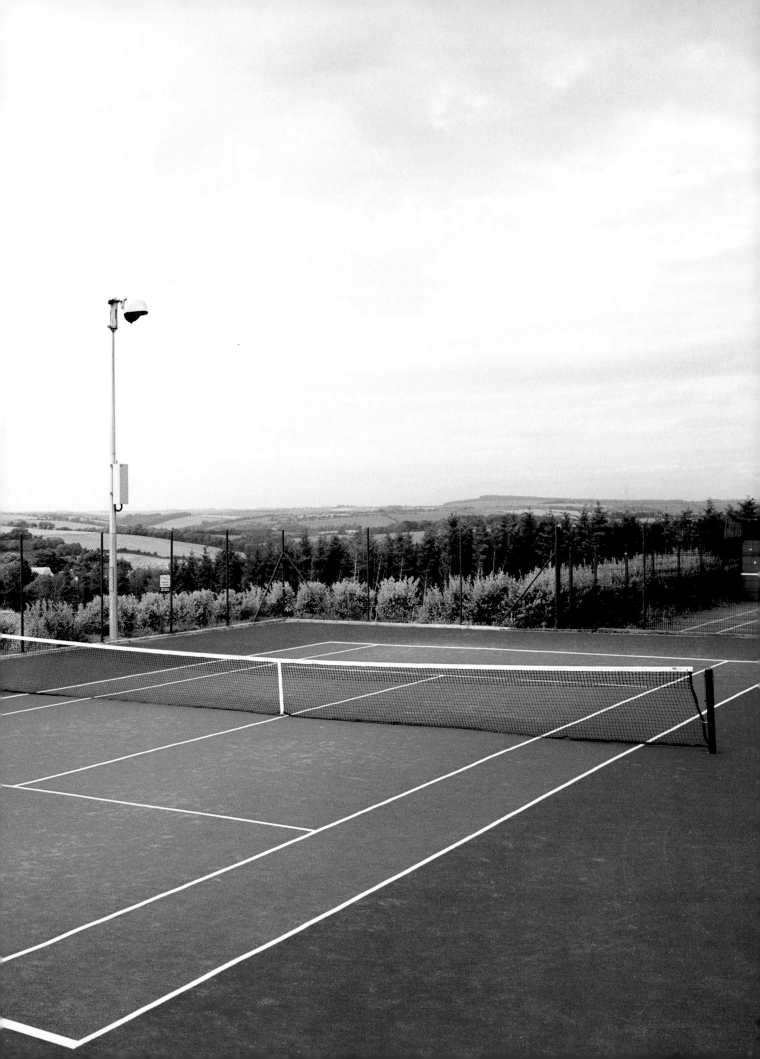

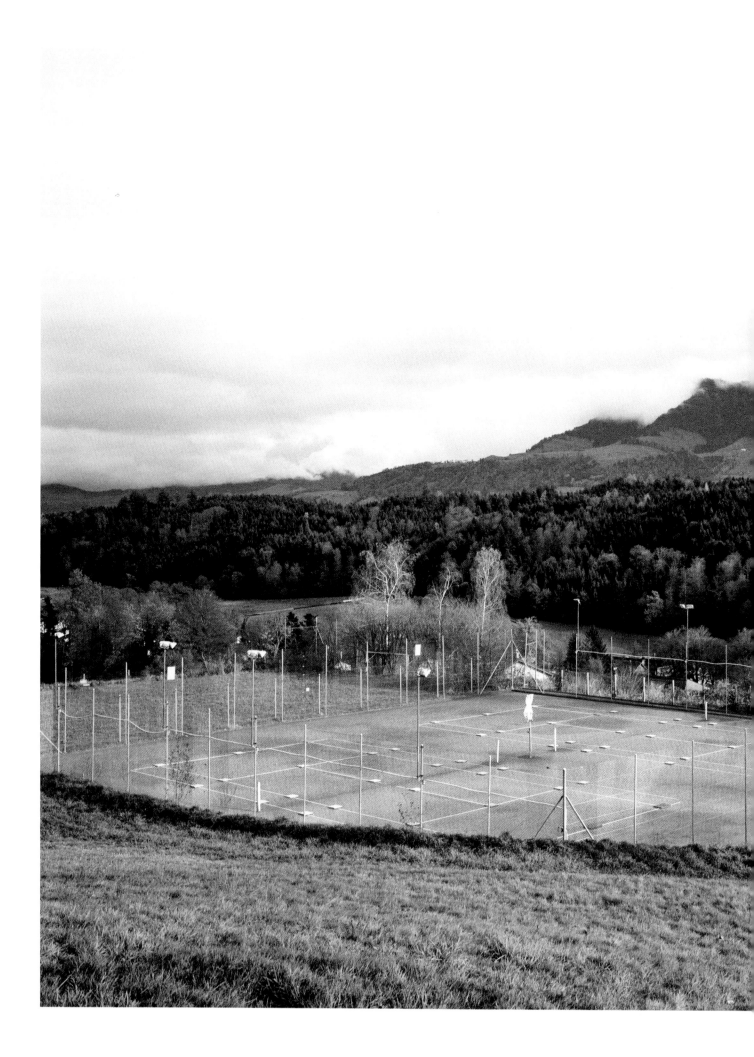

OPPOSITE: Adligenswil, Switzerland
FOLLOWING SPREAD: Grindelwald (left)
and Mürren (right), Switzerland

45

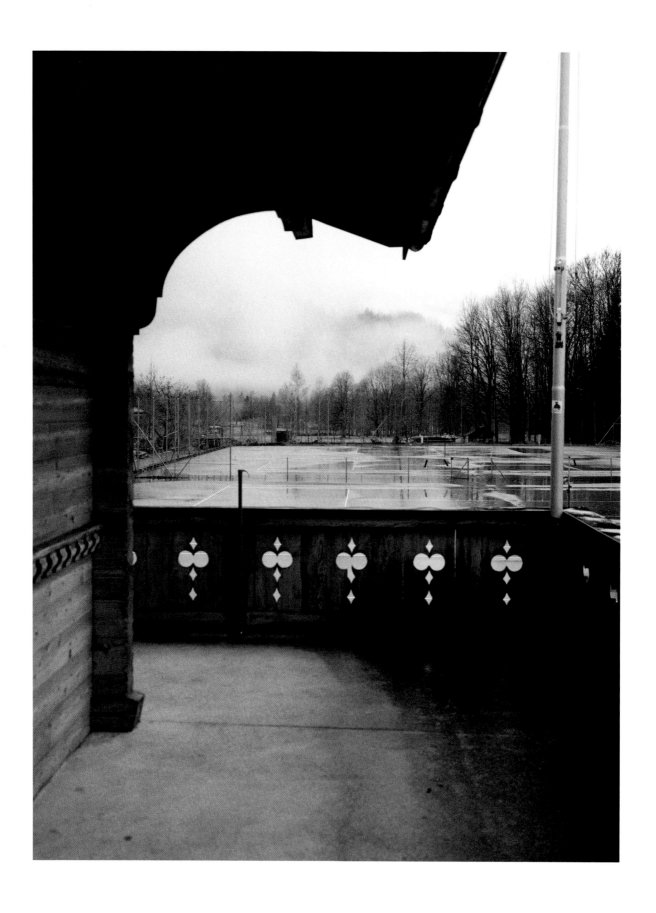

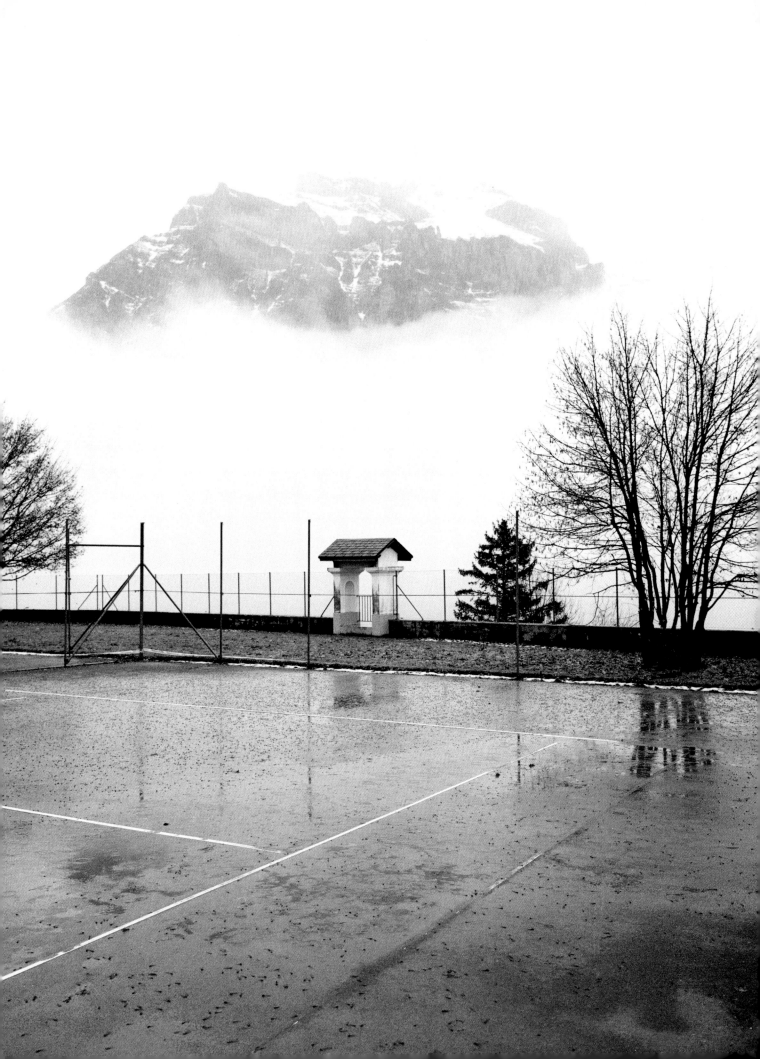

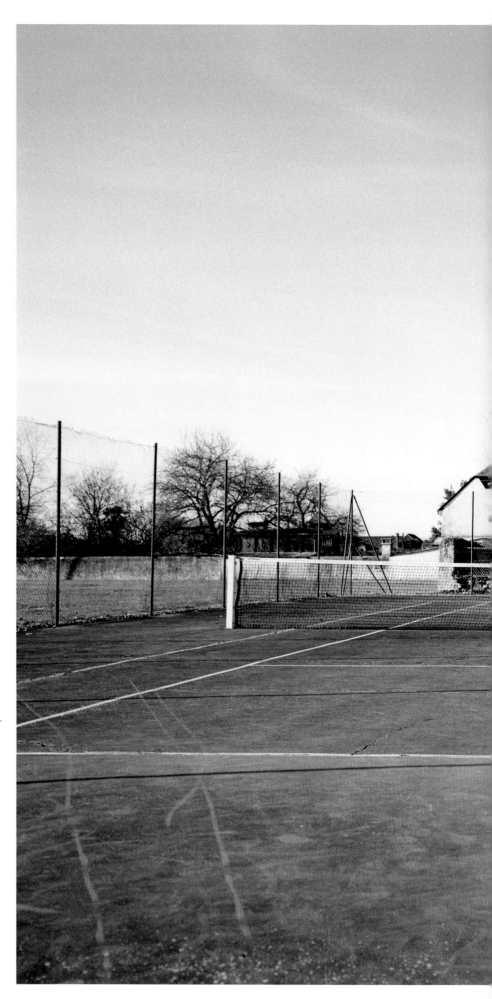

PREVIOUS SPREAD:
Prague, Czech Republic
OPPOSITE: Beuste,
France

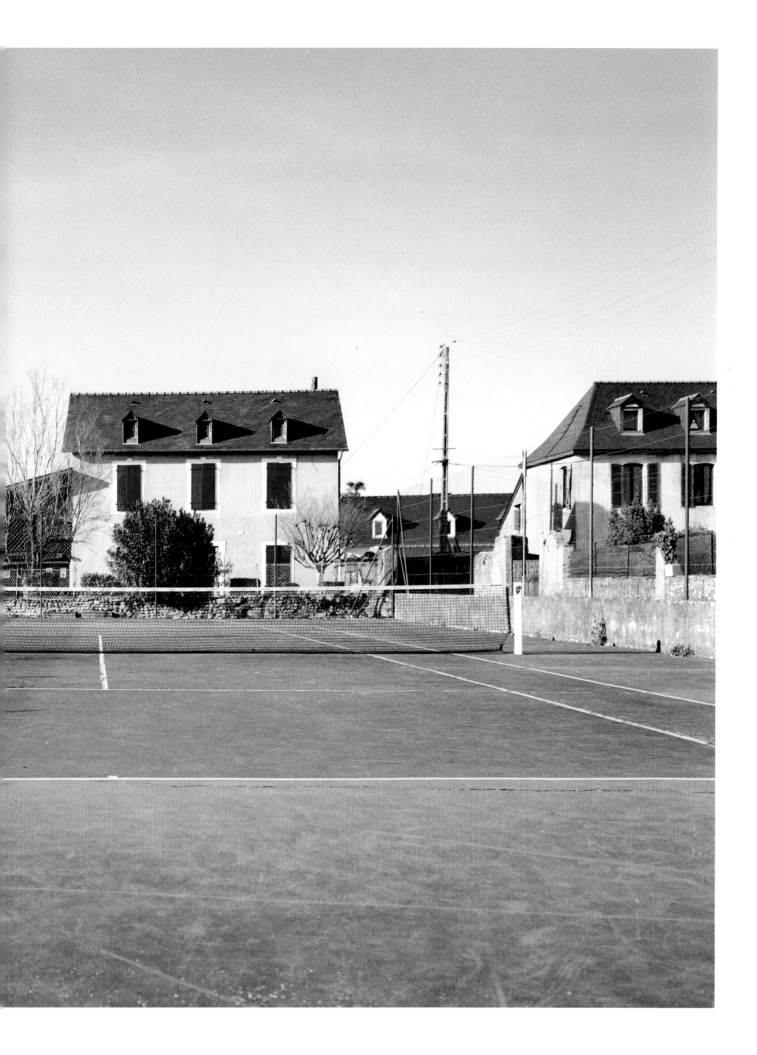

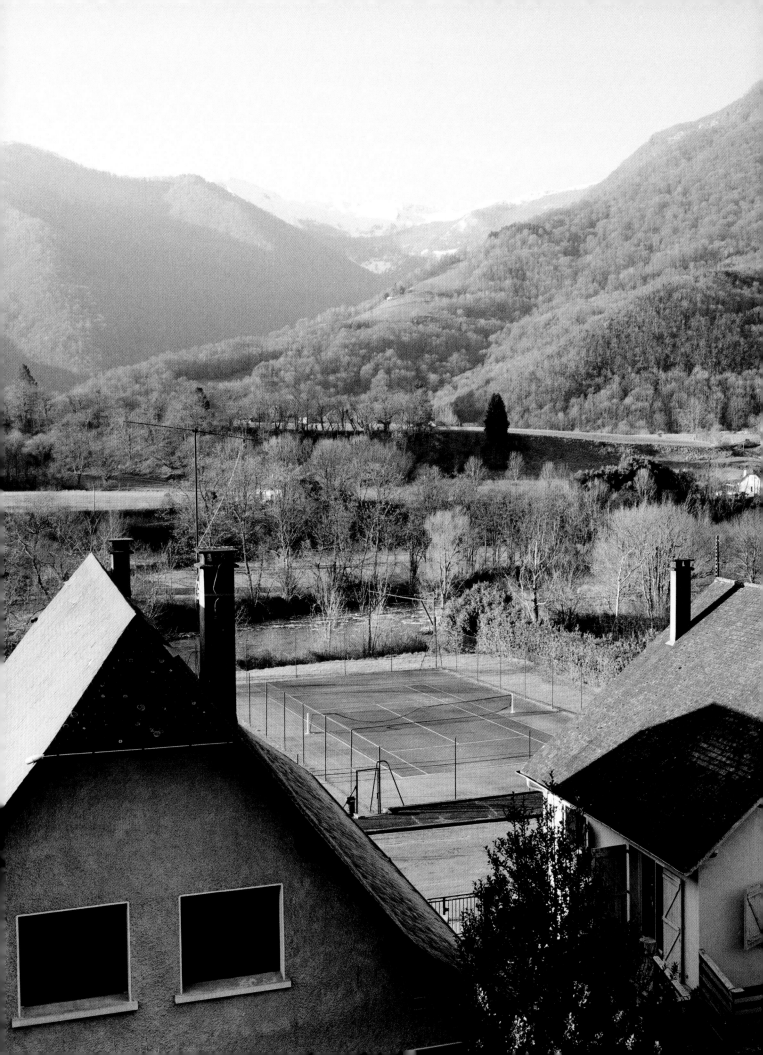

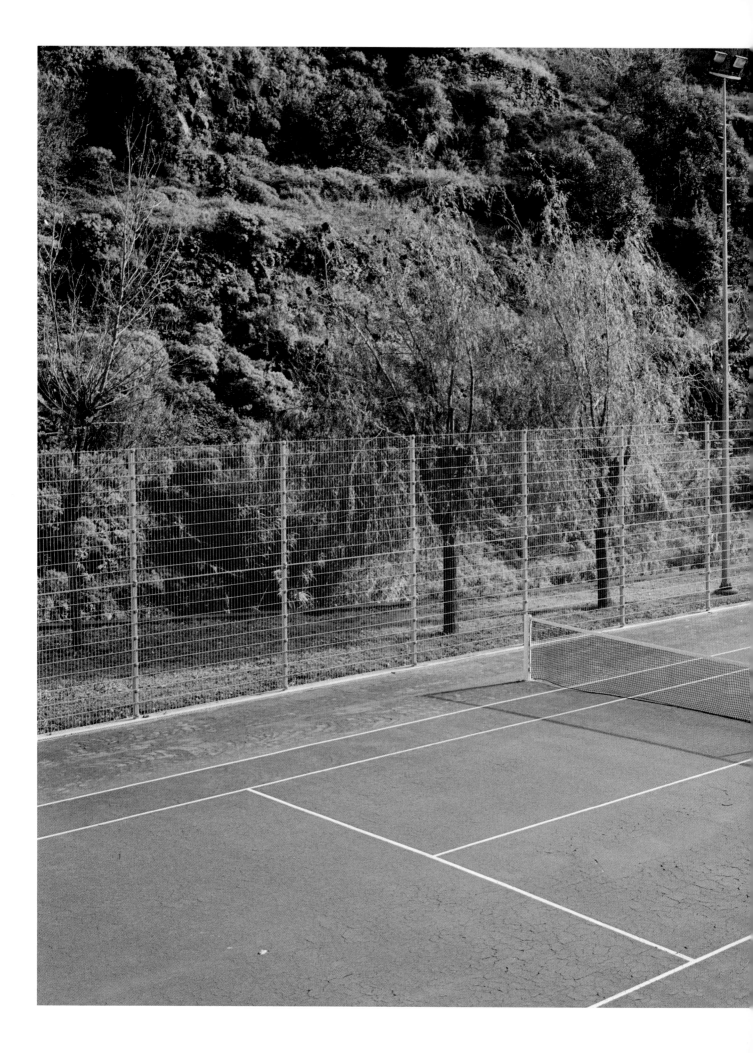

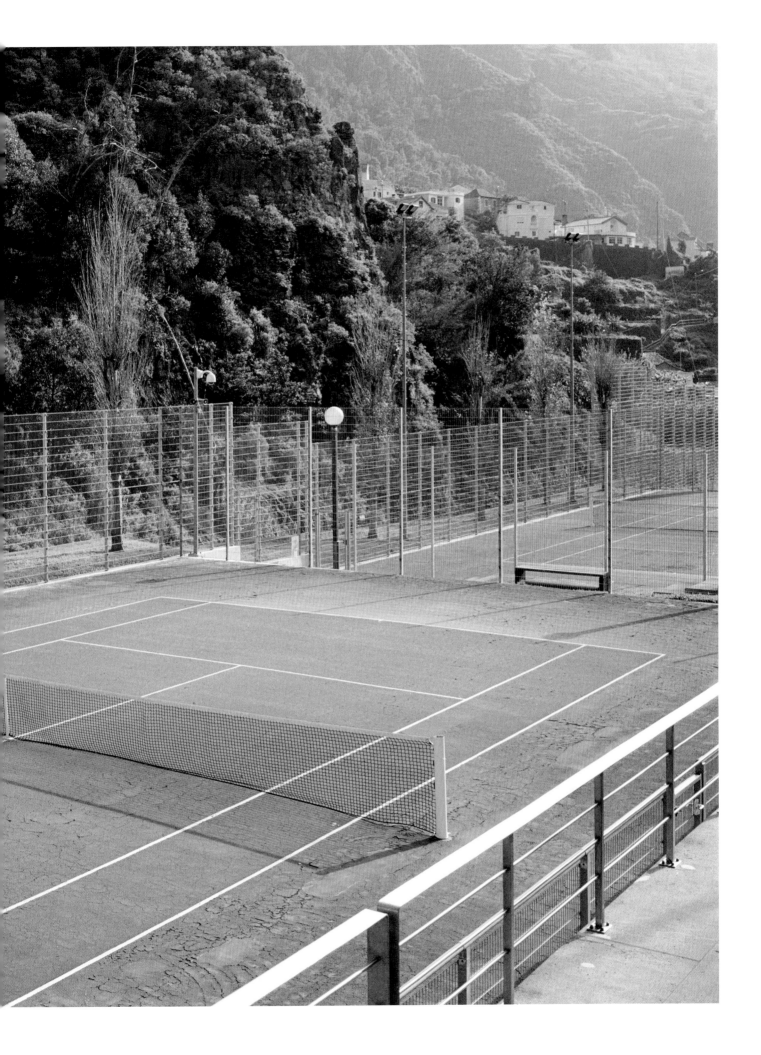

Naples, Italy

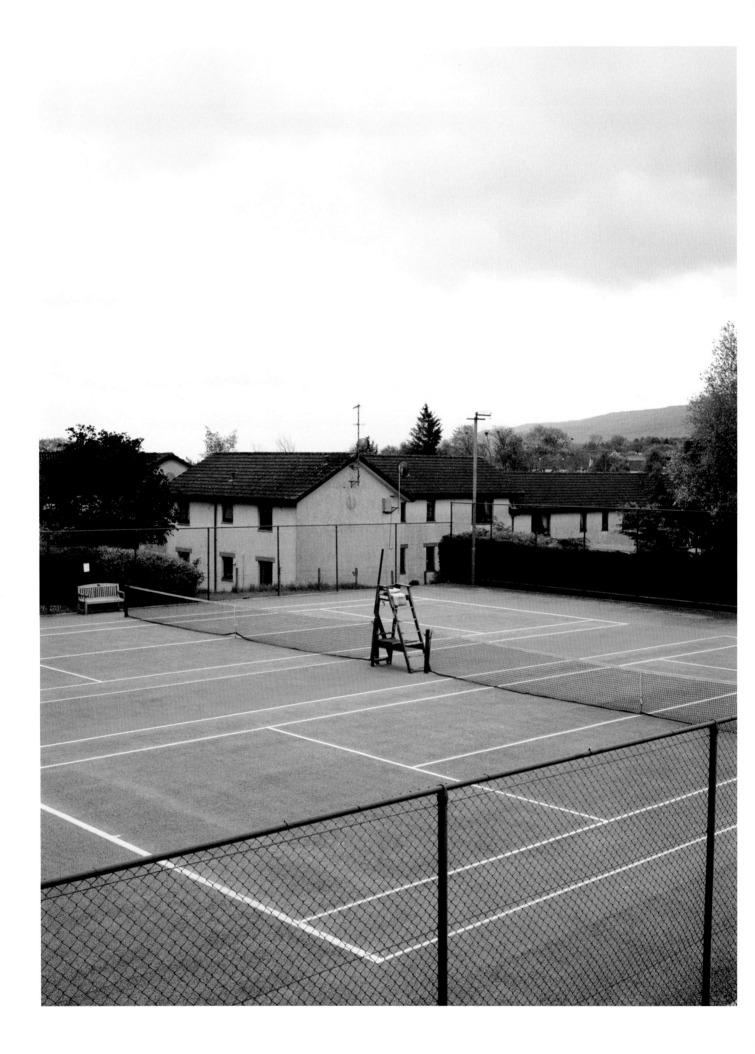

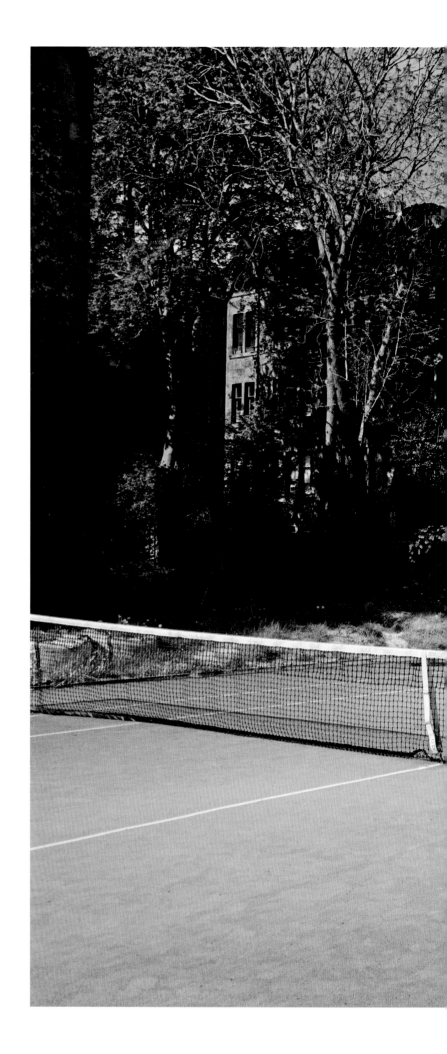

Dowanhill Lawn Tennis Club,
Glasgow, Scotland

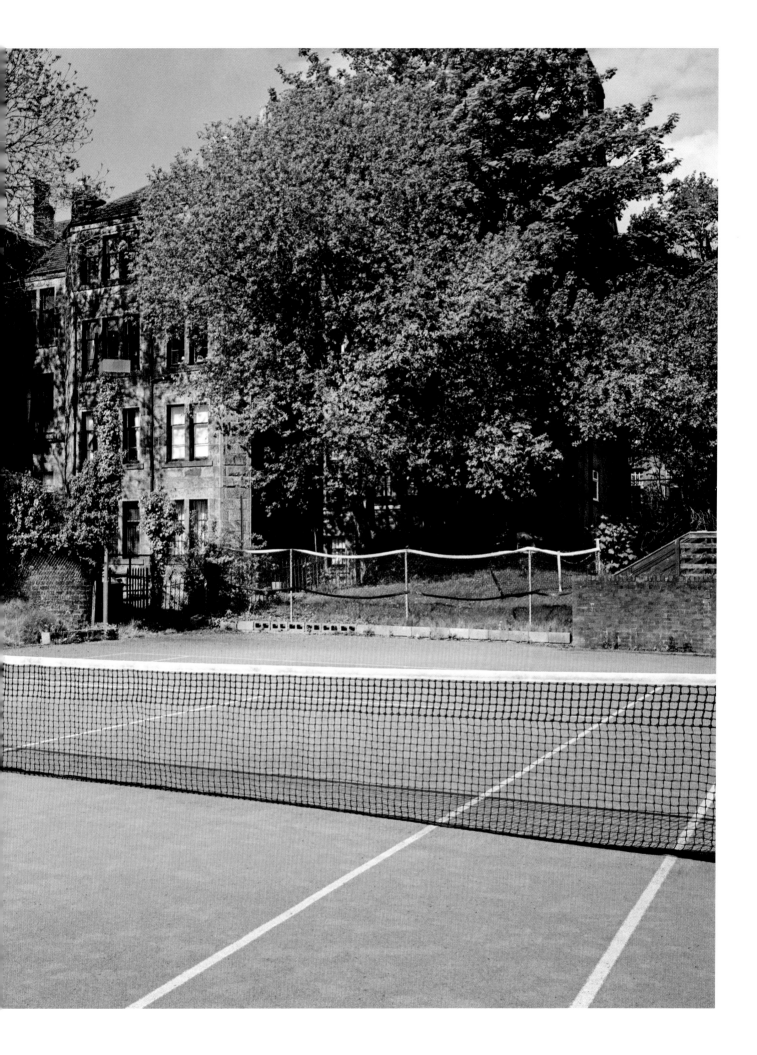

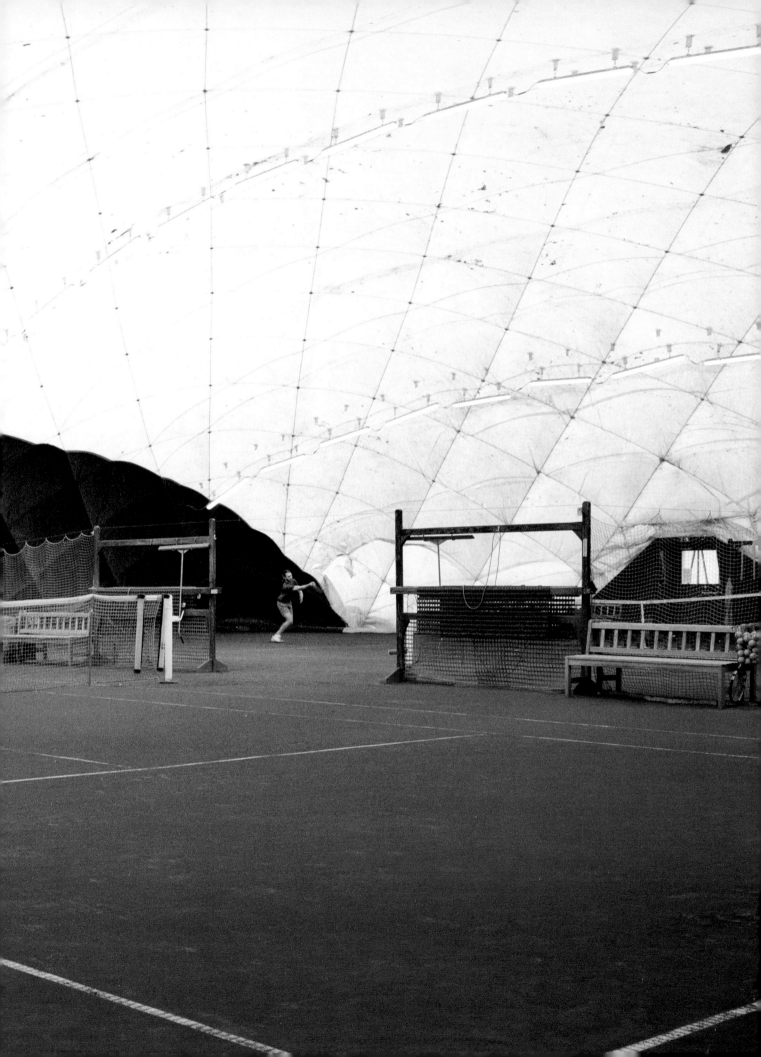

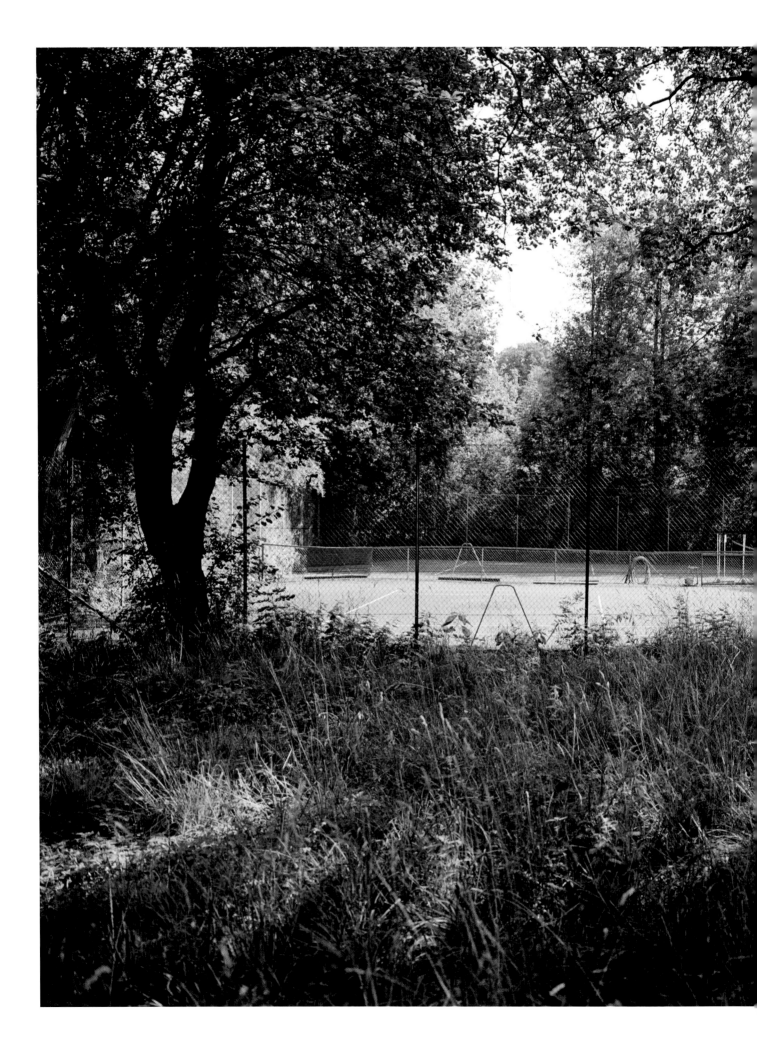

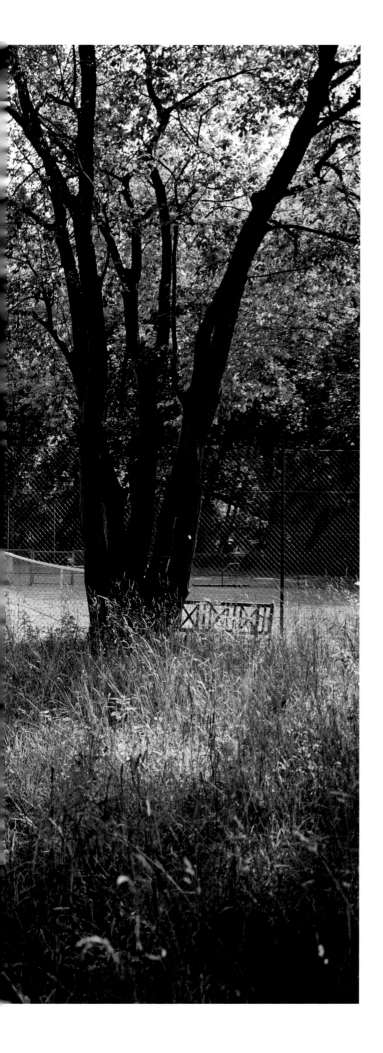

OPPOSITE: Lidingö, Sweden
FOLLOWING SPREAD: A dos Cunhados e Maceira, Portugal
PAGES 70–71: Salamanca, Spain
PAGES 72–73: Copenhagen, Denmark
PAGES 74–75: I. Český Lawn Tennis Klub, Prague, Czech Republic
PAGES 76–77: Lower Aghada Tennis and Sailing Club, Midleton, Ireland

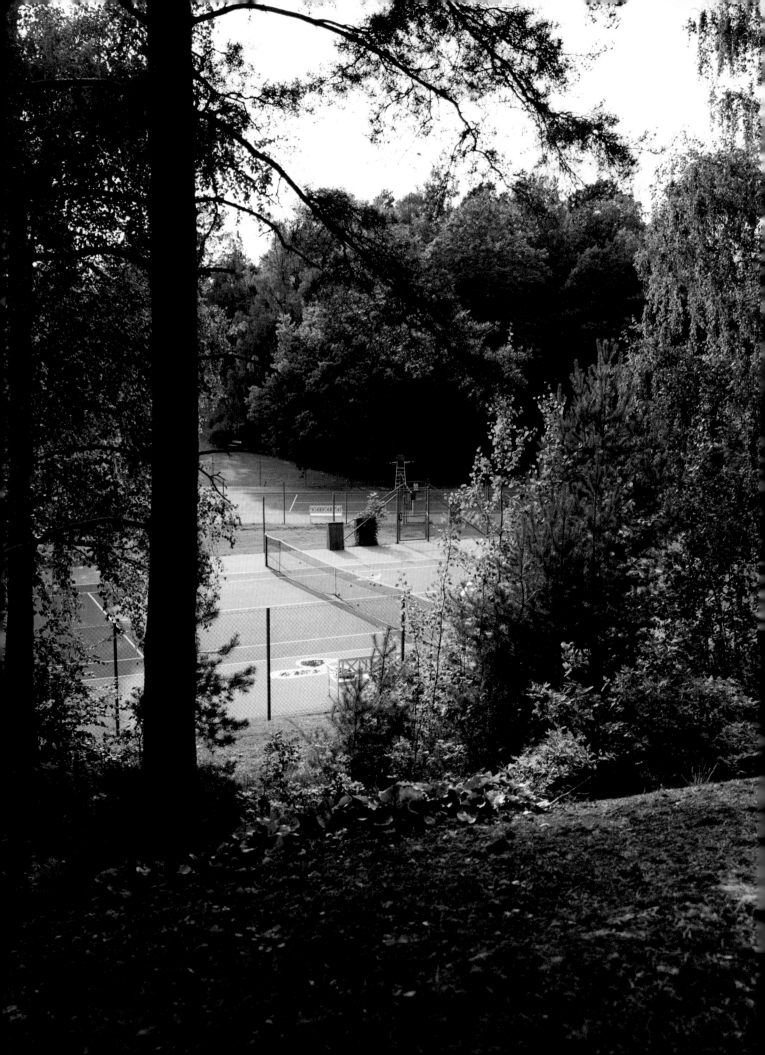

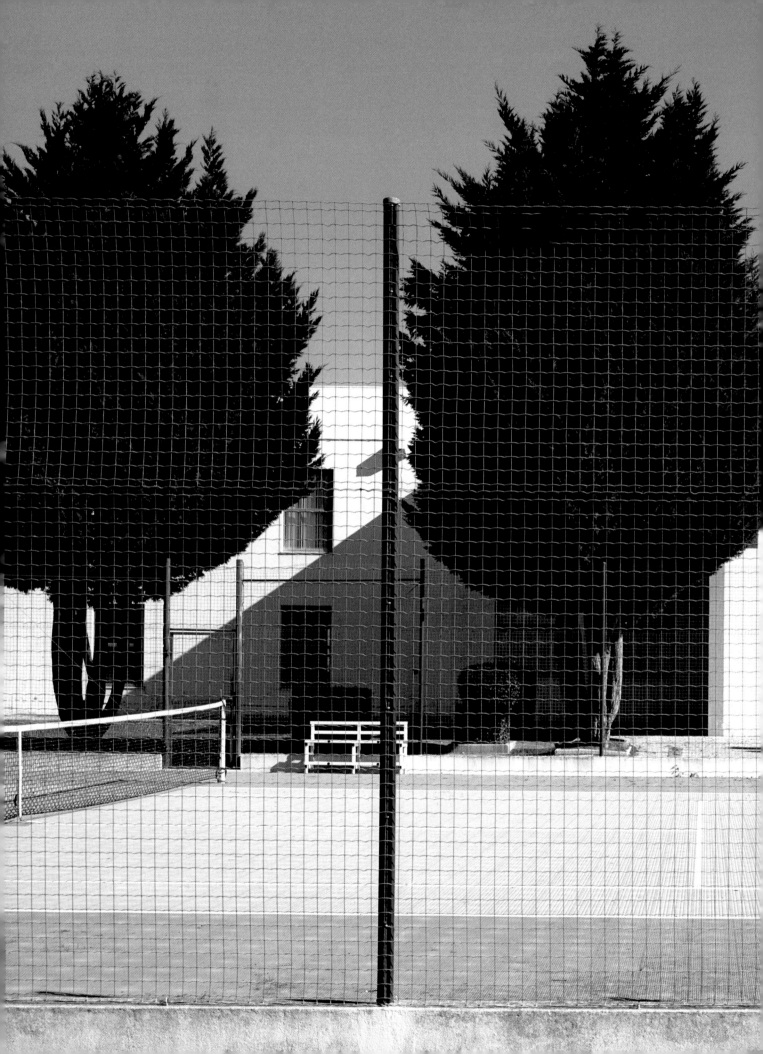

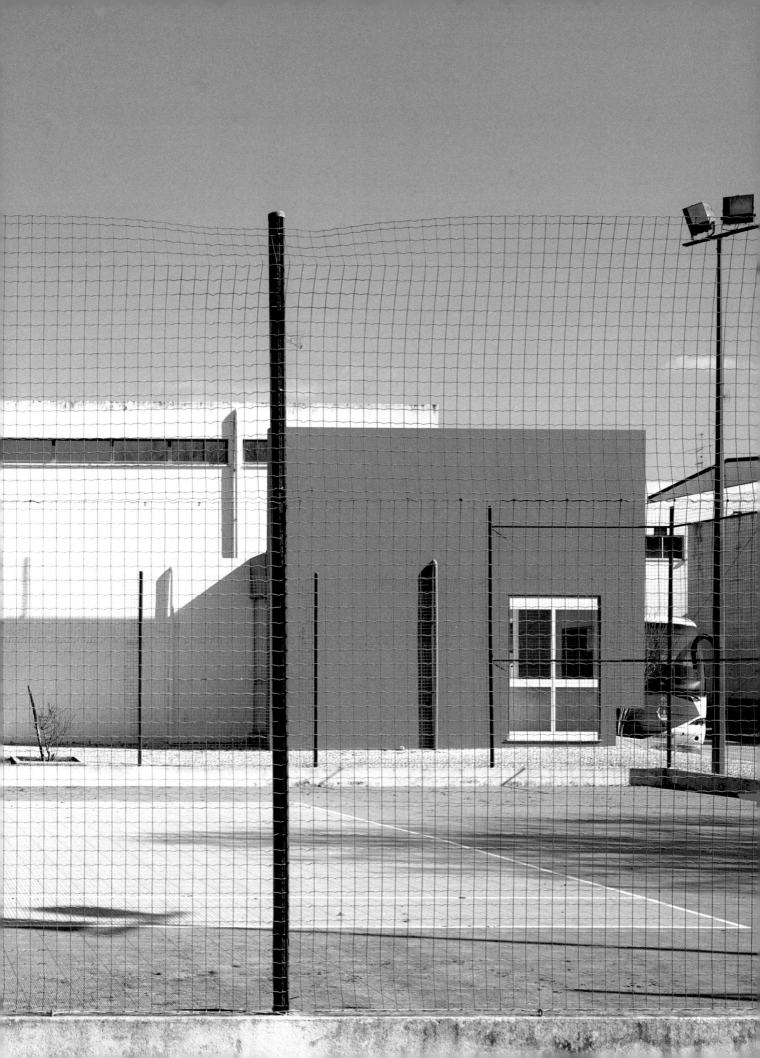

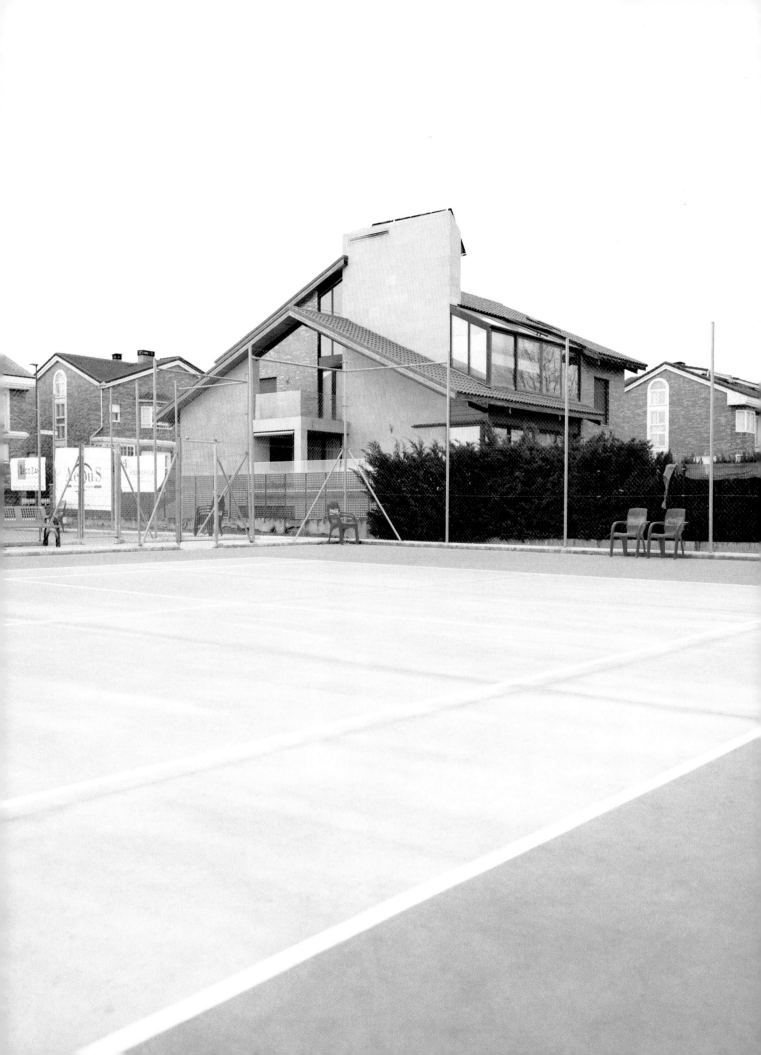

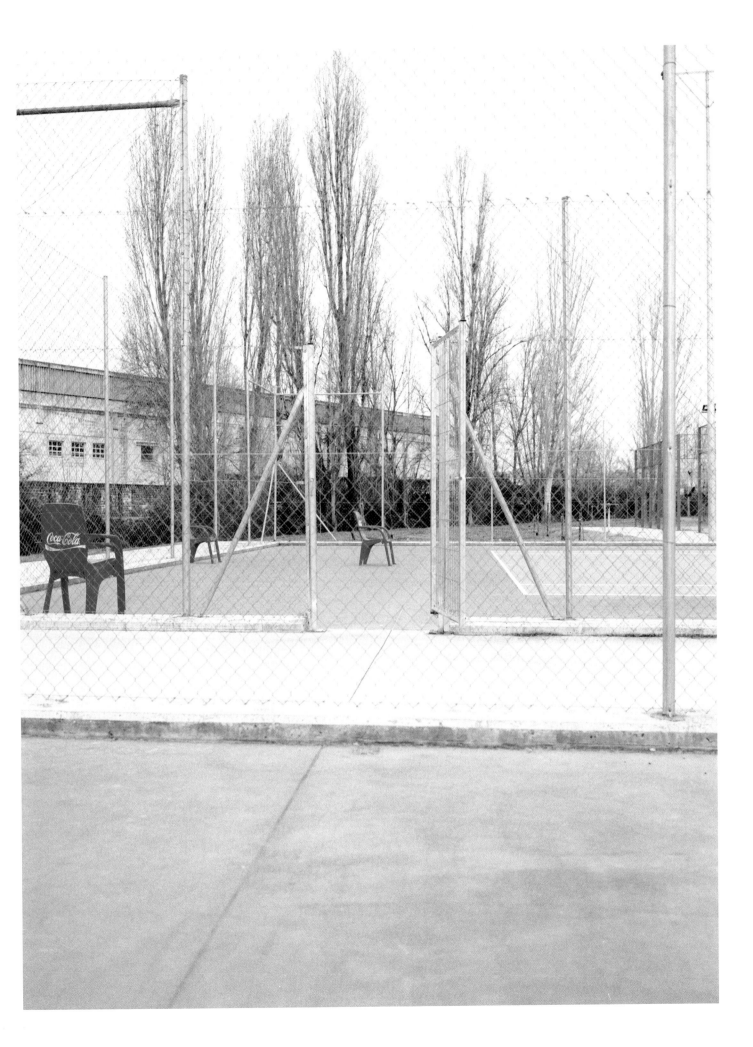

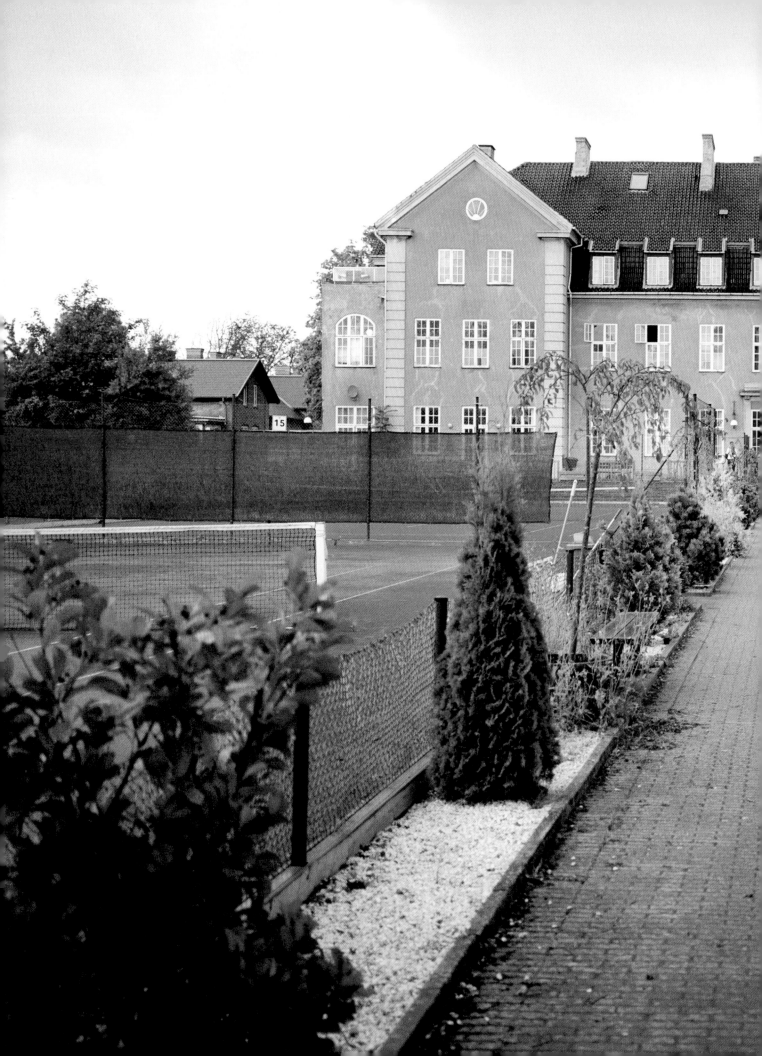

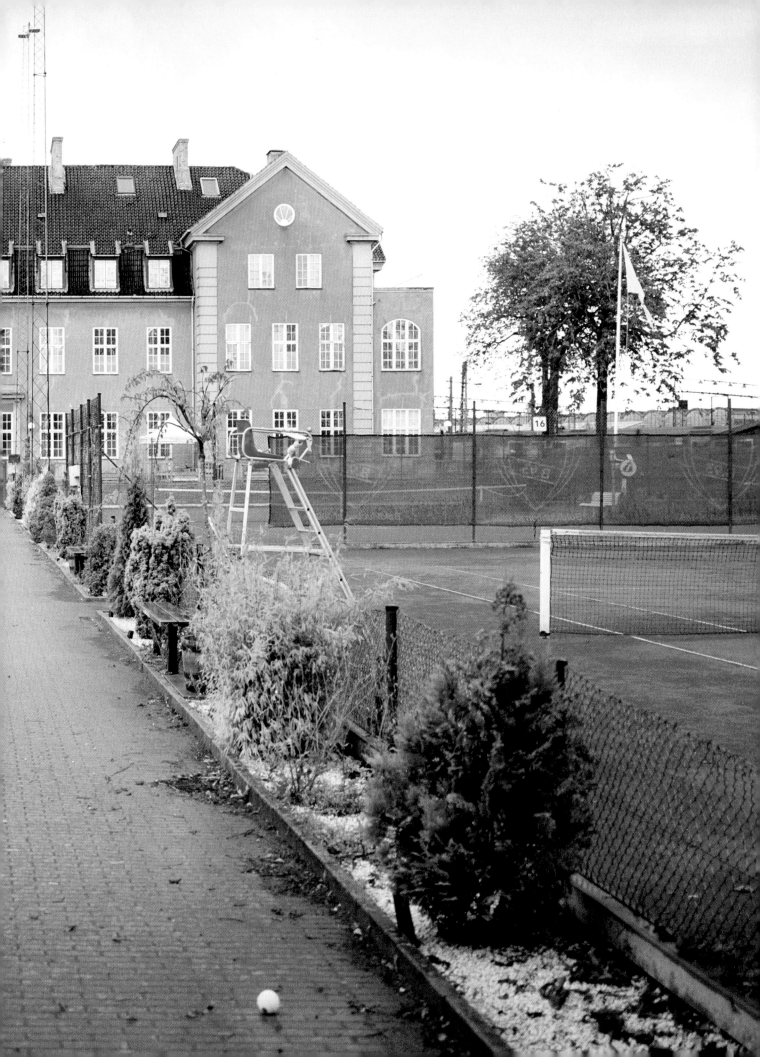

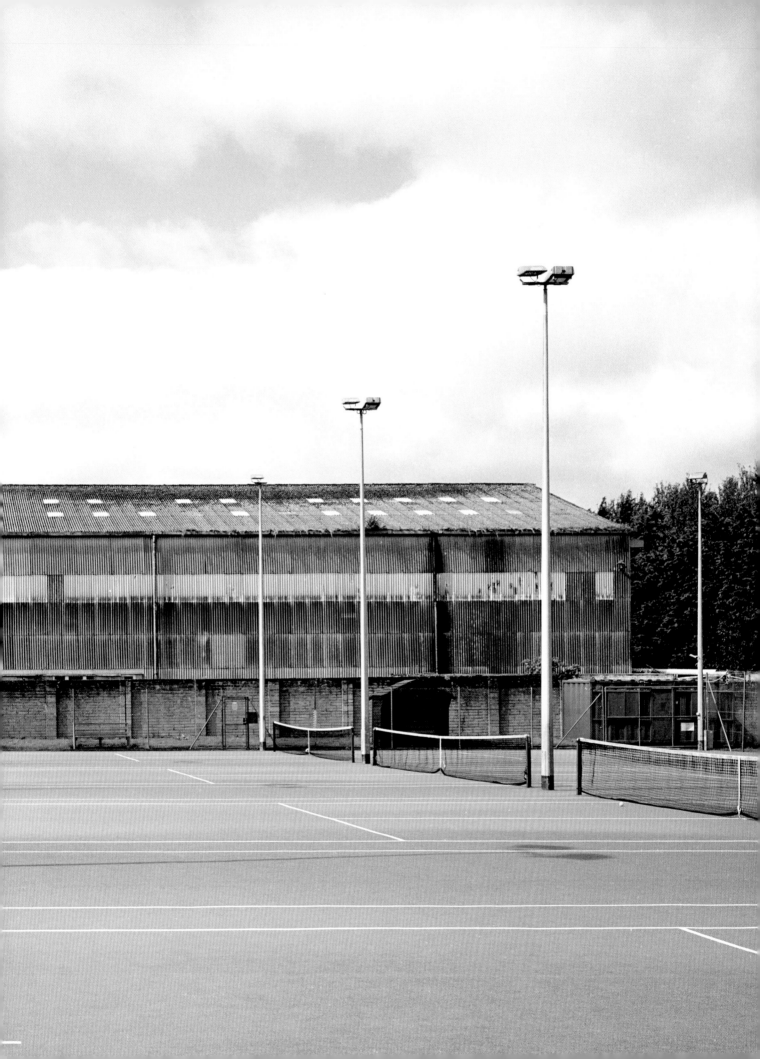

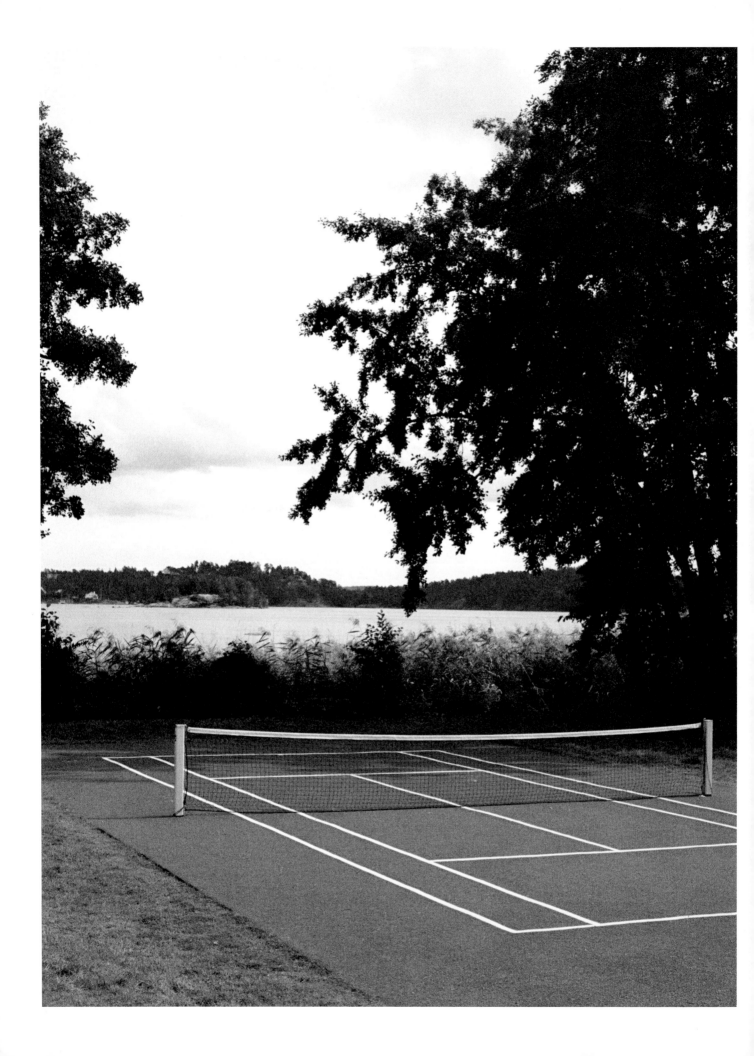

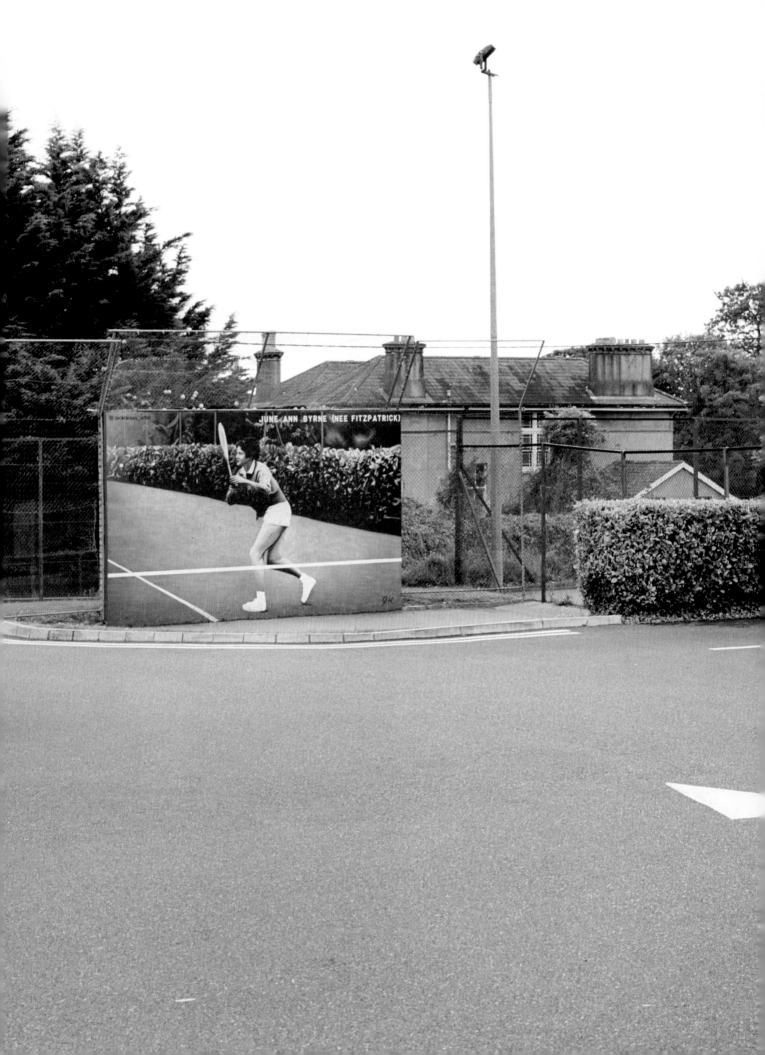

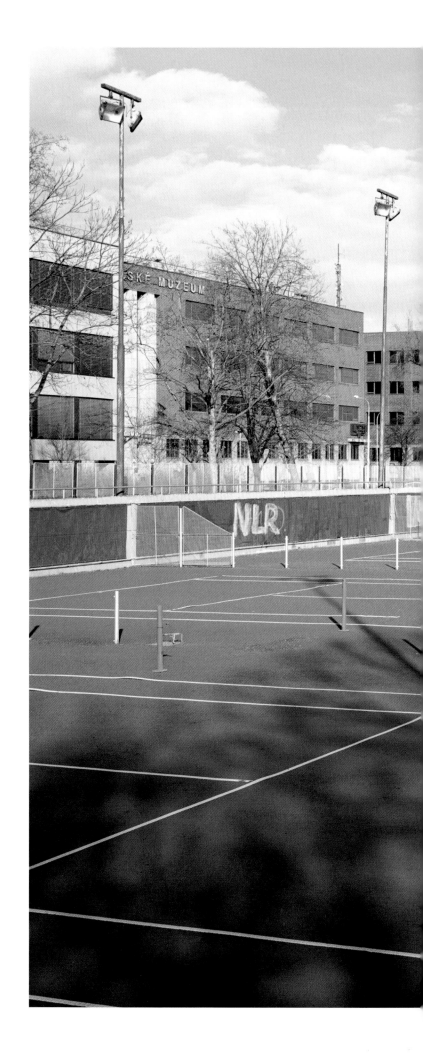

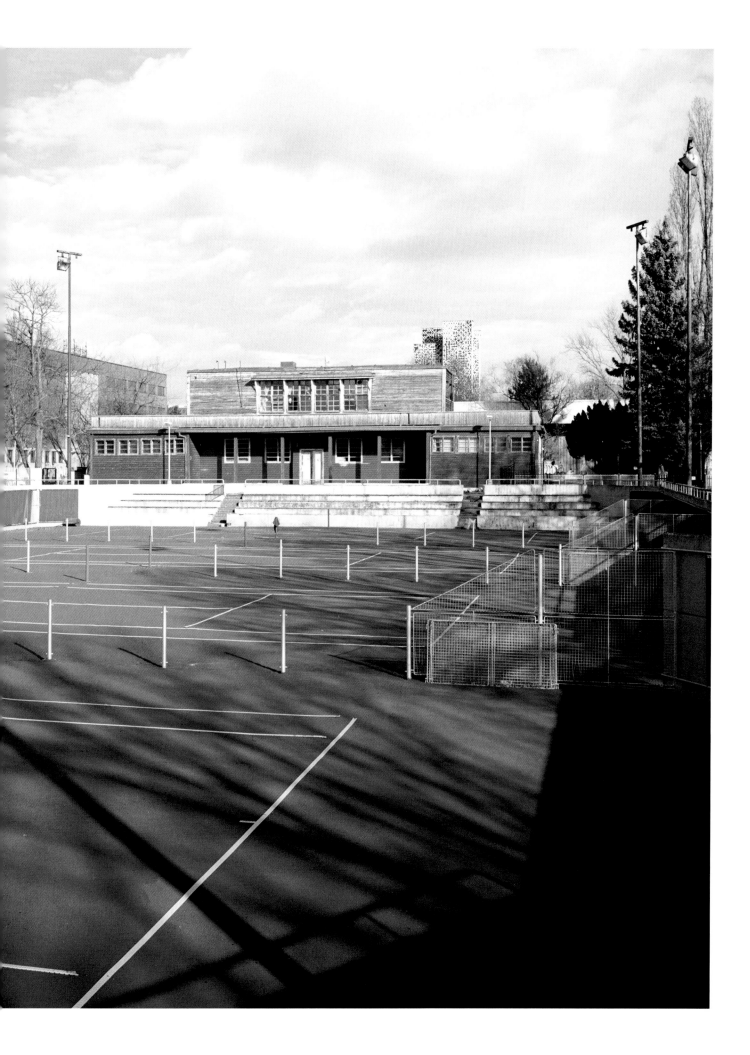

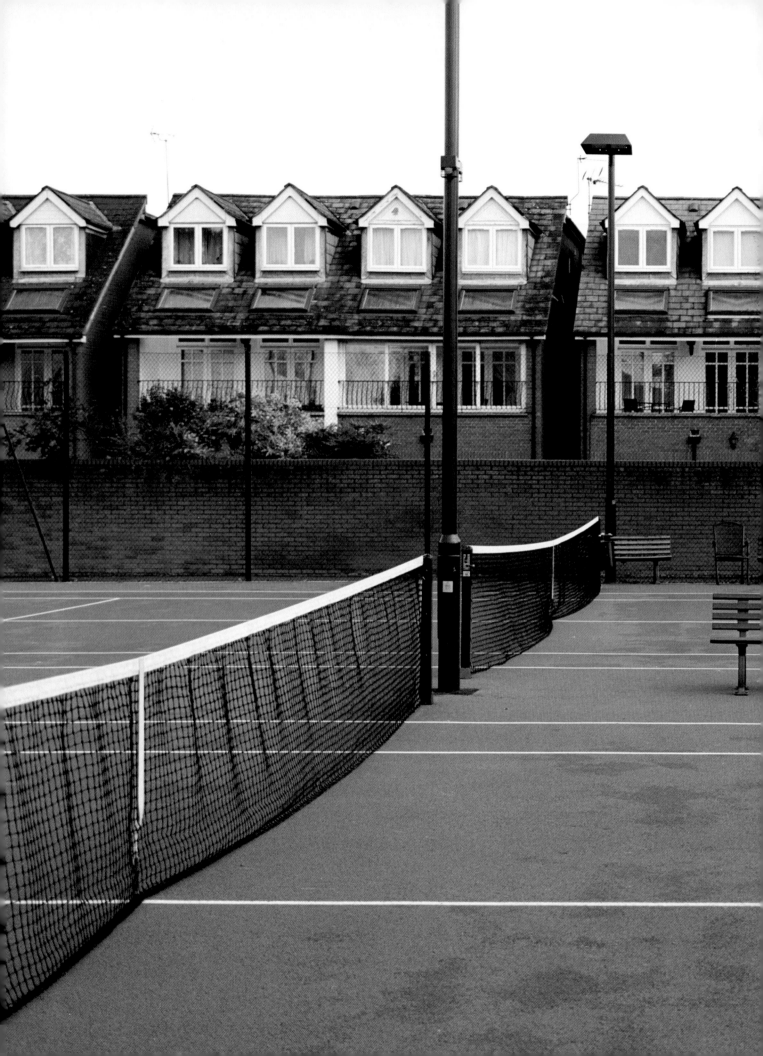

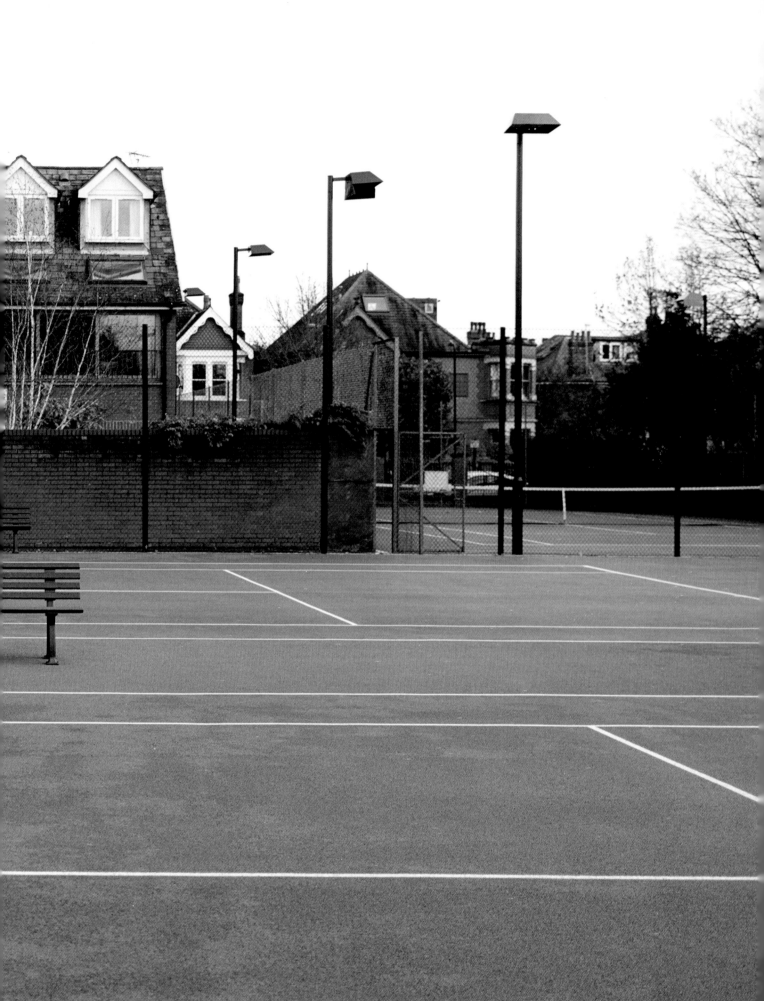

PREVIOUS SPREAD: Ealing, London
OPPOSITE: Lija, Malta

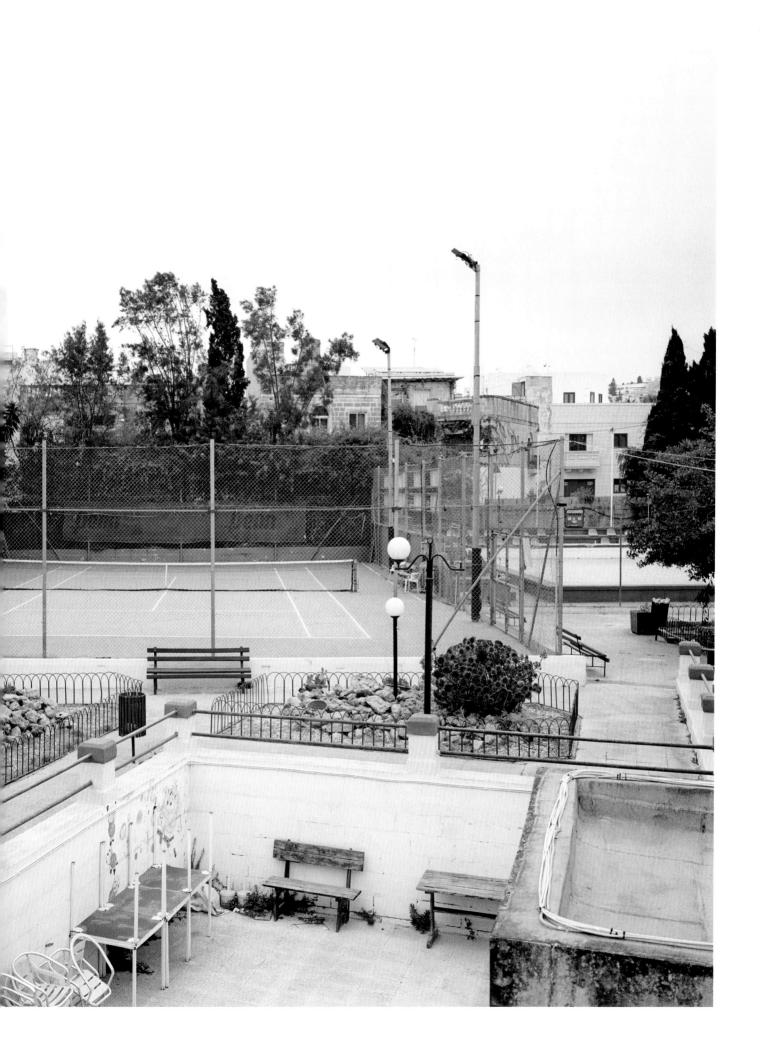

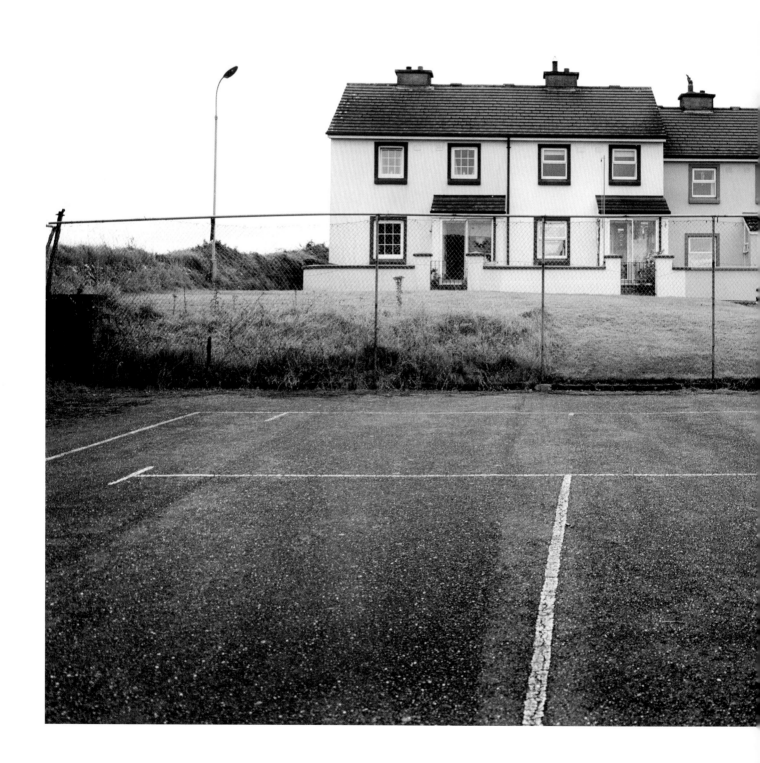

OPPOSITE: Ballycotton, Ireland
FOLLOWING SPREAD: Lower Aghada Tennis and
Sailing Club, Midleton, Ireland

87

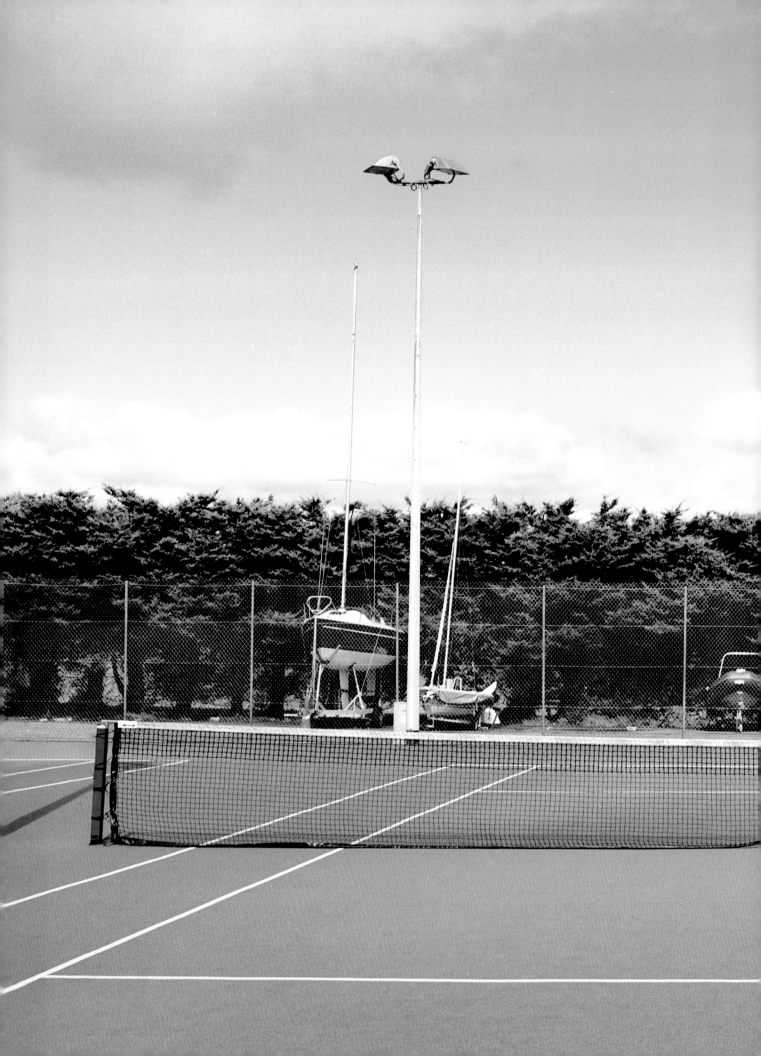

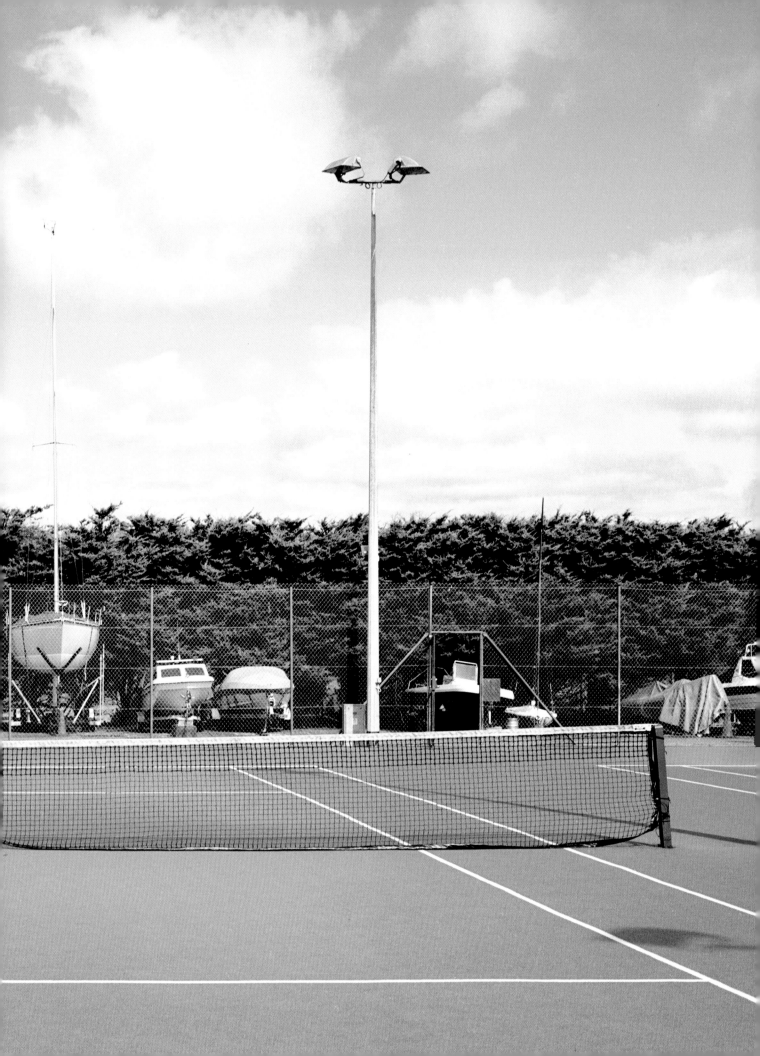

OPPOSITE: Greenwich, London
FOLLOWING SPREAD: Cork, Ireland

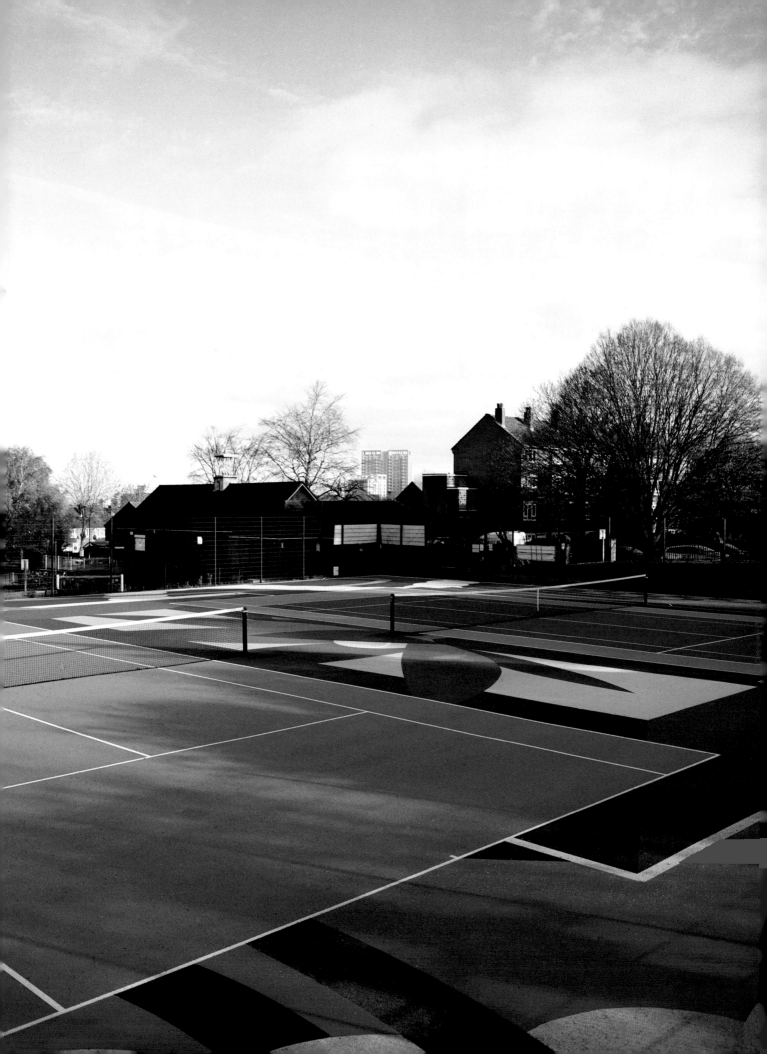

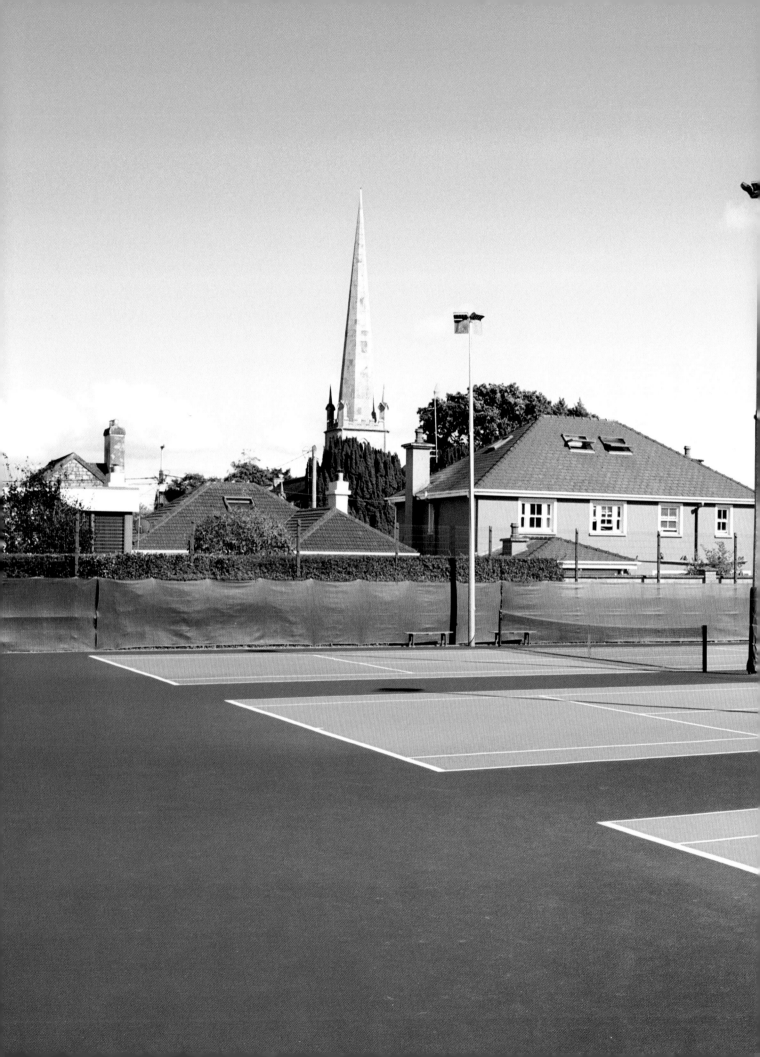

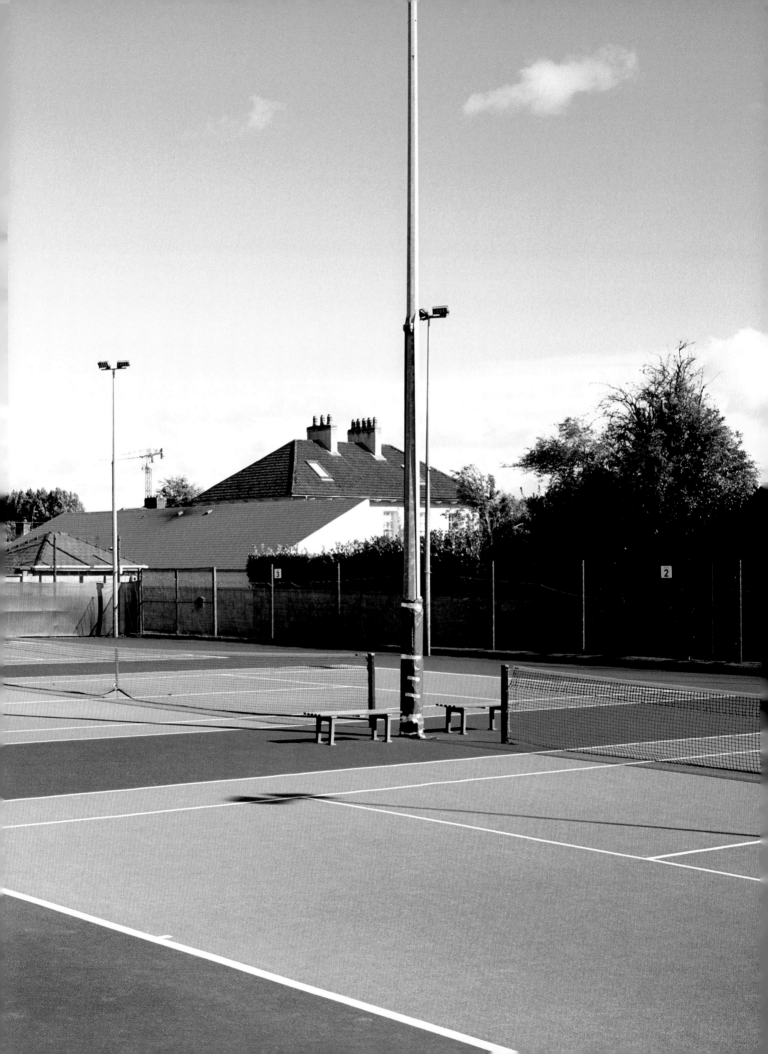

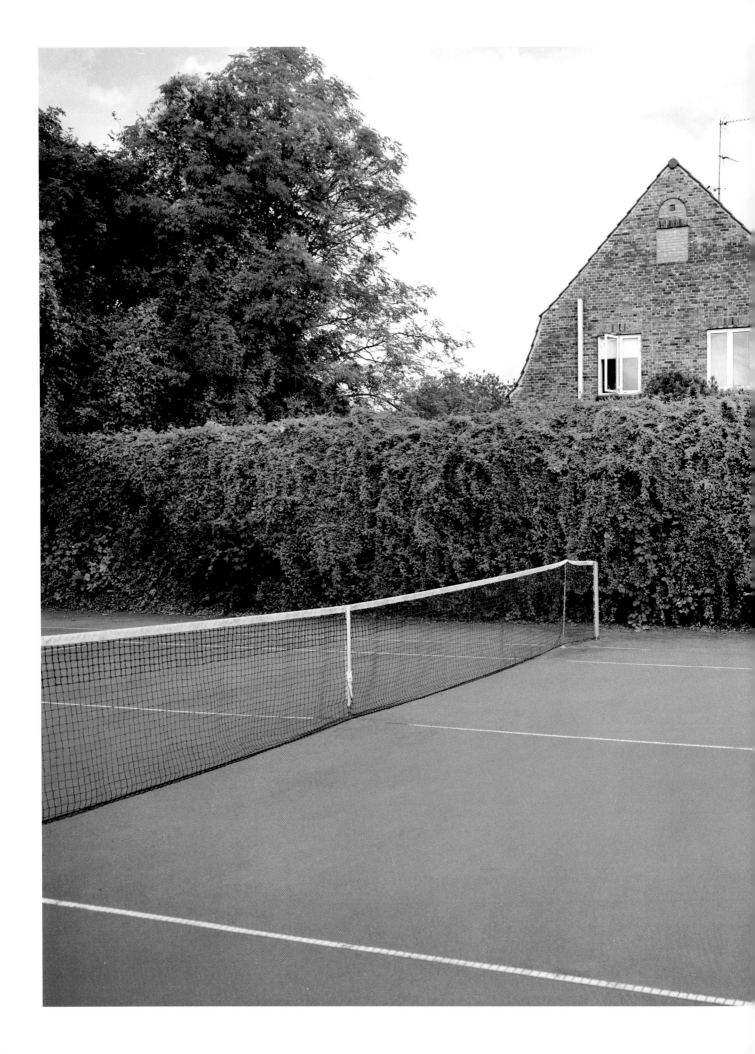

Kløvermarkens Tennis Club, Copenhagen

OPPOSITE: Burgos, Spain
FOLLOWING SPREAD: Syracuse, Sicily
PAGES 100-101: Tennis de L'Atlantique, Paris

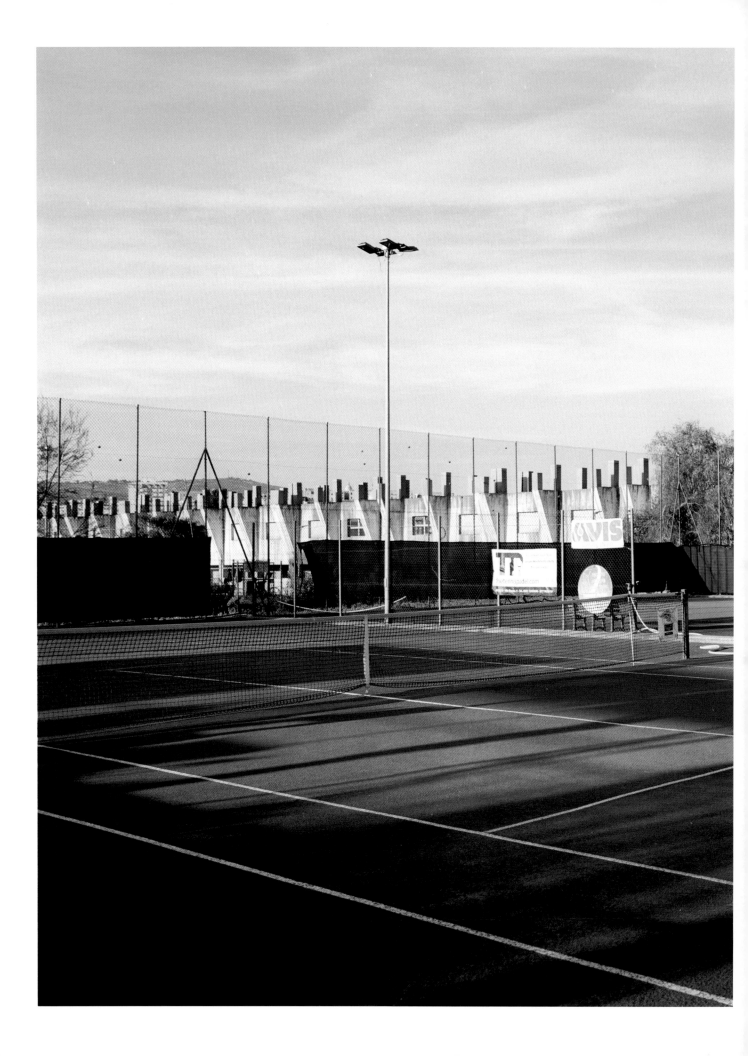

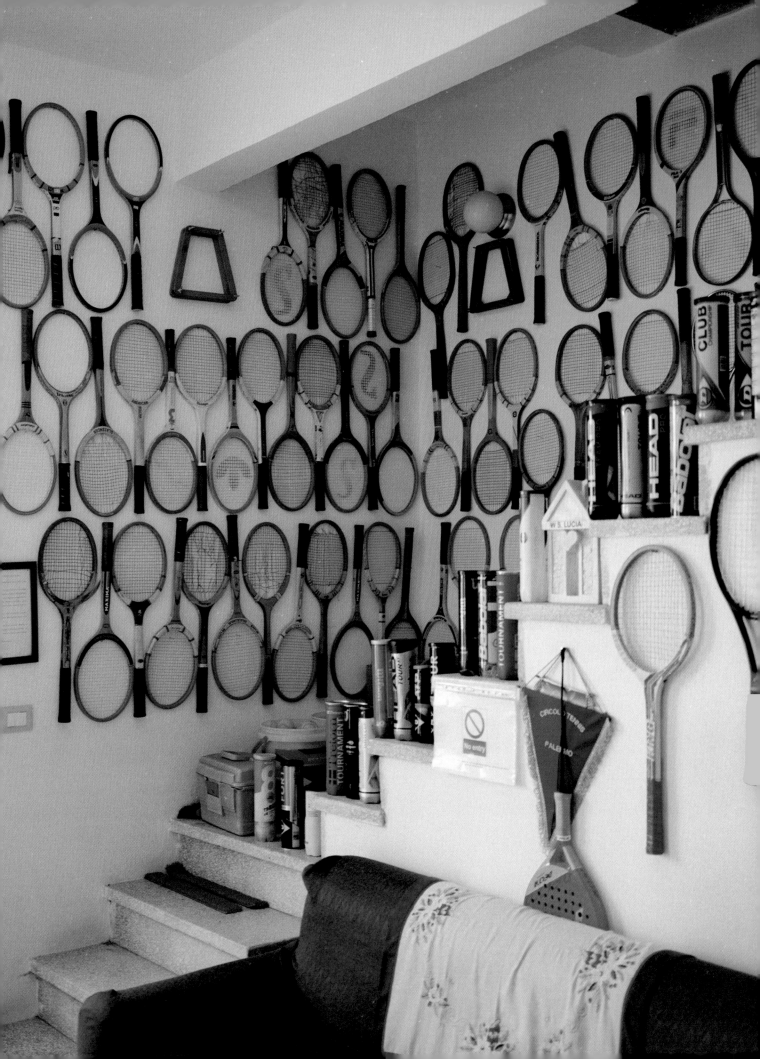

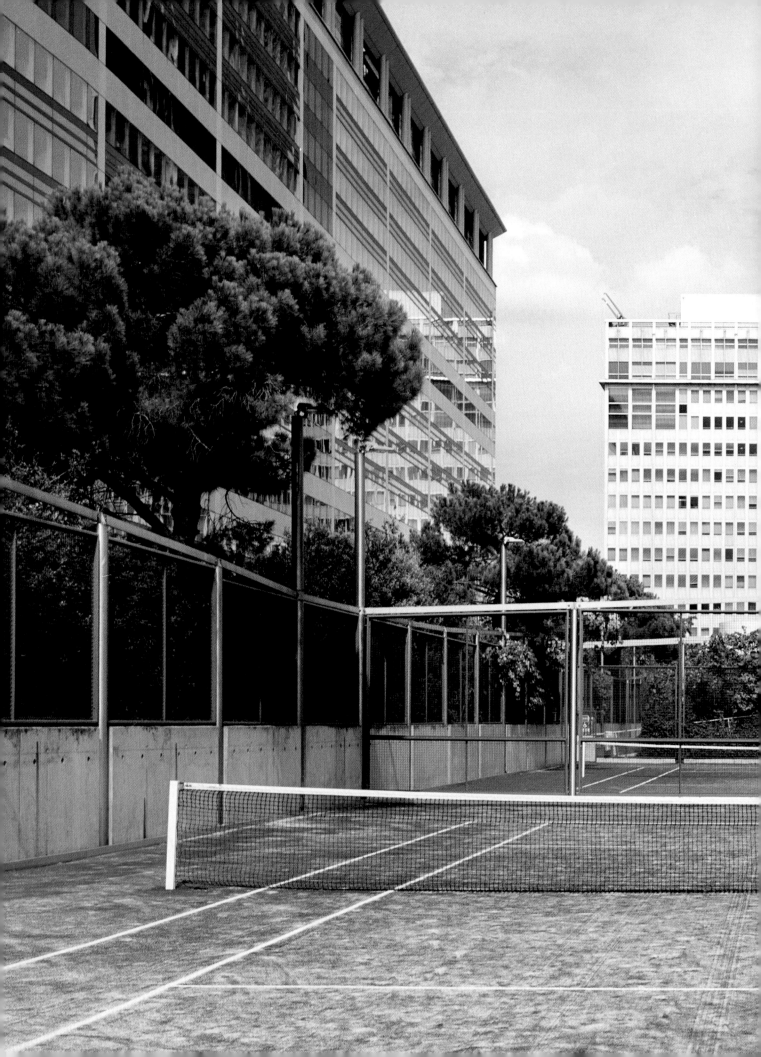

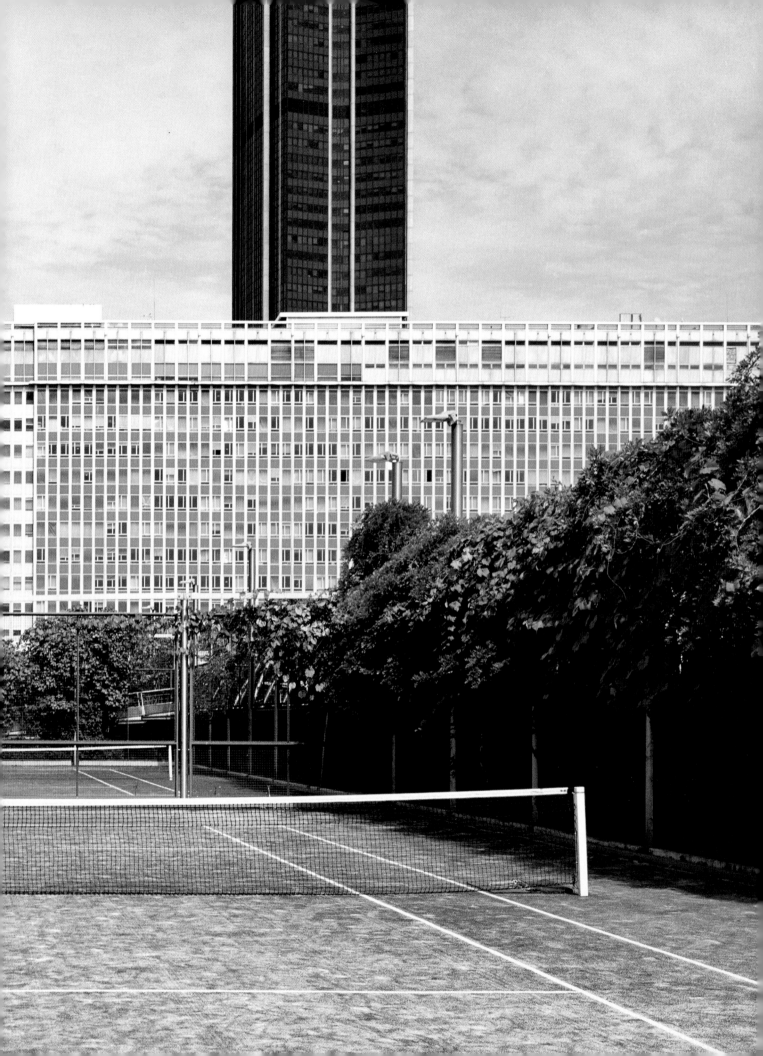

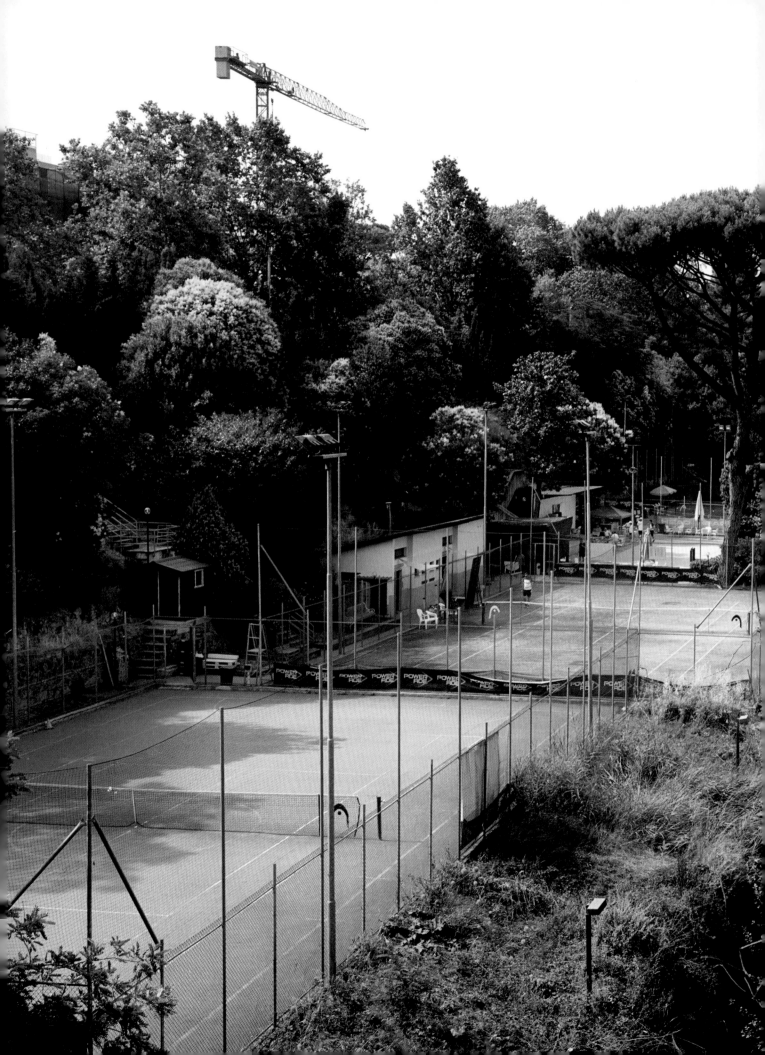

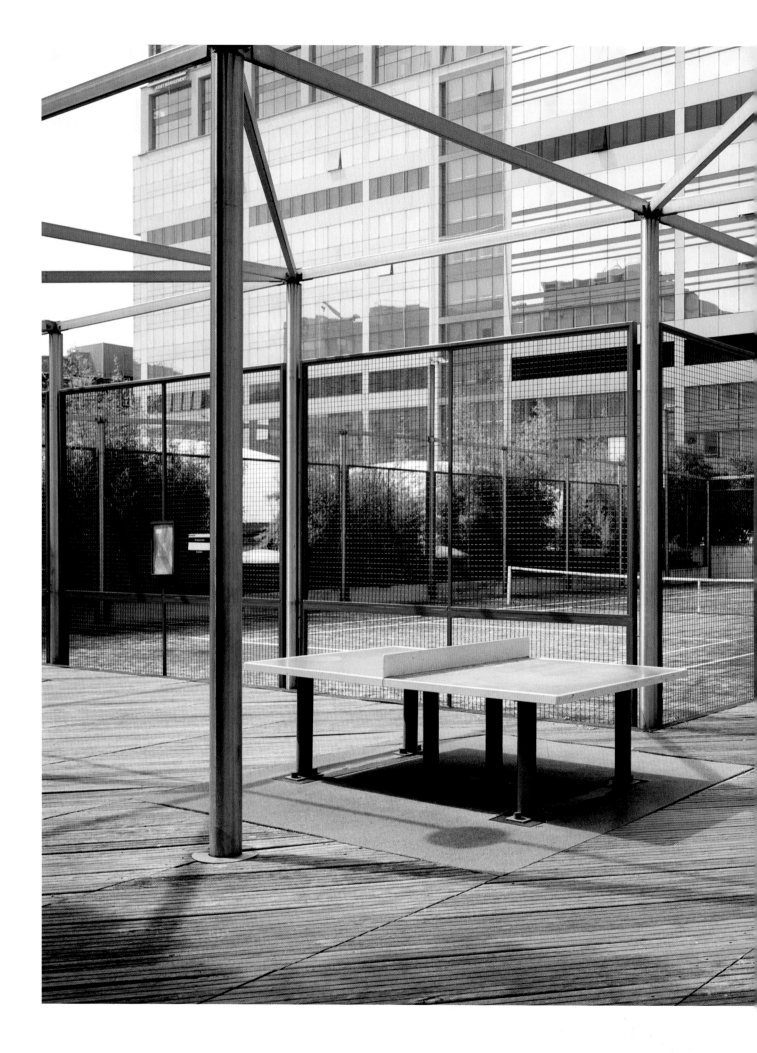

PREVIOUS SPREAD: SSD Lazio Tennis, Rome
OPPOSITE: Tennis de L'Atlantique, Paris

105

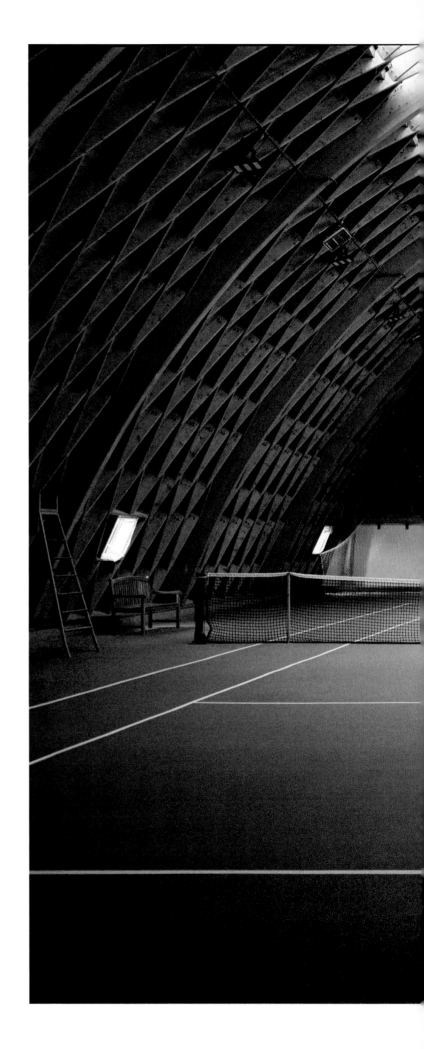

OPPOSITE AND FOLLOWING
SPREAD: Tennis de la Cavalerie, Paris

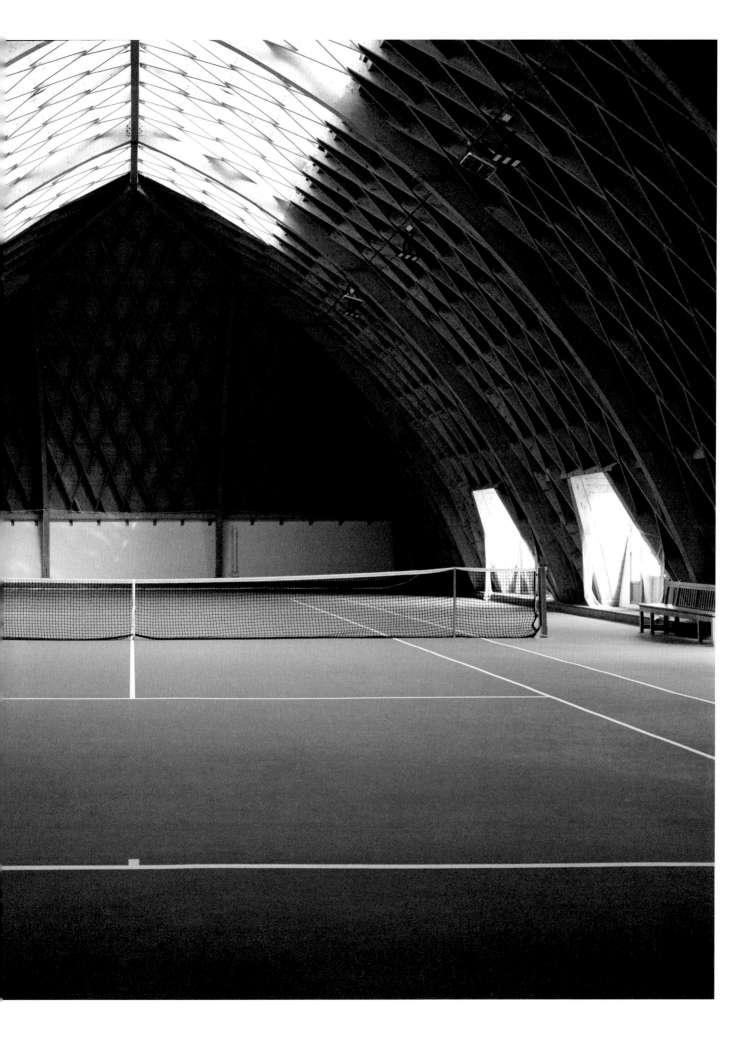

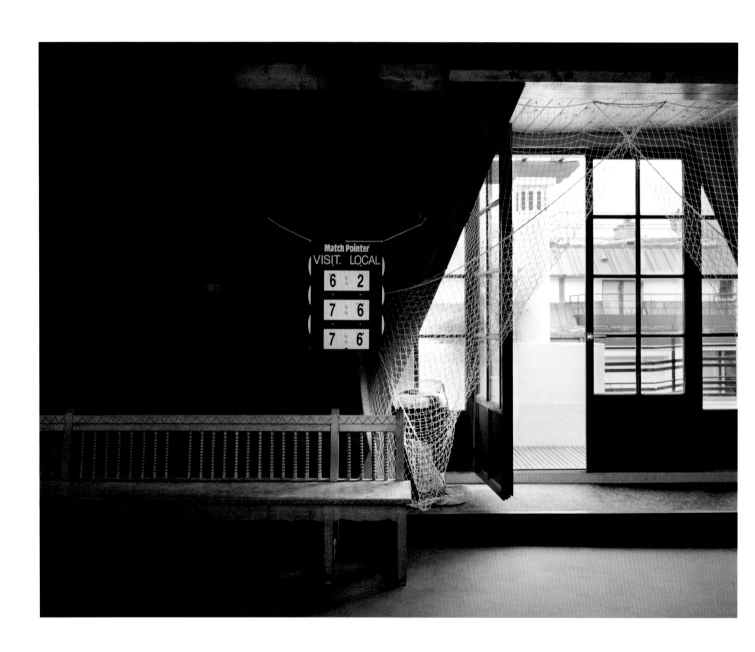

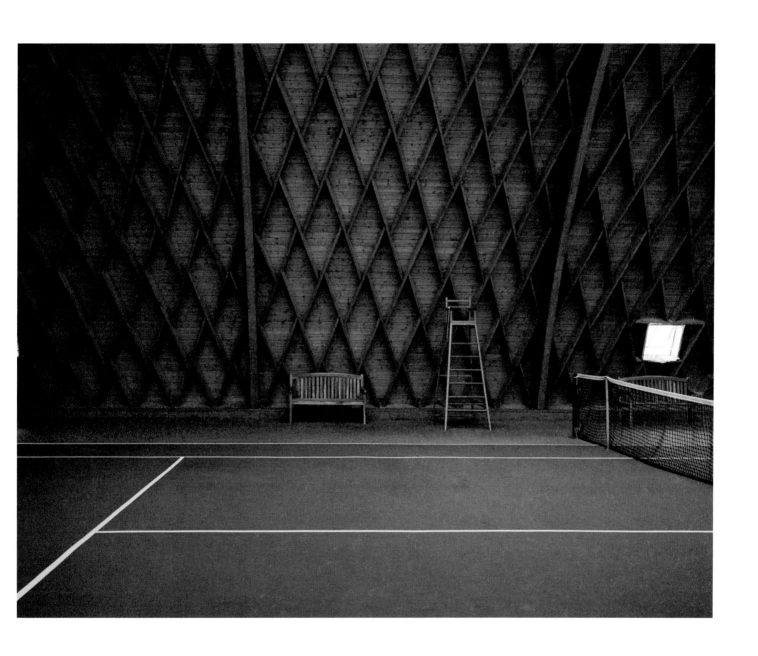

OPPOSITE AND
FOLLOWING SPREAD:
Warsaw, Poland

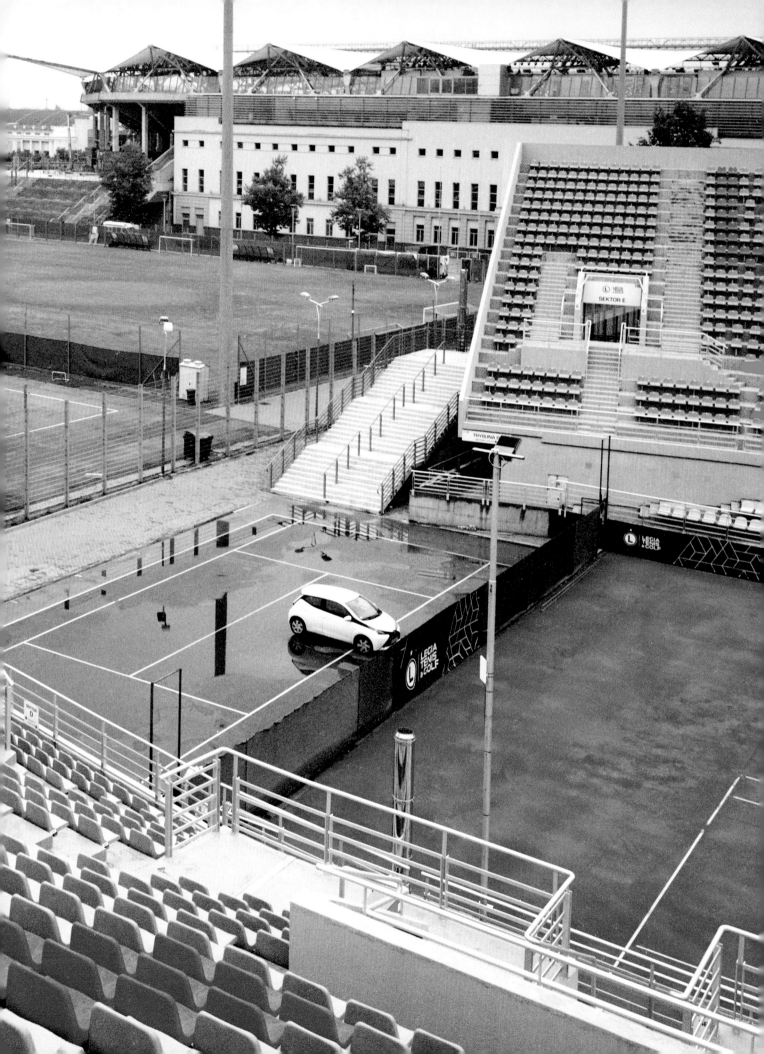

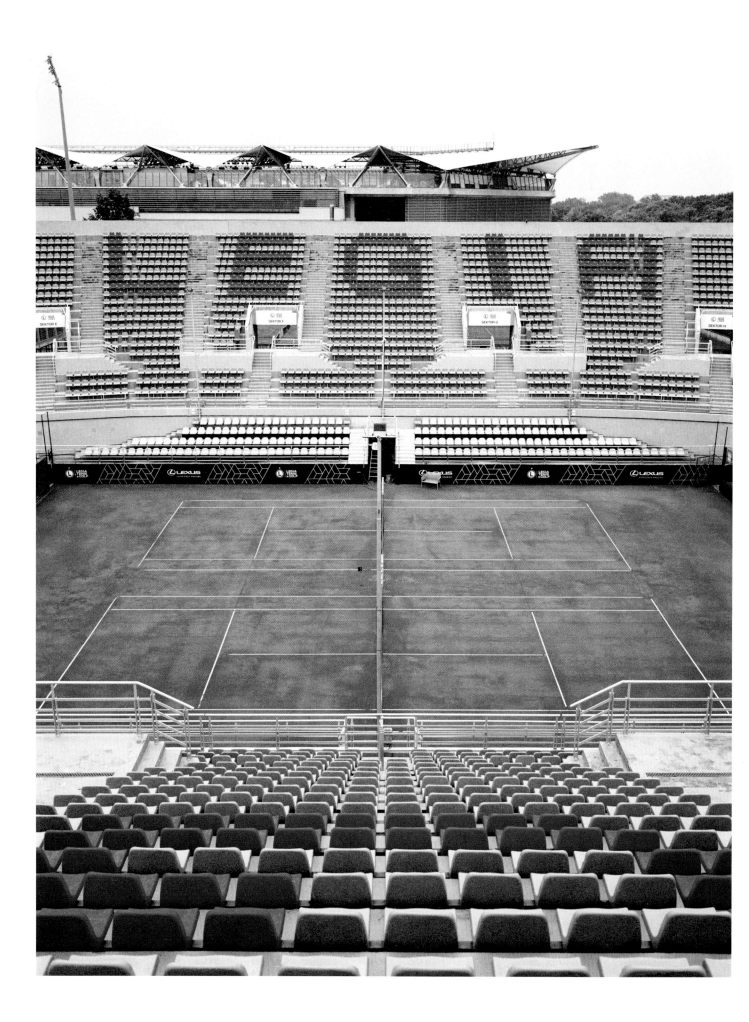

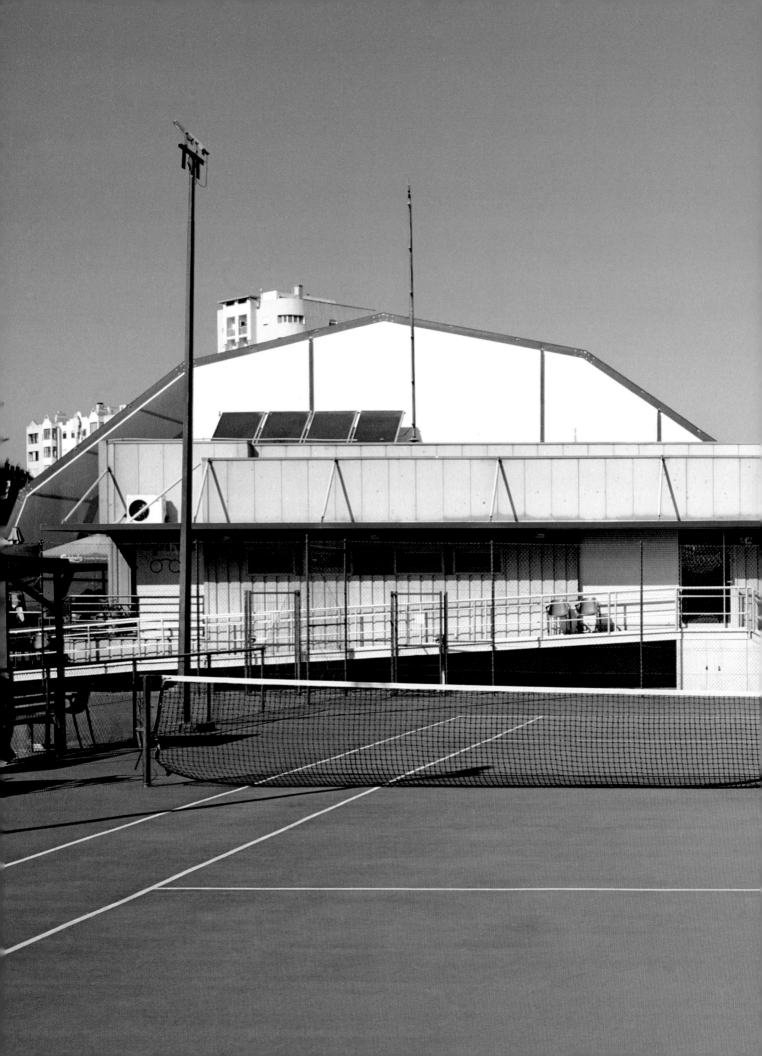

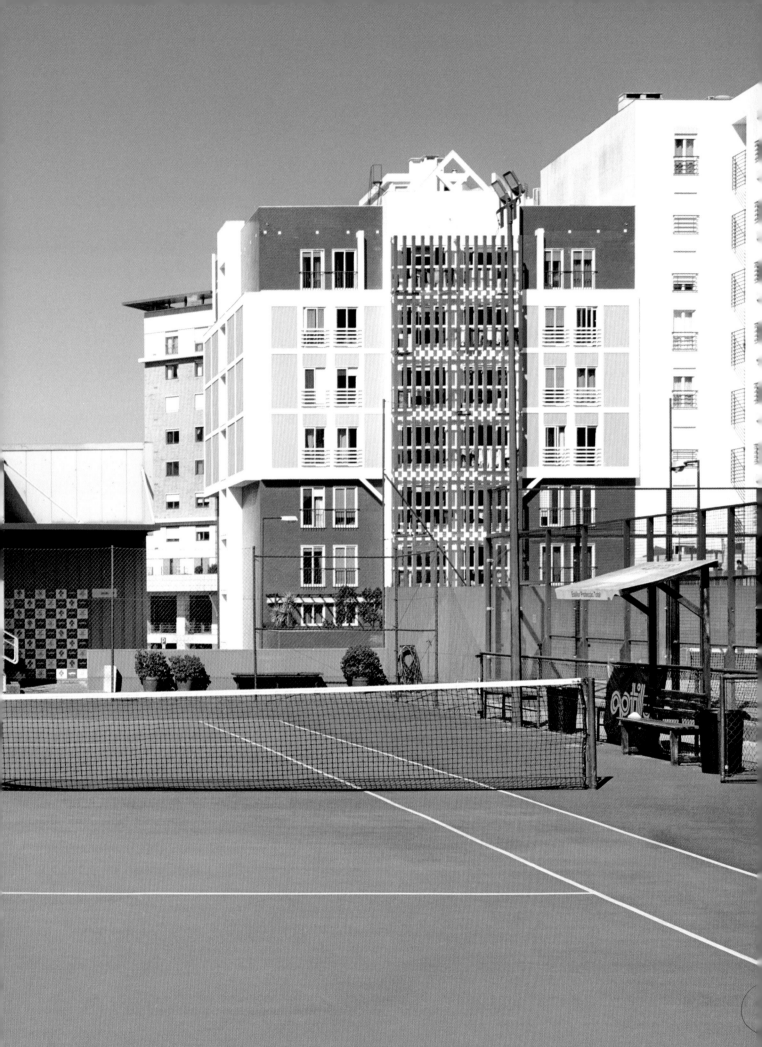

OPPOSITE: Barbican, London
FOLLOWING SPREAD: The Westway, London

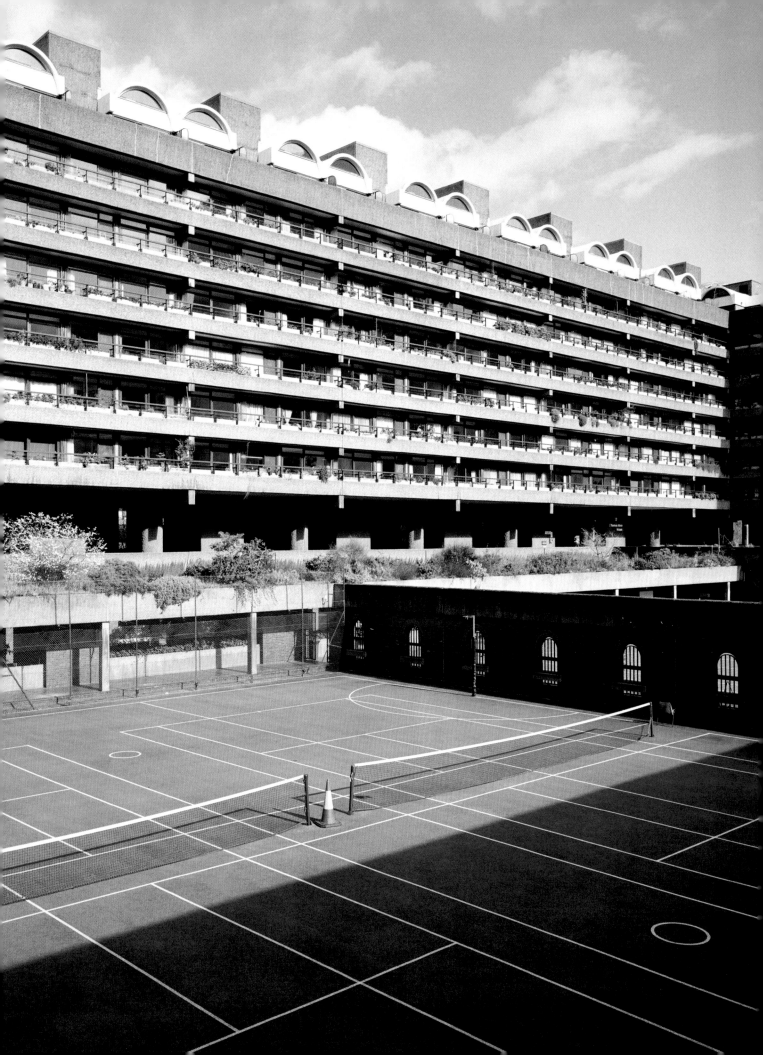

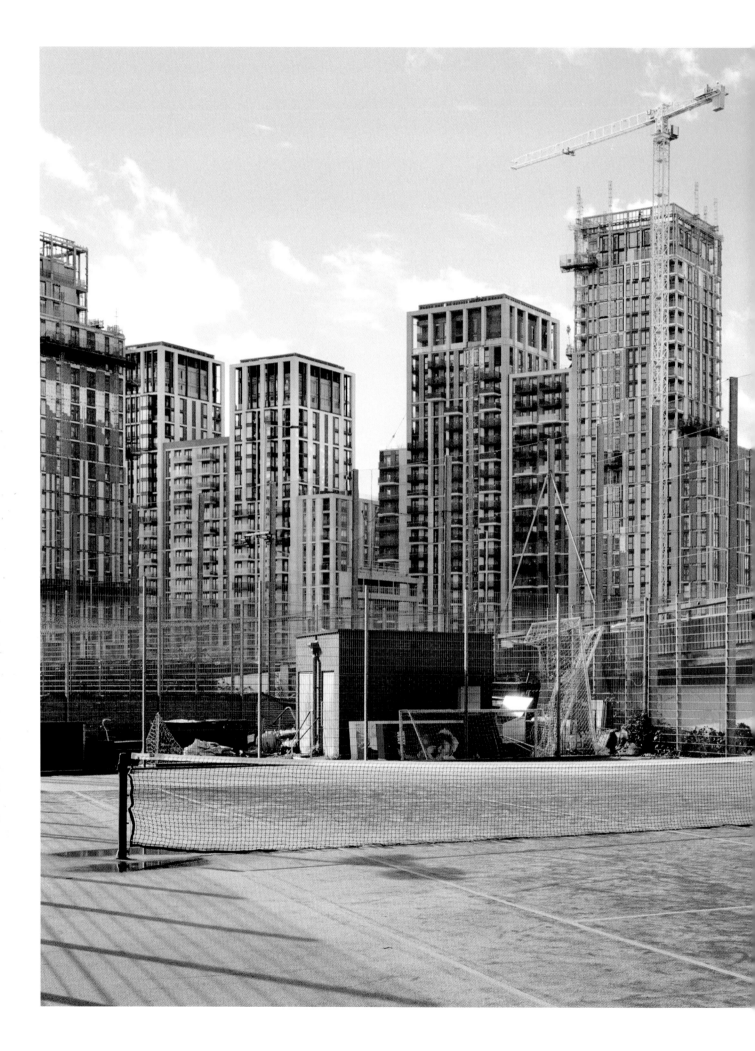

OPPOSITE AND FOLLOWING
SPREAD: Santa Agnese, Rome

123

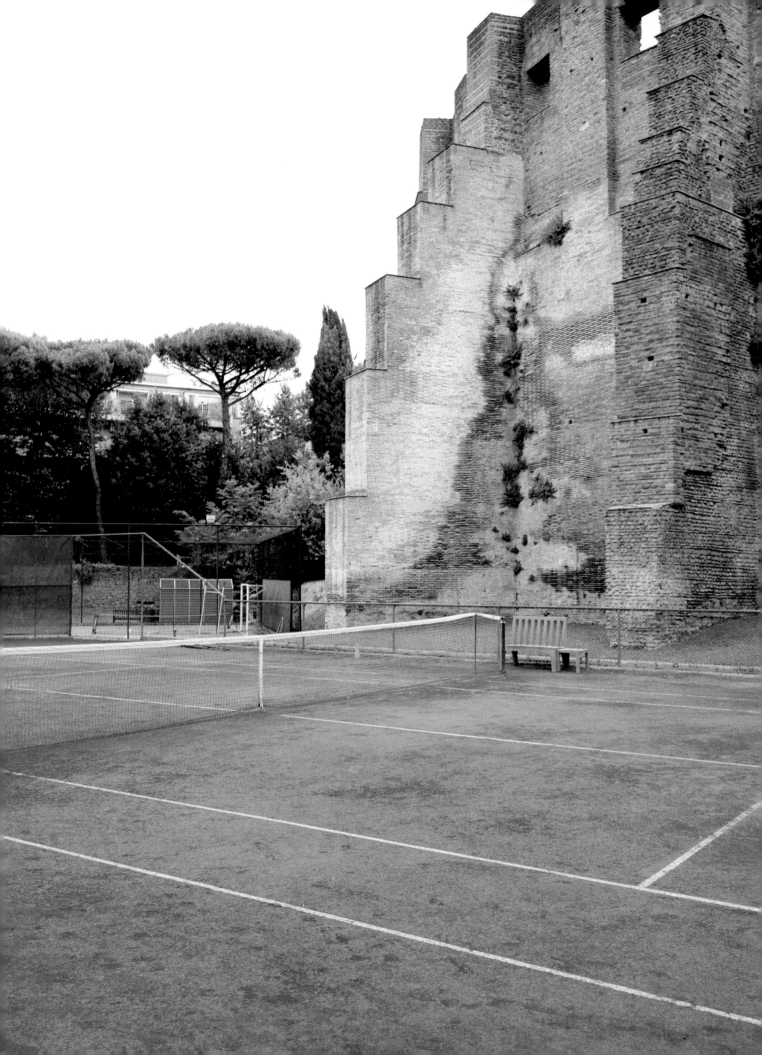

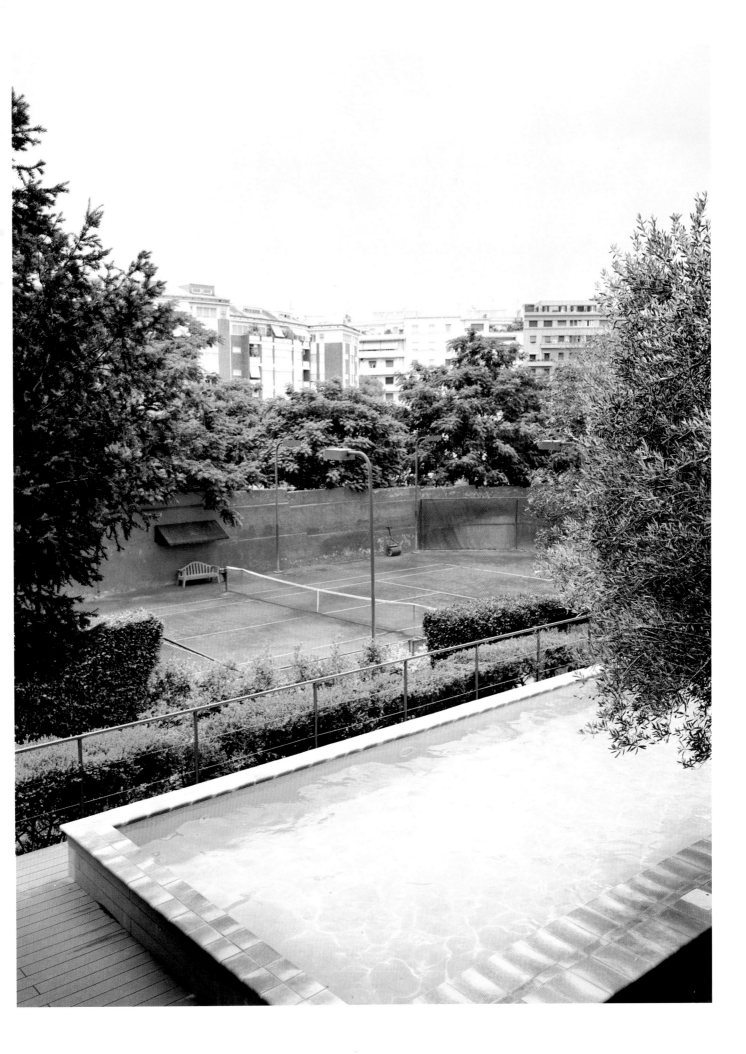

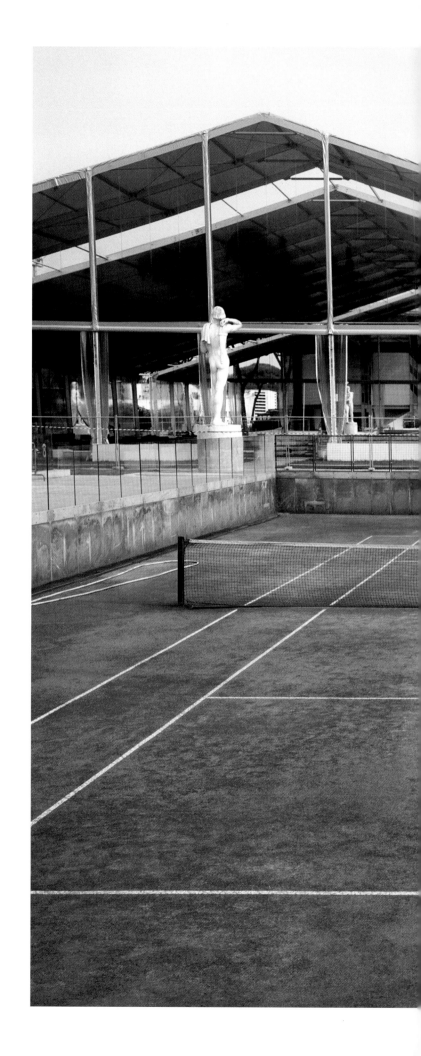

OPPOSITE AND FOLLOWING SPREAD:
Foro Italico, Rome

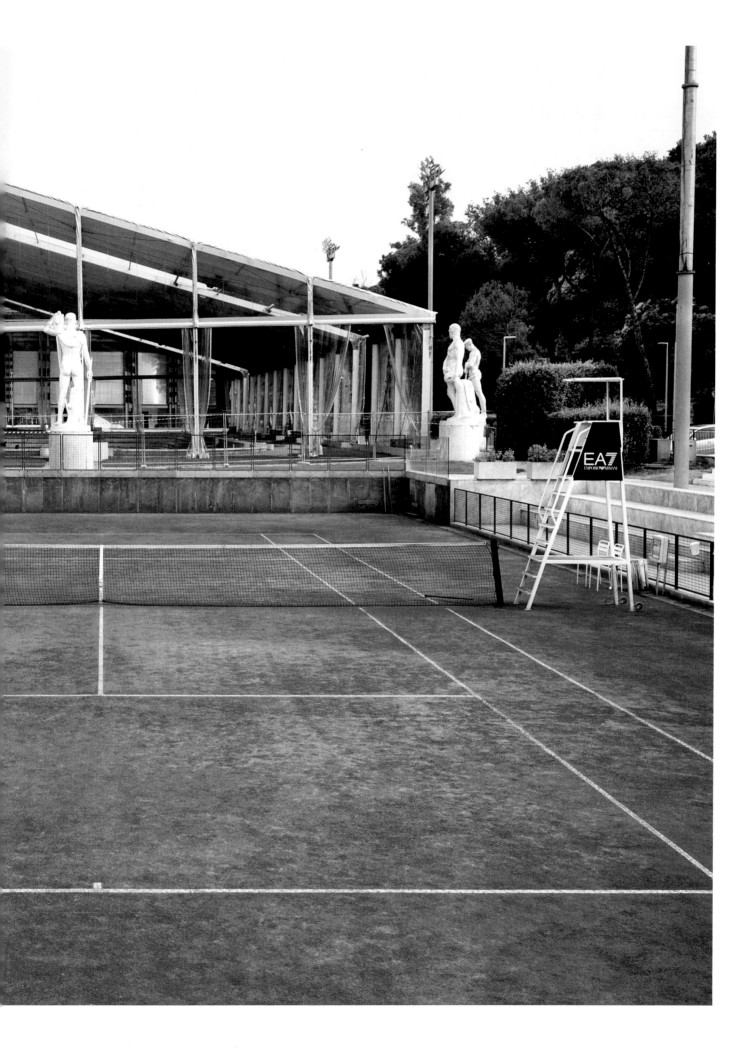

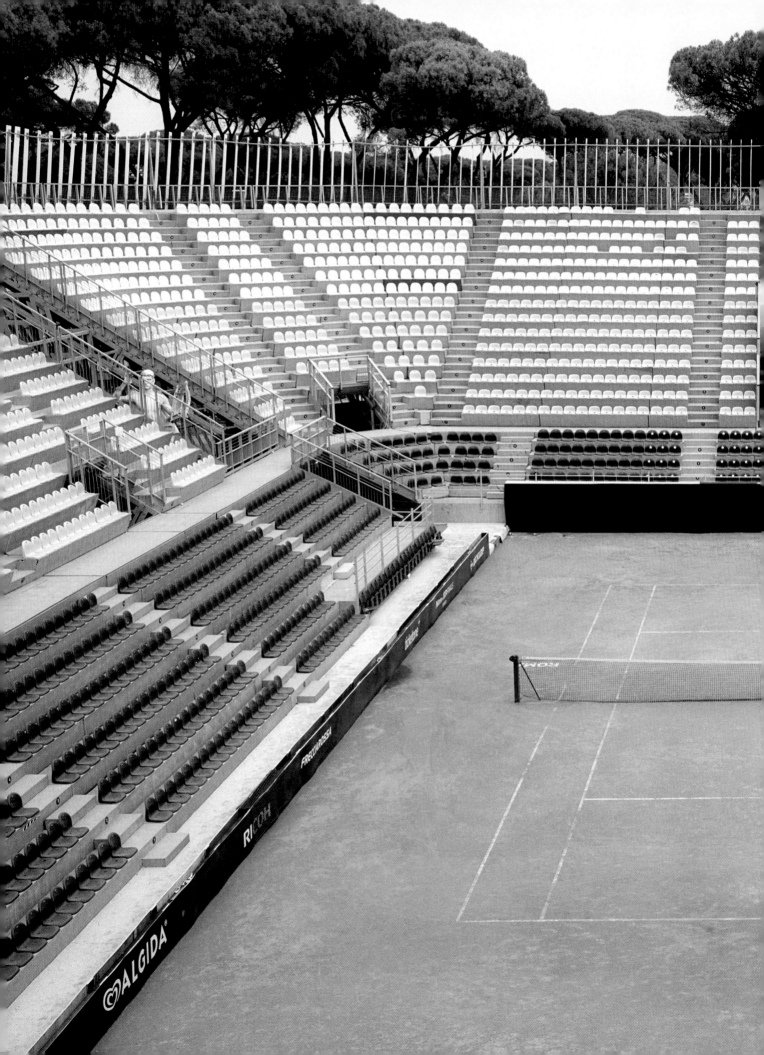

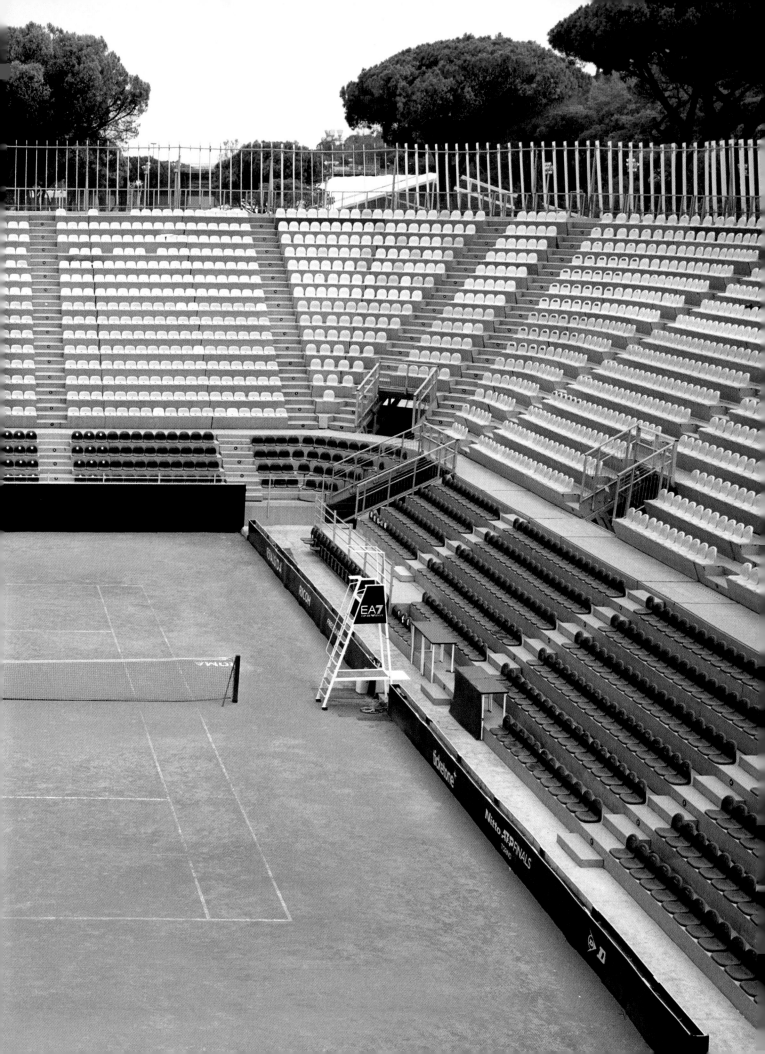

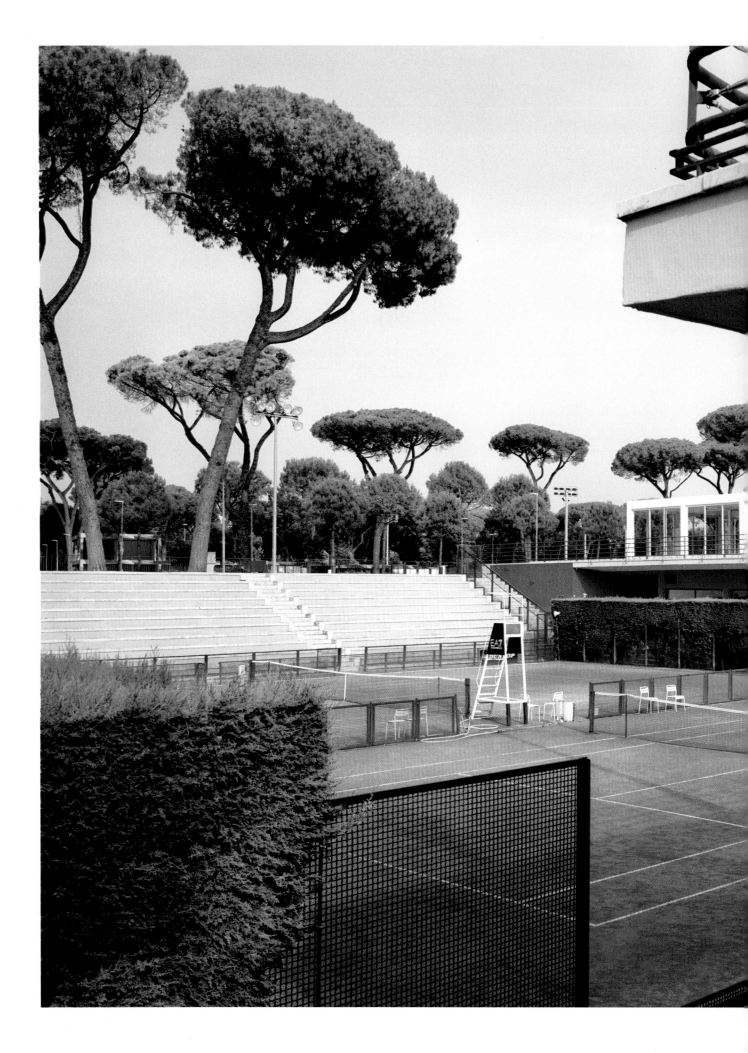

Foro Italico, Rome

OPPOSITE: Cap d'Ail, France
FOLLOWING SPREAD: Prague,
Czech Republic

132

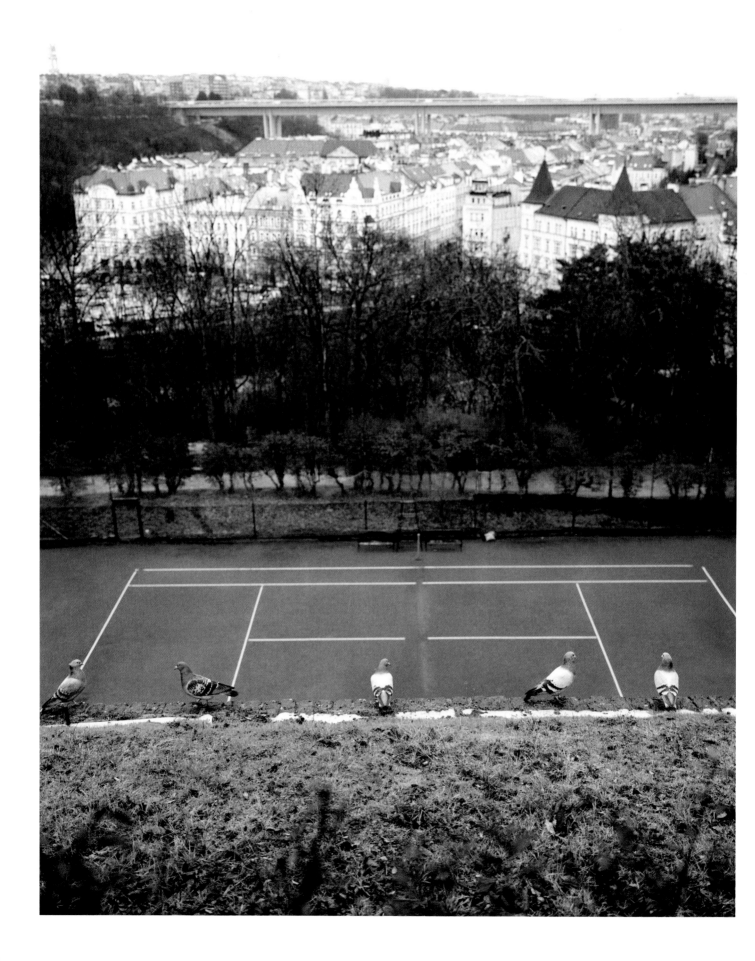

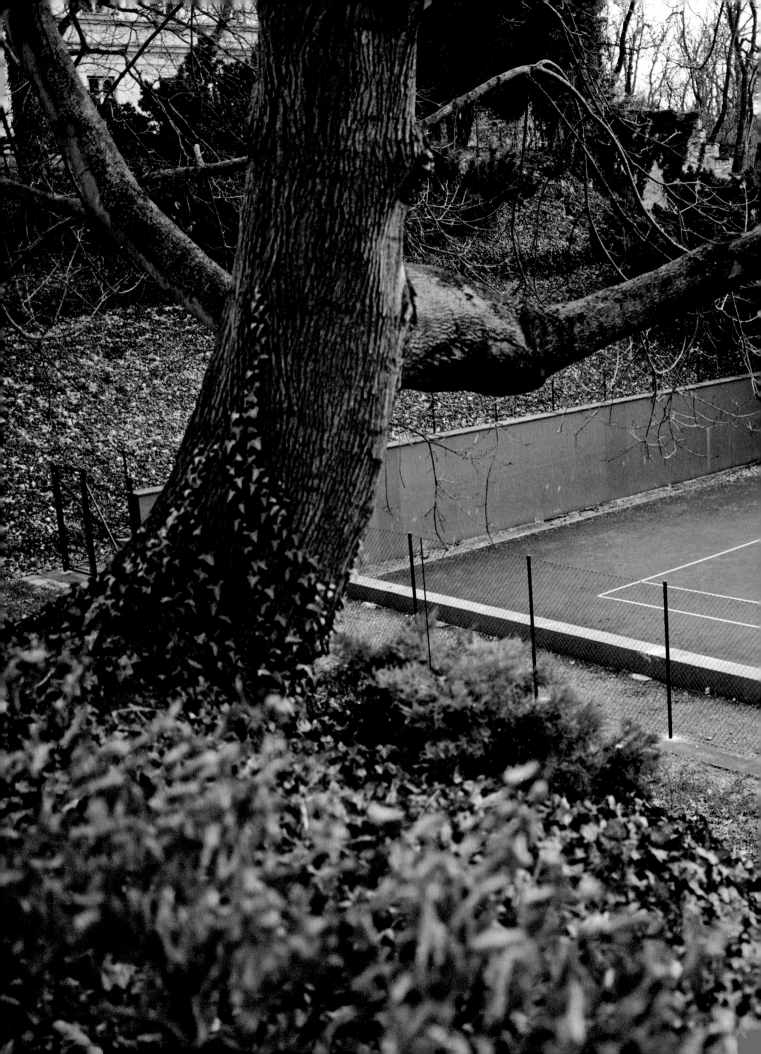

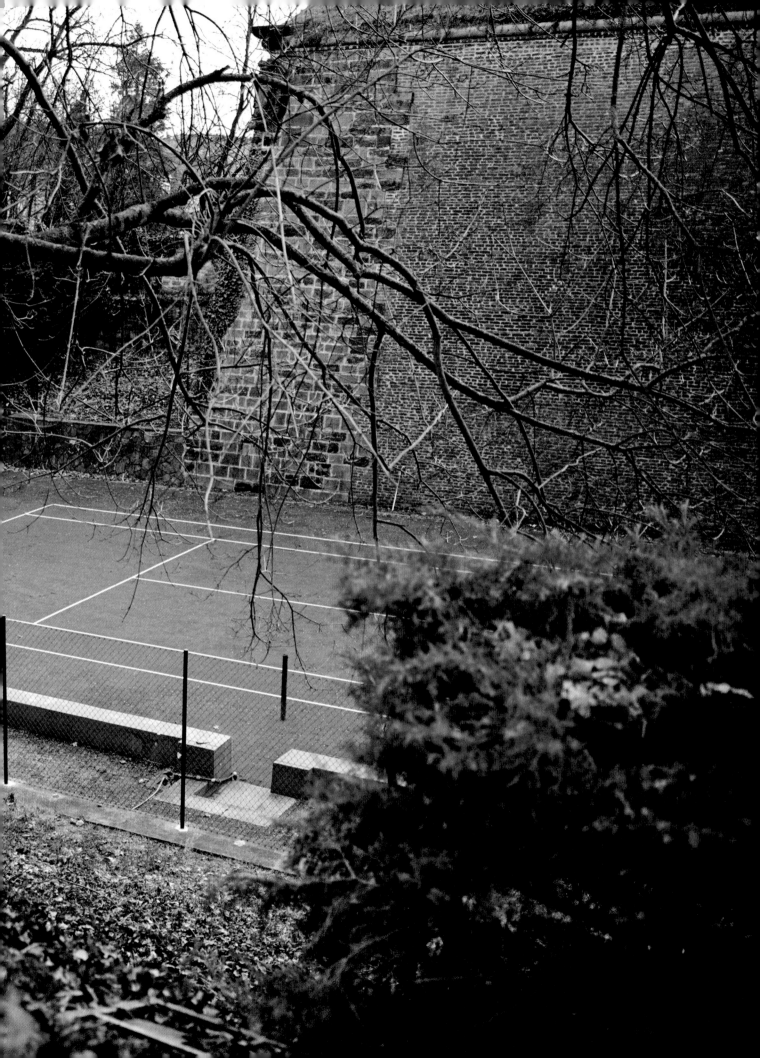

PREVIOUS SPREAD: Prague,
Czech Republic
OPPOSITE: Copenhagen, Denmark

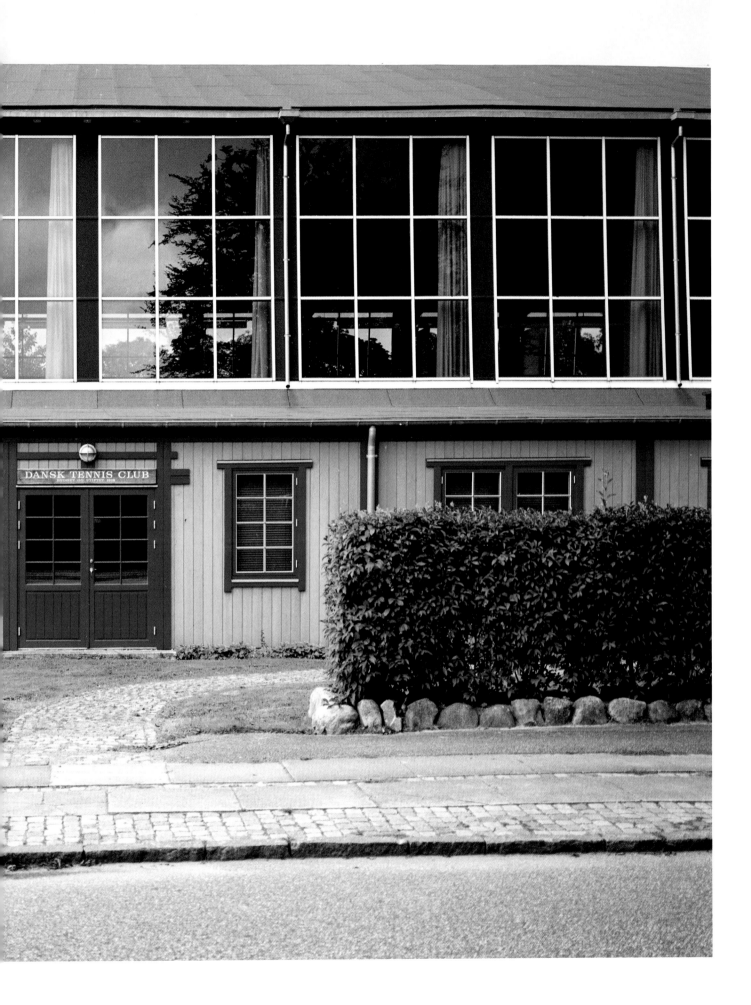

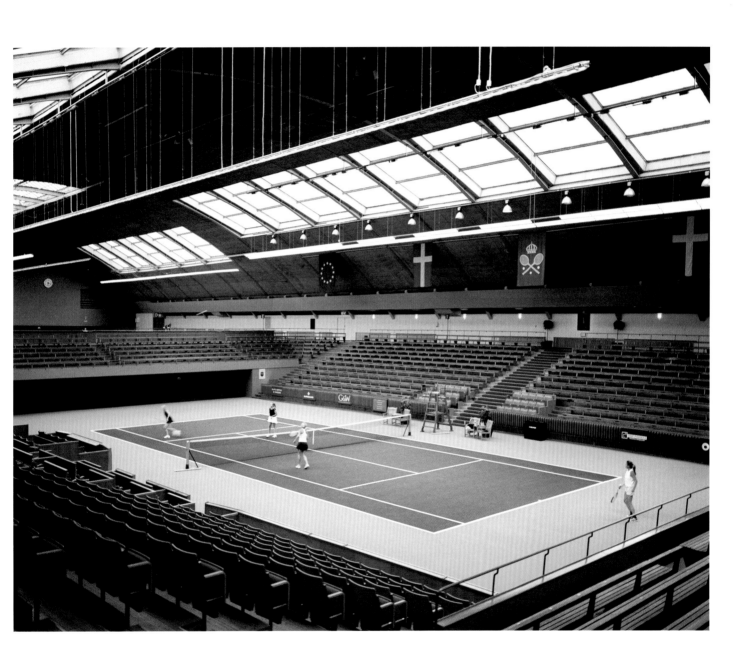

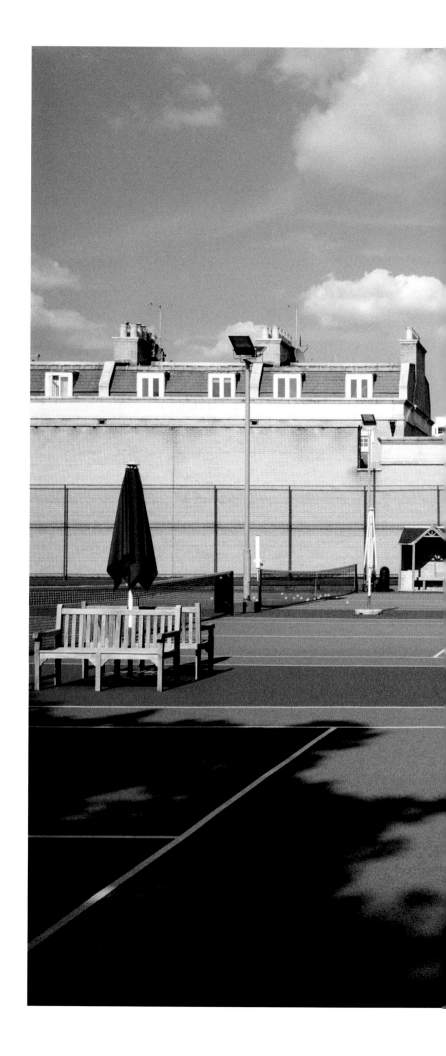

Campden Hill Lawn
Tennis Club, London

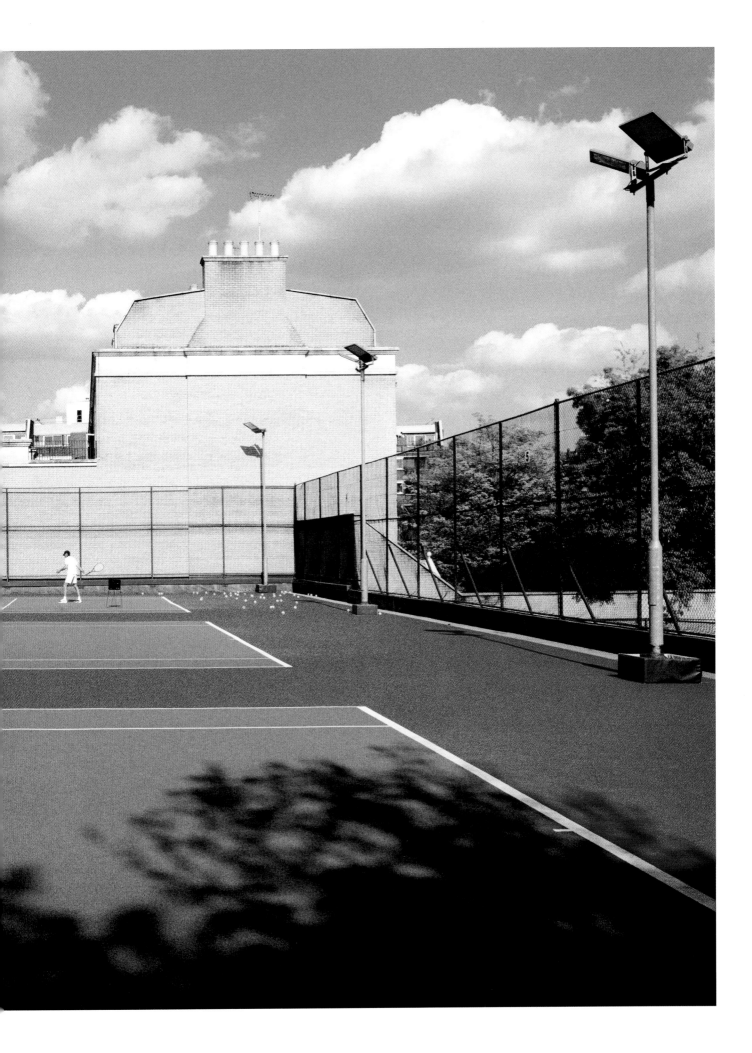

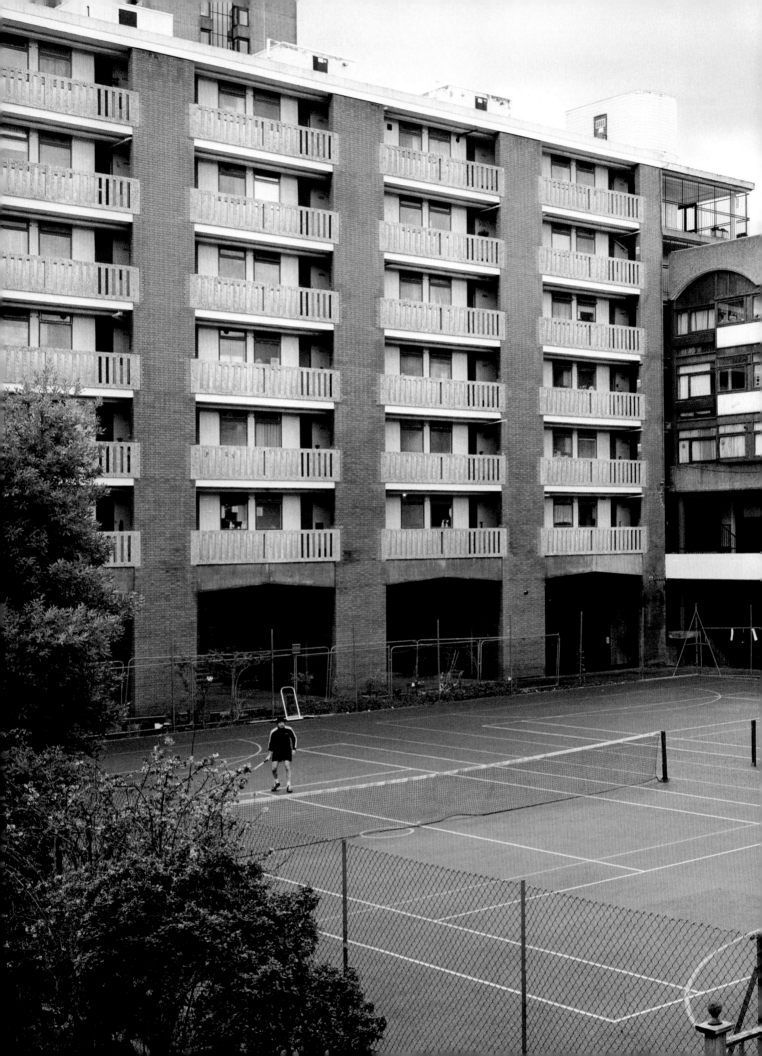

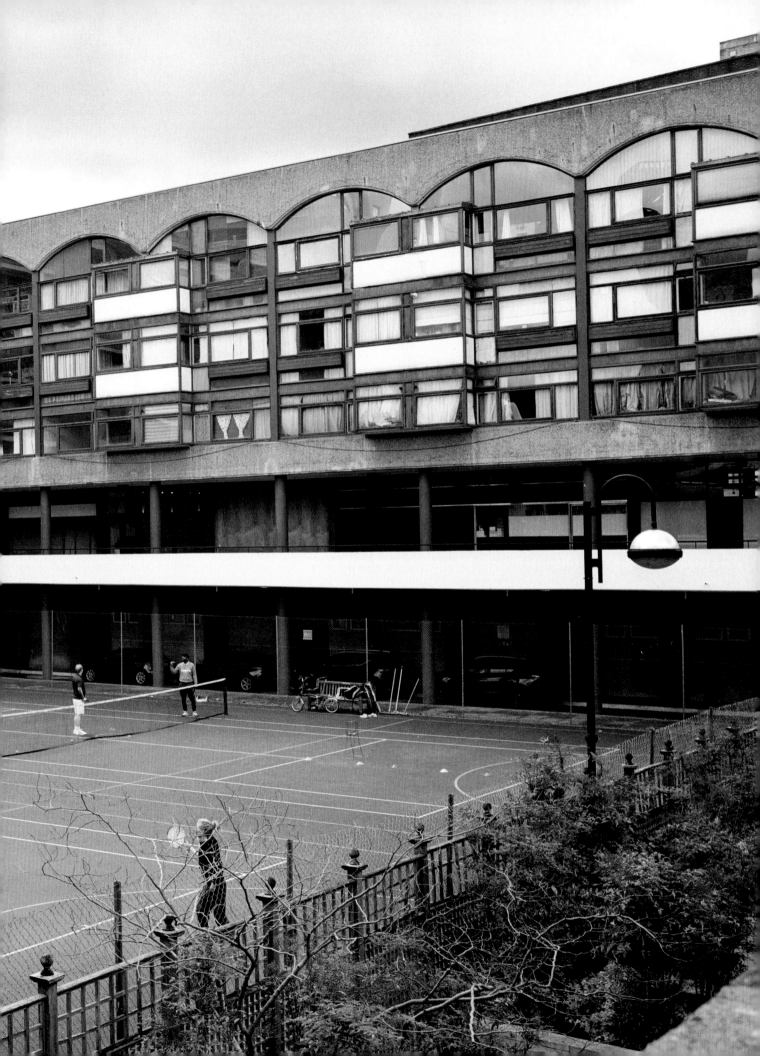

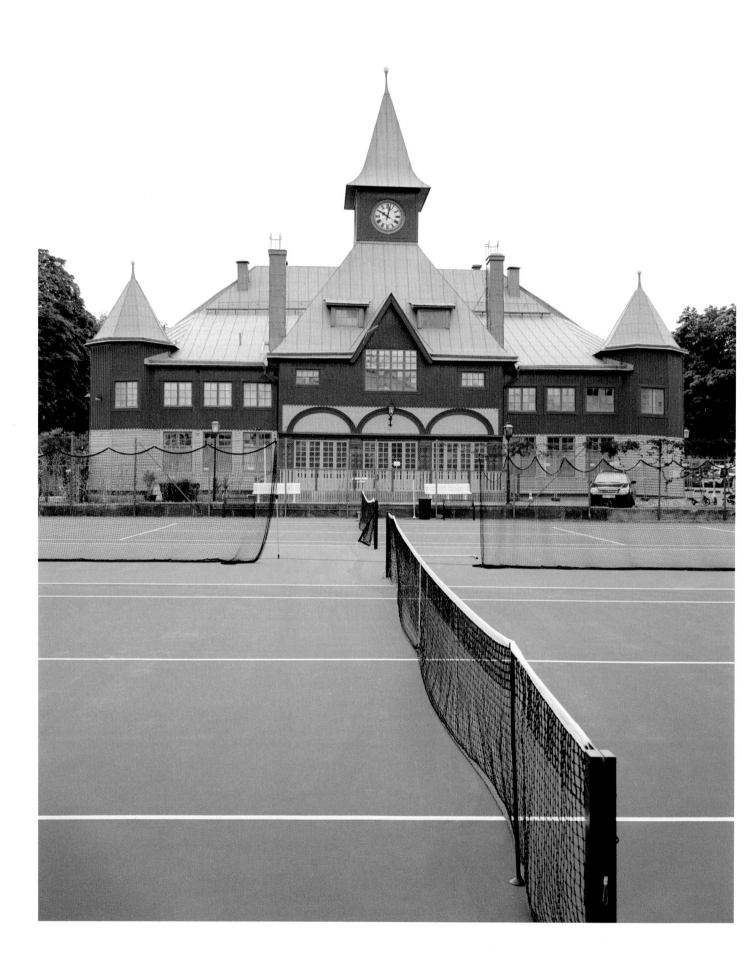

Tennis Club du Jardin du
Luxembourg, Paris

Watersedge Tennis Courts, St. Julian's, Malta

OPPOSITE: Schull Tennis Courts,
Meenvane, Ireland
FOLLOWING SPREAD: Hotel Il San
Pietro di Positano, Positano, Italy 169

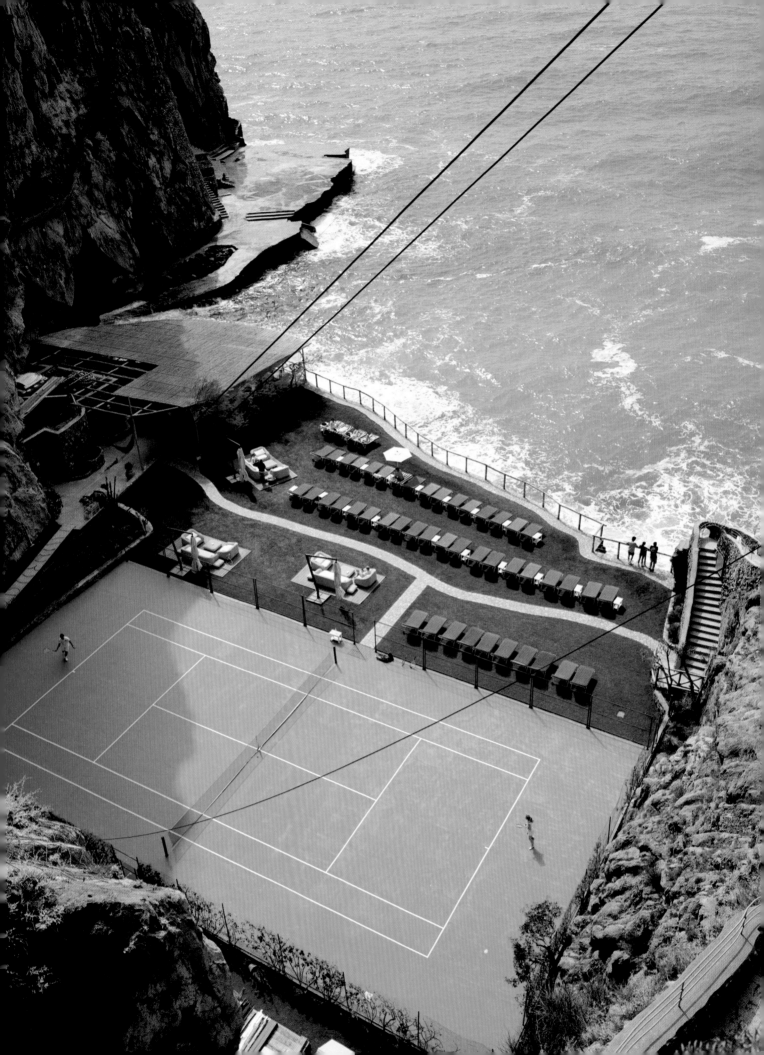

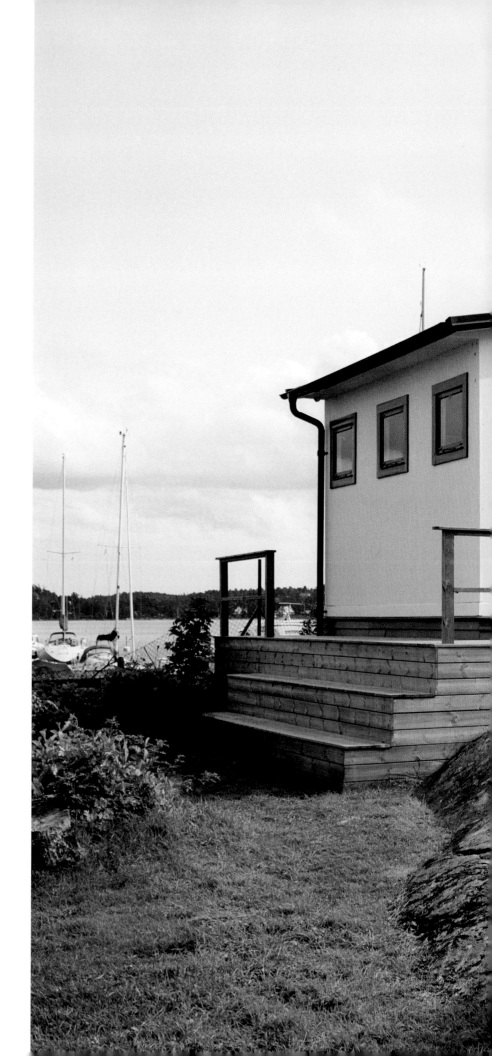

Café Tennispaviljongen,
Saltsjöbaden, Sweden

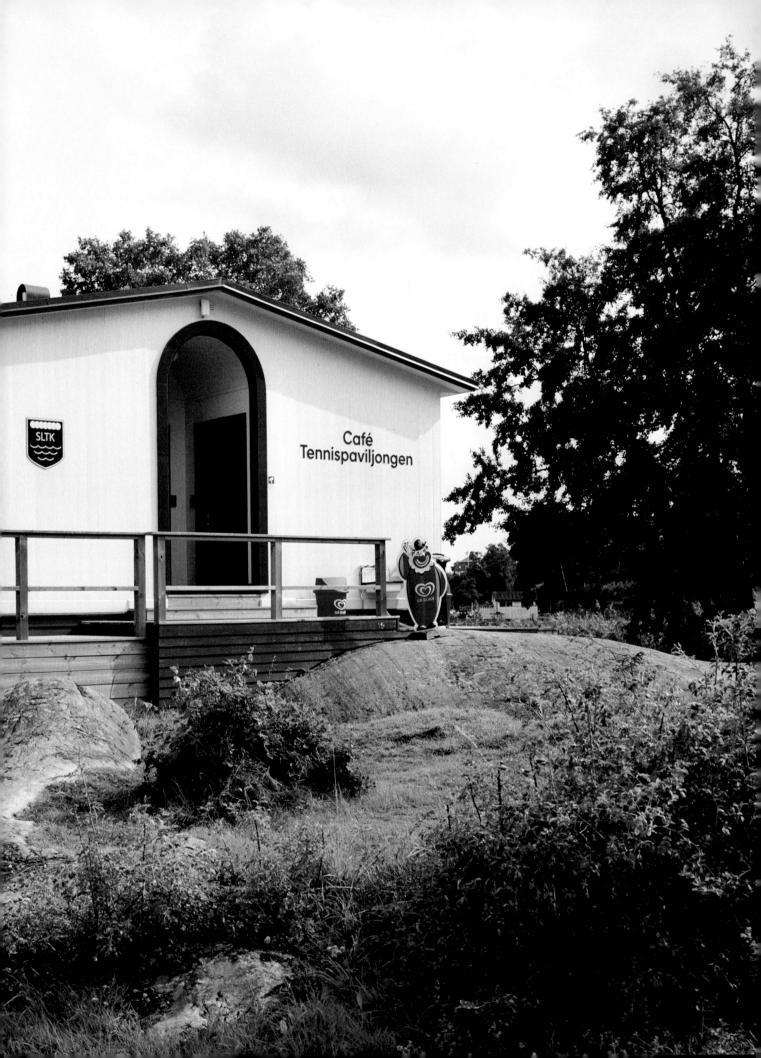

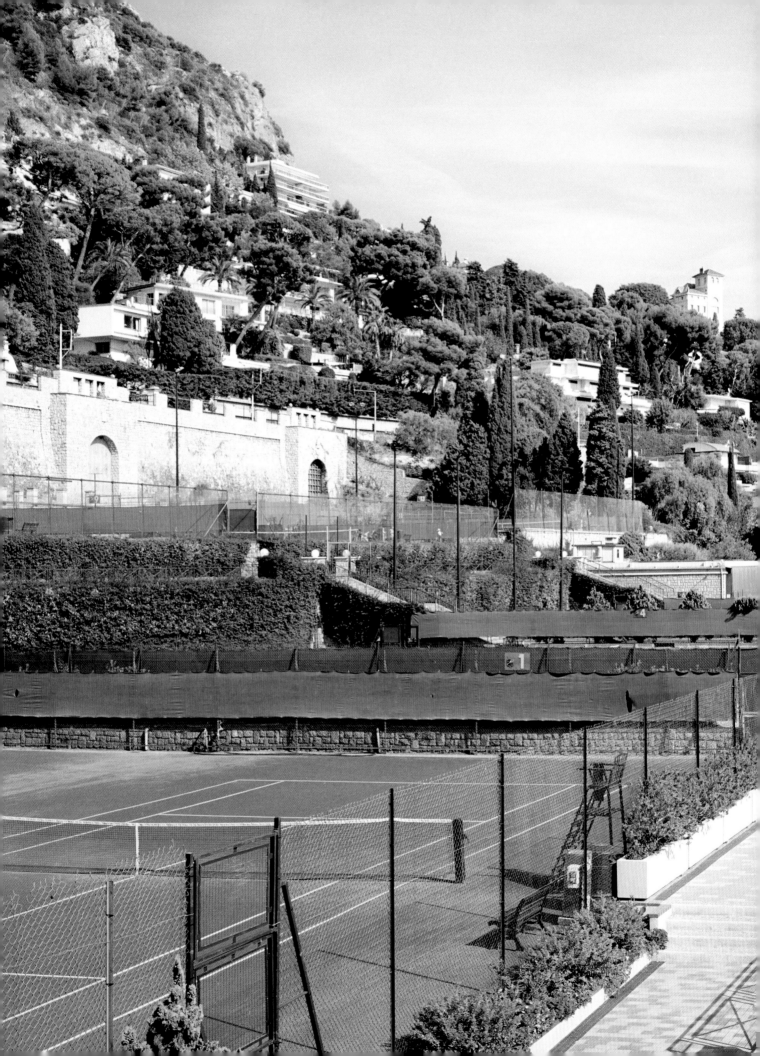

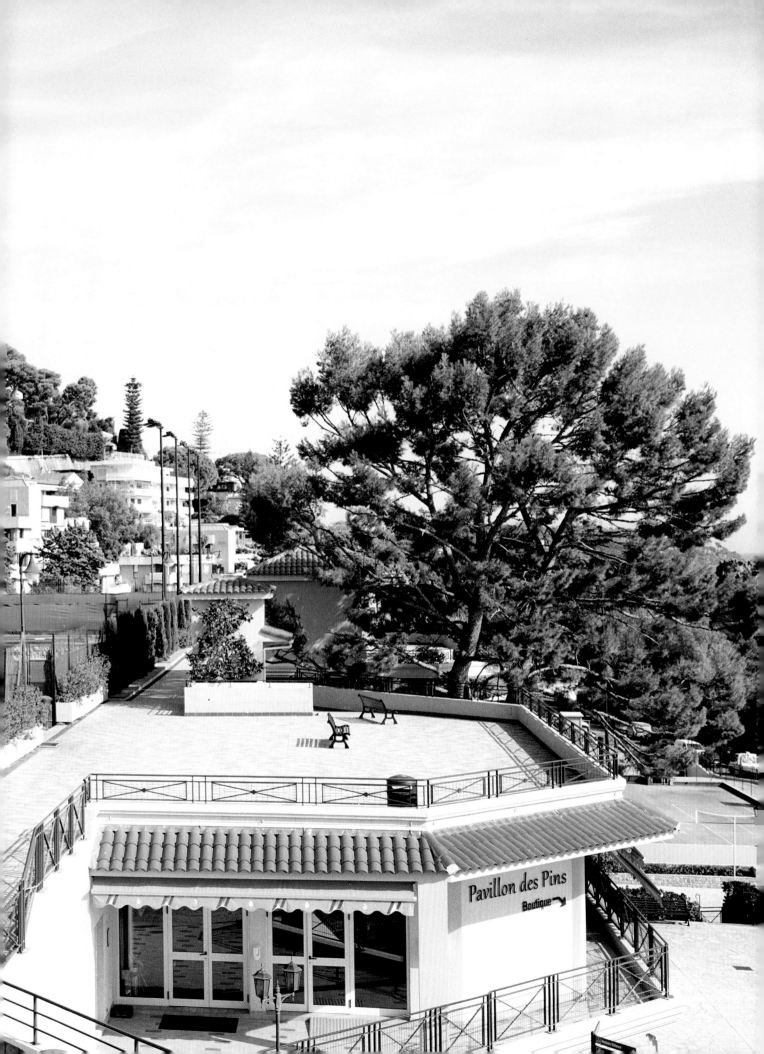

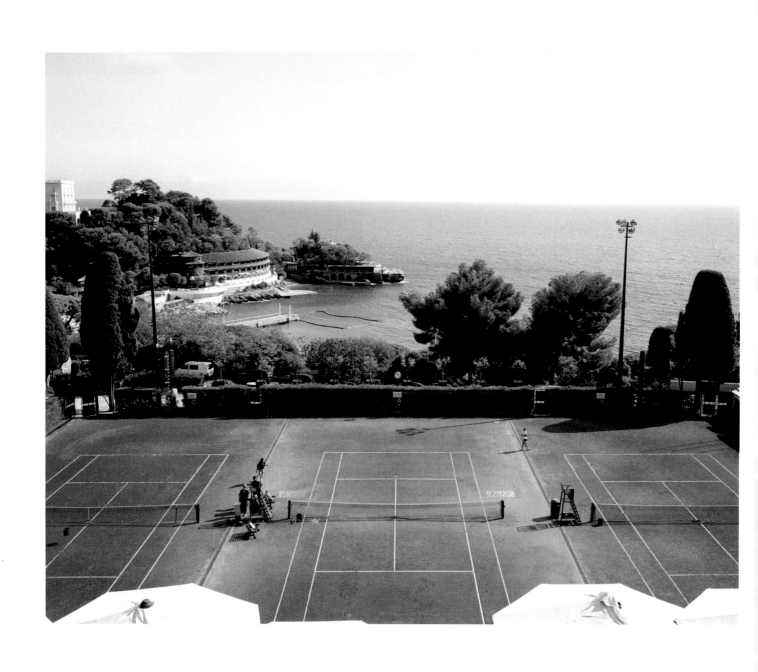

PREVIOUS SPREAD, ABOVE AND OPPOSITE: Monte-Carlo
Country Club, Roquebrune-Cap-Martin, France
FOLLOWING SPREAD: Hotel Cap-Estel, Èze, France

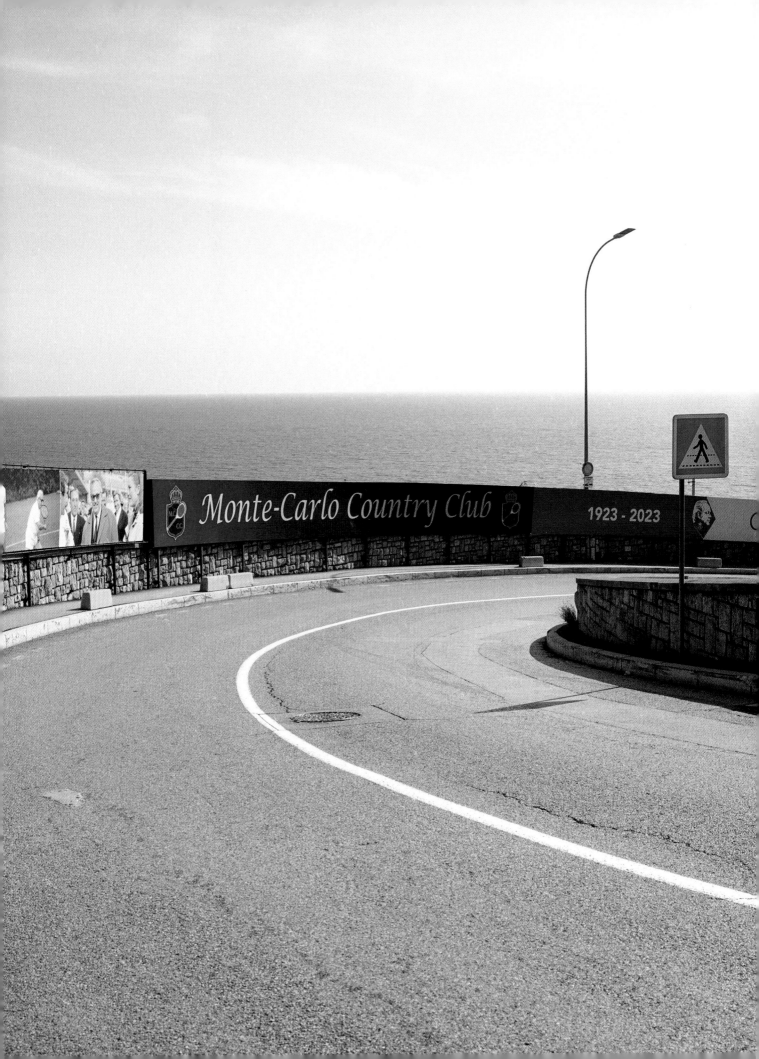

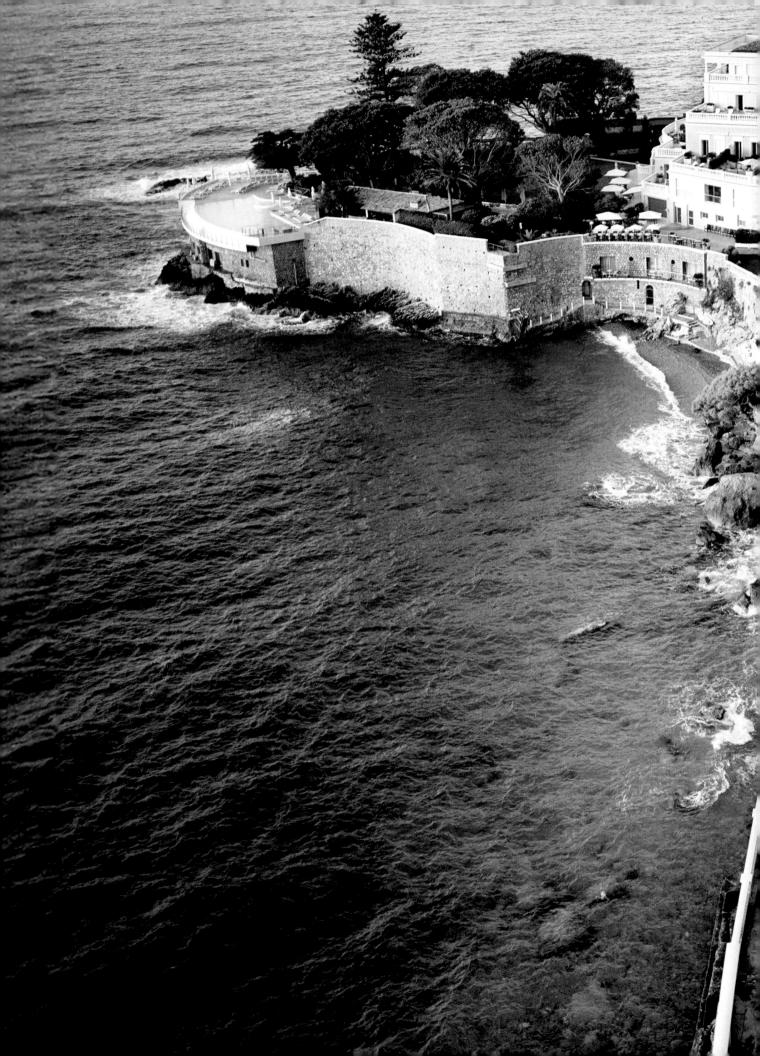

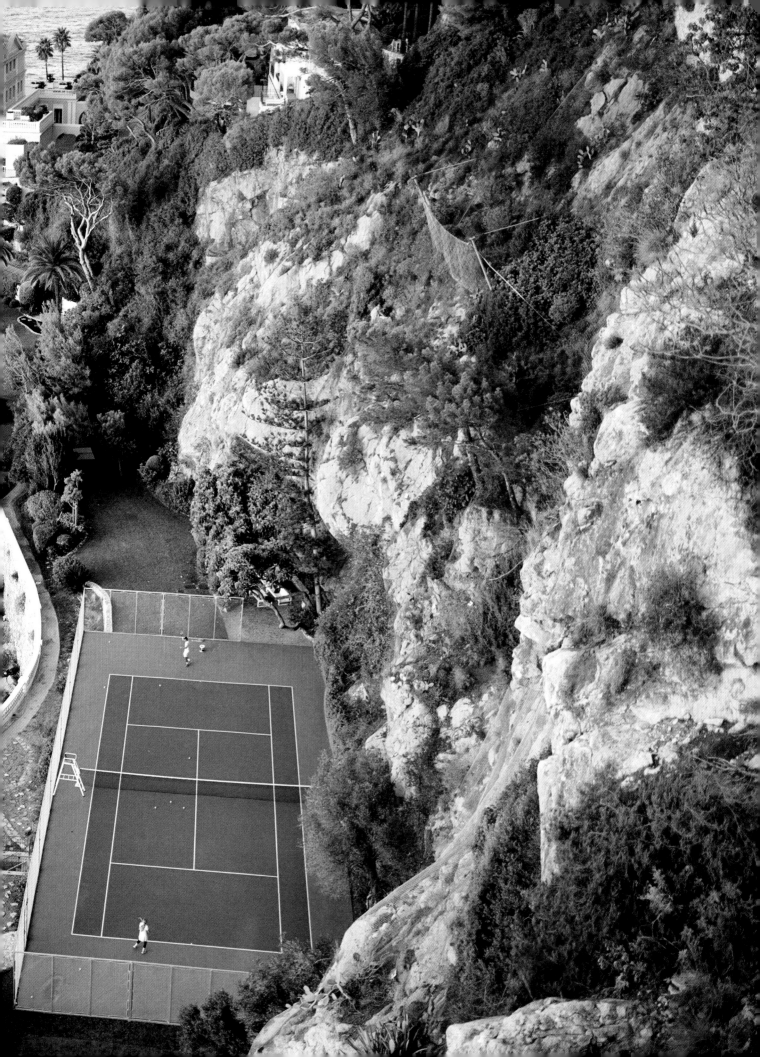

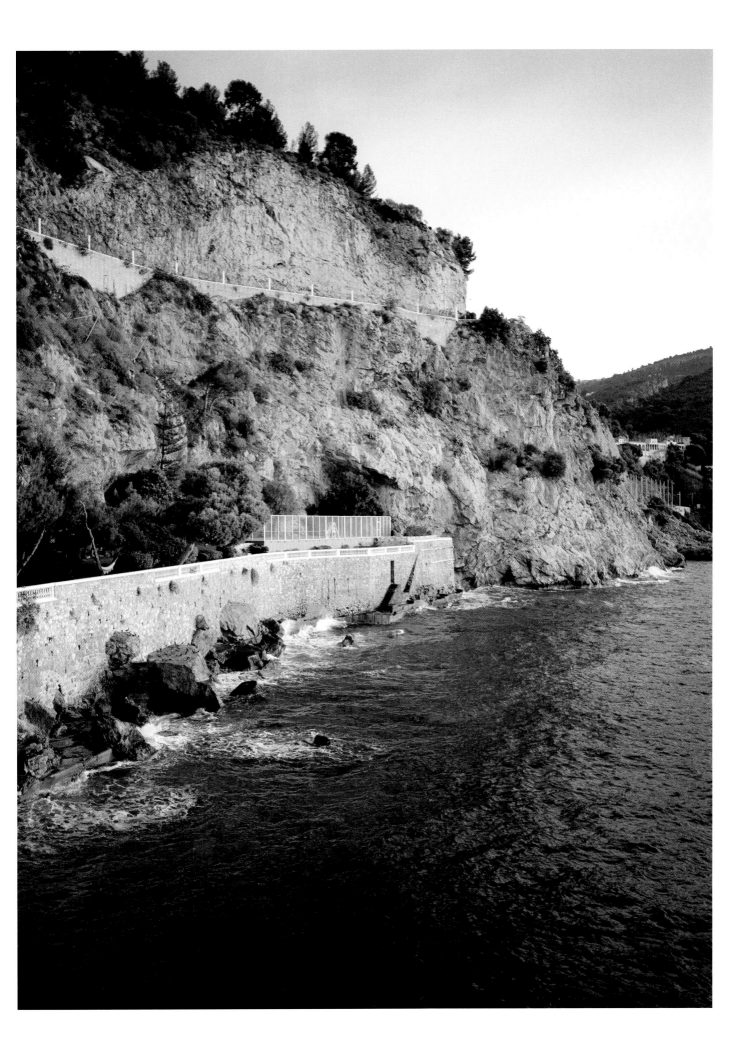

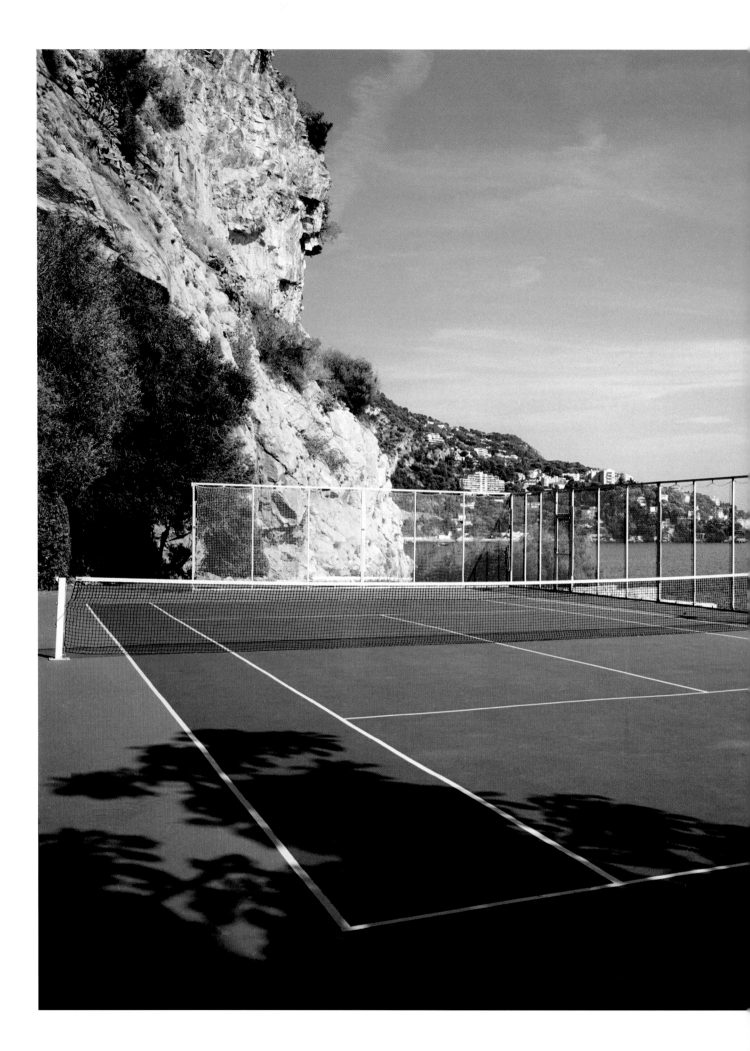

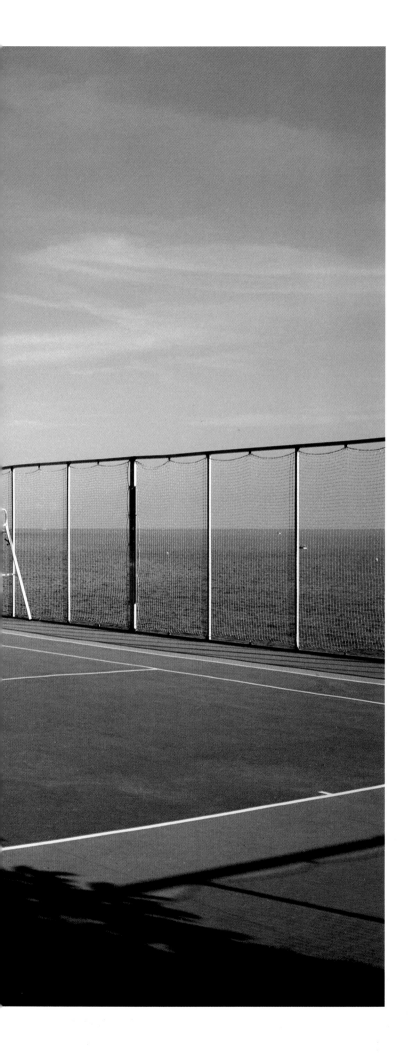

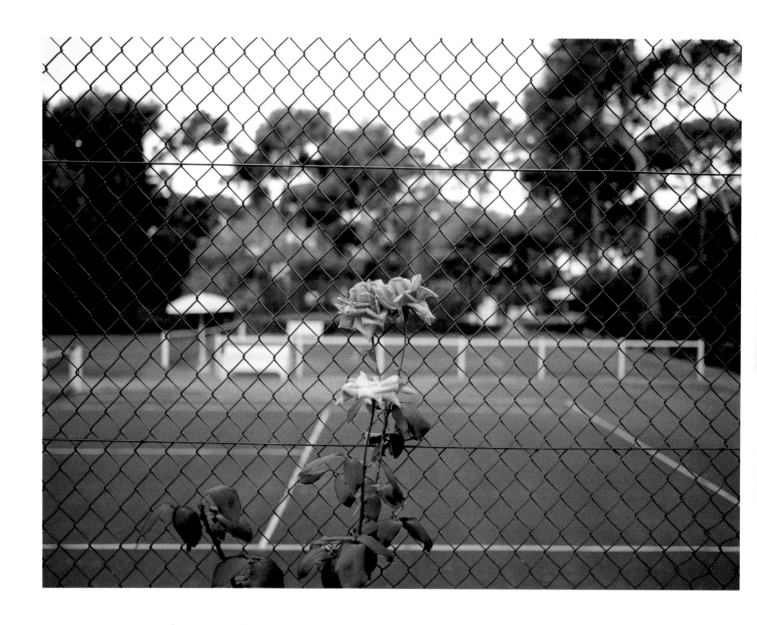

ABOVE: Hotel du Cap-Eden-Roc, Antibes, France
OPPOSITE: Nice Lawn Tennis Club, Nice, France

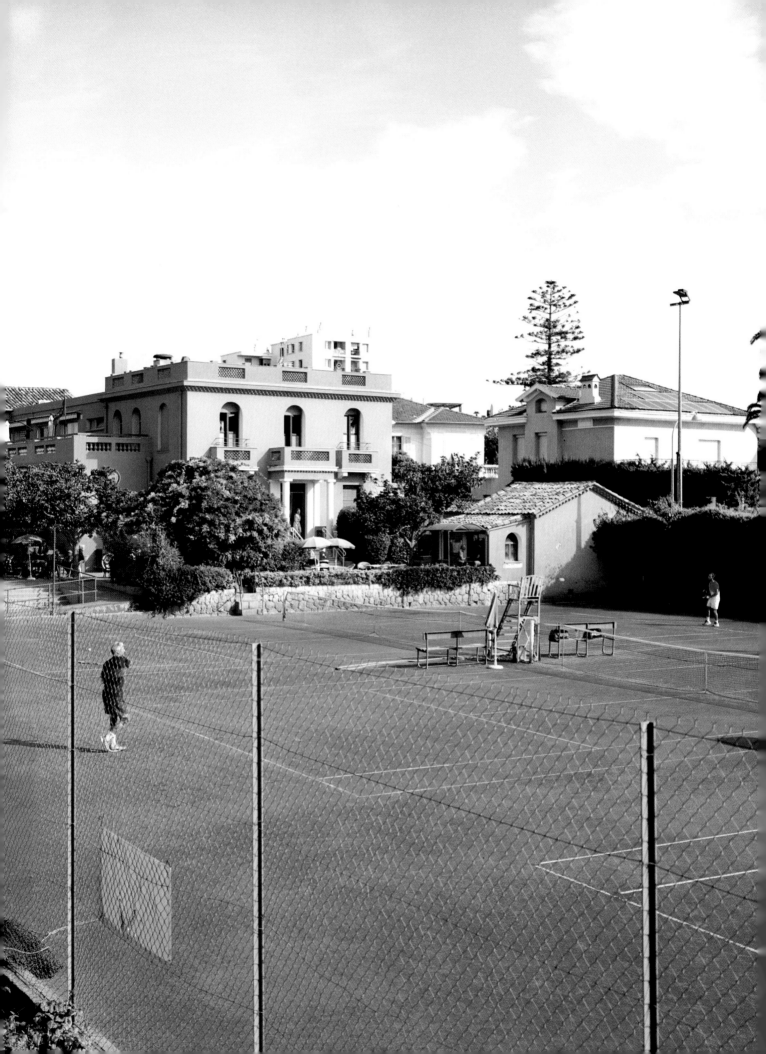

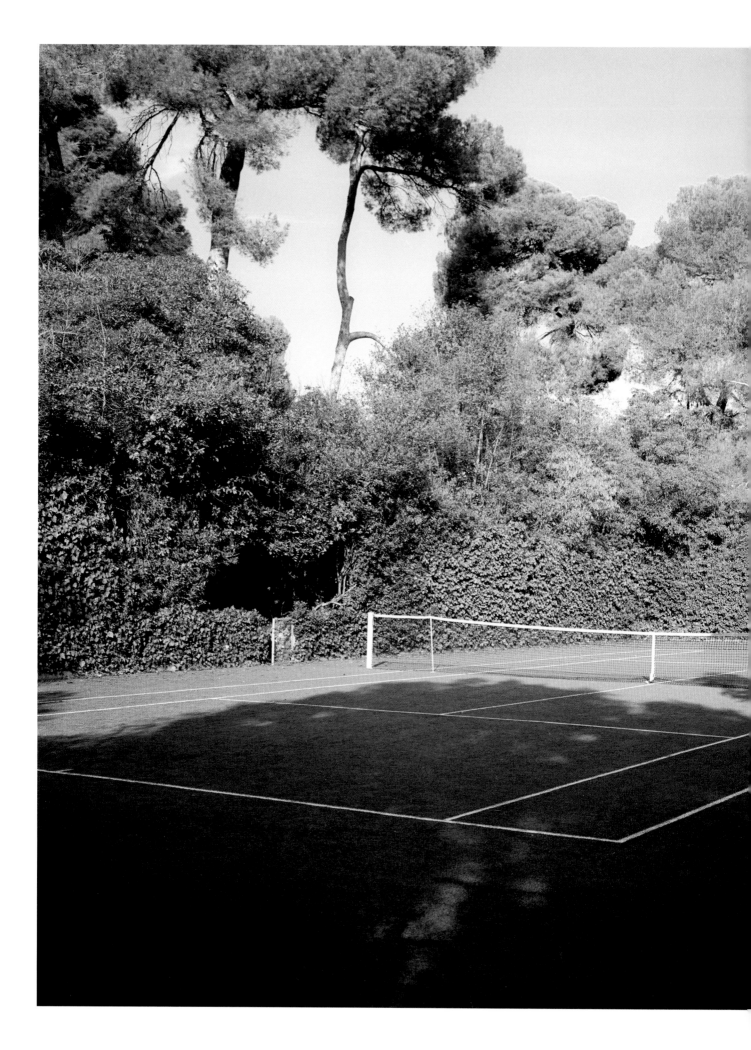

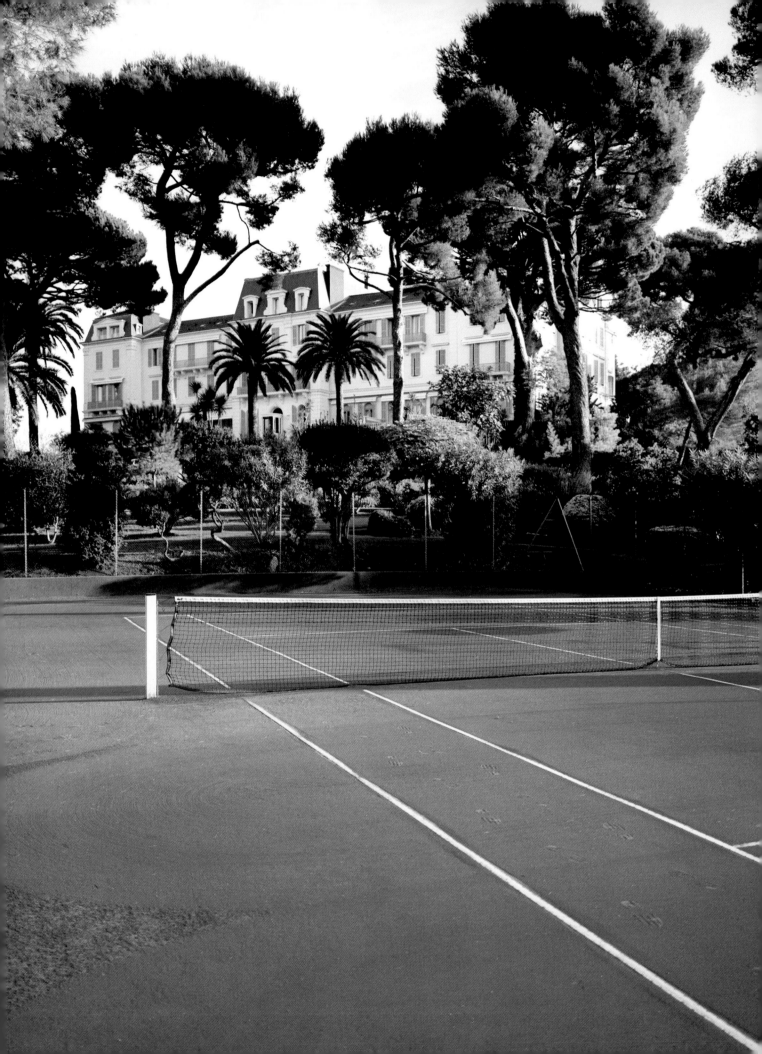

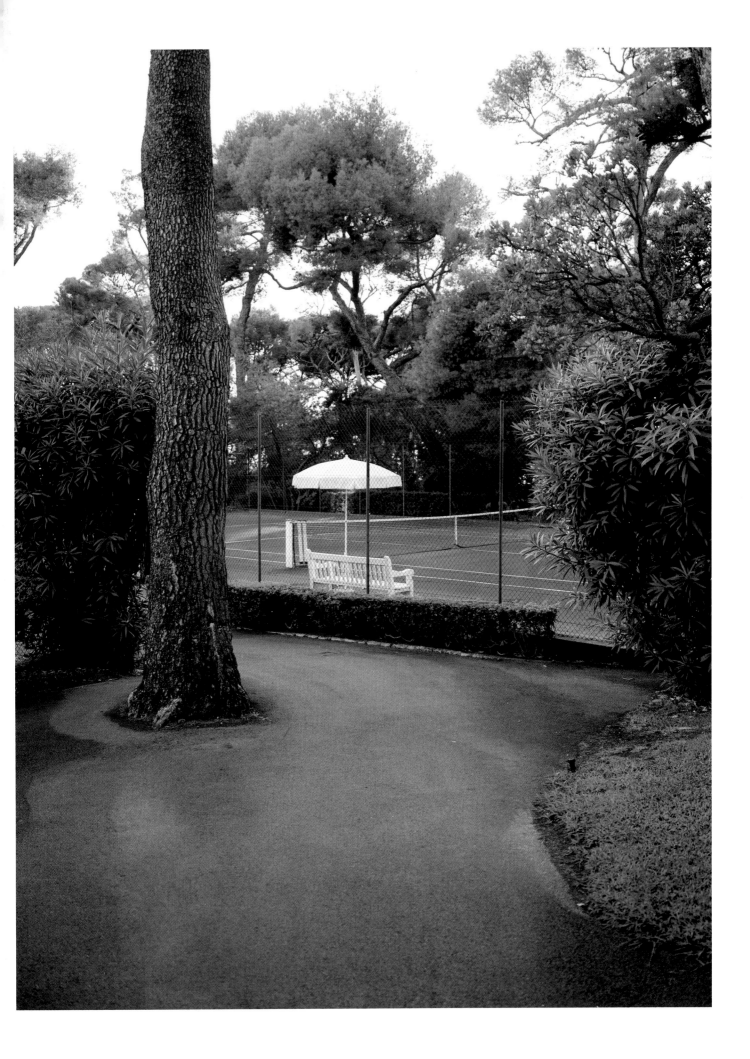

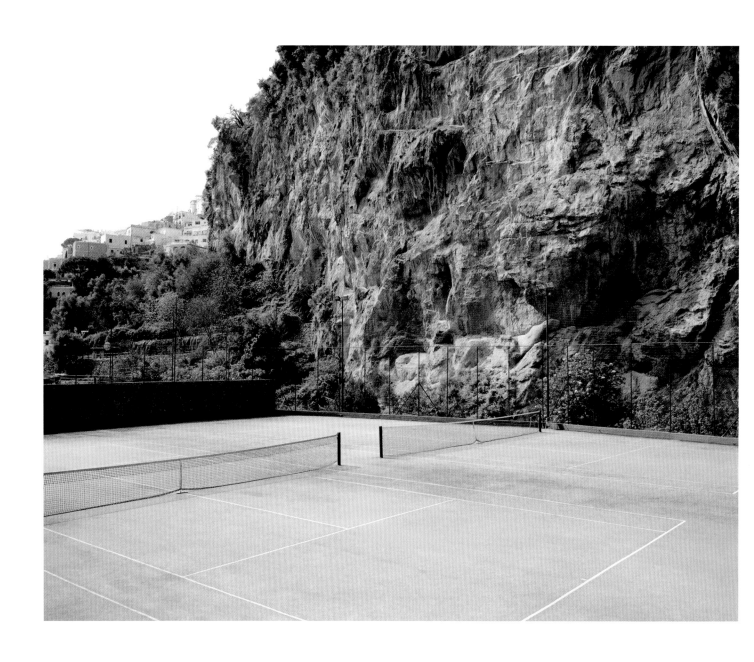

PREVIOUS SPREAD: Hotel du Cap-Eden-Roc, Antibes, France
OPPOSITE AND FOLLOWING SPREAD: Tennis al Settimo Piano, Positano, Italy

193

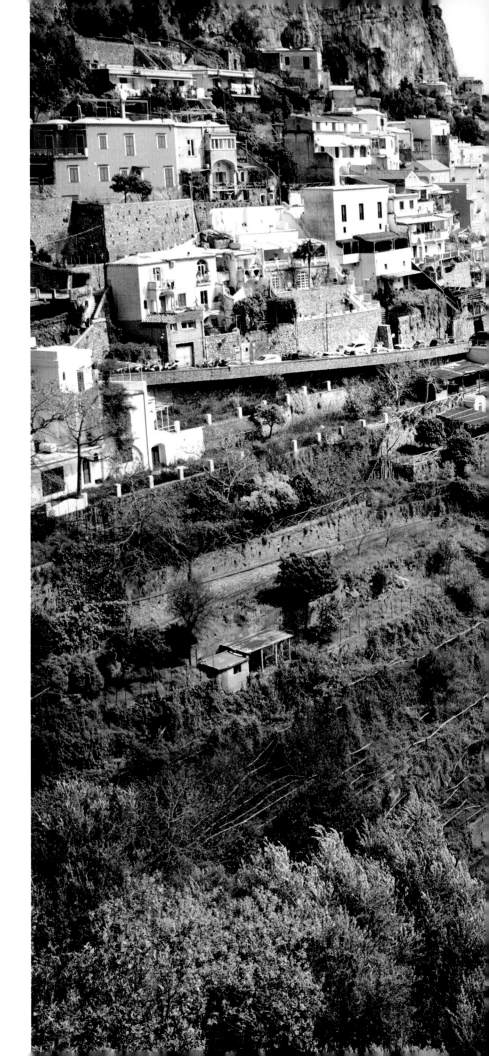

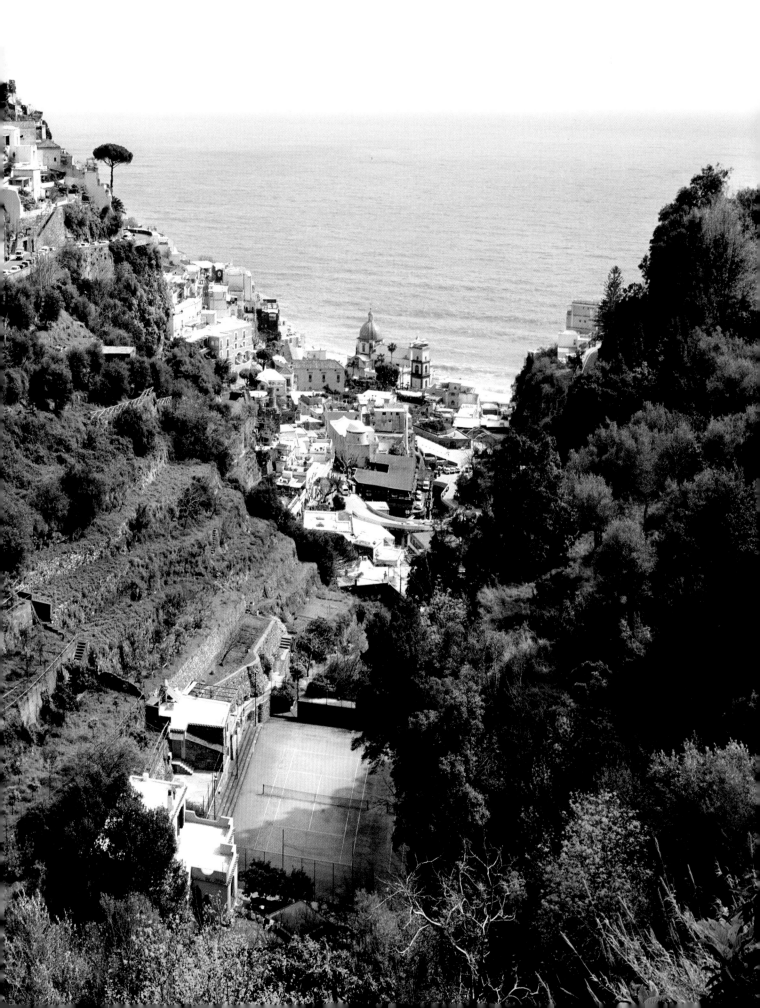

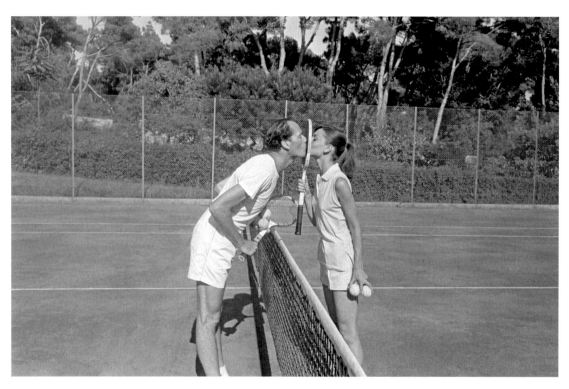

Mel Ferrer and Audrey Hepburn in Cap-d'Antibes, 1956

Love All

After the first time I had proper tennis coaching (and only the second time I had ever played the sport) I said to my mom, 'Mommy, I know what I am going to do with my life!' I wanted to be the number one tennis player in the world. A few days earlier my friend Susan Williams and I learnt there was free tennis instruction every Tuesday at Houghton Park with Clyde Walker. Susan had taken me to play tennis at her country club before, but I knew a country club was not something my parents could afford. Then Val Halloran, our softball coach, told us about the free instruction and the free public courts at Houghton Park. Those public parks courts and the free instruction from Clyde changed my life.

After that first day with Clyde I remember getting in the car with my mother and telling her about my dream. She looked at me with that very supportive smile of hers and said, 'That's great, but you have homework and piano lessons'.

She always kept me grounded, but I knew that first visit to Houghton Park was a life-changing moment for me. Soon after, I learnt that Clyde moved from park to park during the week, and I found myself following him around, showing up at Silverado on Mondays, Houghton on Tuesdays, Wednesdays at Somerset, Thursdays at Ramona and Recreation Park on Fridays.

Tennis came alive for me on those public park courts. Clyde would always be a big part of my life, and he coached Karen Hantze and me to our first Wimbledon doubles championship in 1961. We are still the youngest team to win the Ladies Doubles. Without Susan Williams, Clyde Walker and Houghton Park, I would never have had the wonderful journey I have travelled.

— Billie Jean King

Tennis champion with thirty-nine Grand Slam titles, activist

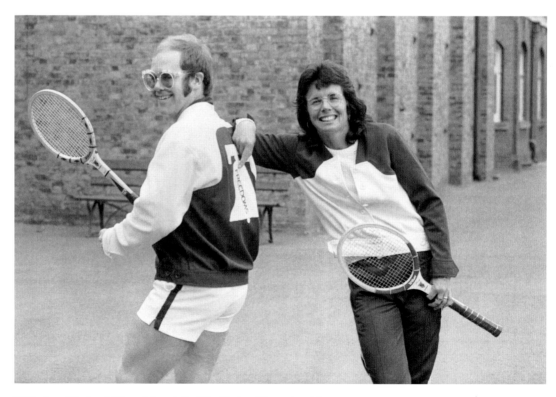

Billie Jean King and Elton John at the Wimbledon Championships, photographed by Terry O'Neill, 1976

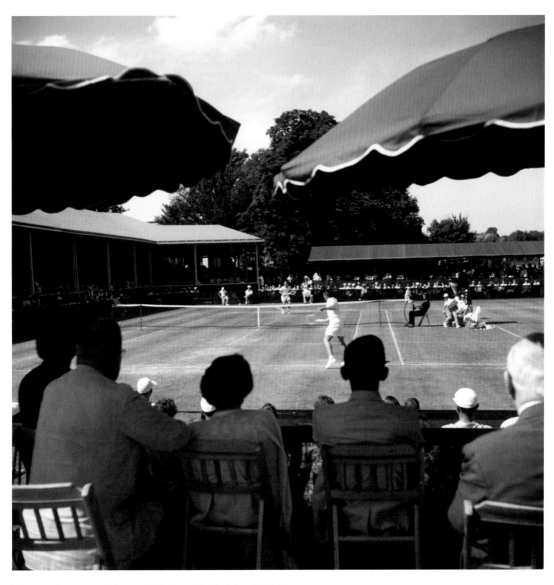

The tennis court at Newport Casino, Rhode Island, 1953

When players unite, laying down their gear, it's a dance of souls, where camaraderie is held dear.

In this game's embrace, culture and passion intertwine, a testament to resilience, in every serve and line.

As the red clay shifts and shadows grow, our spirits find peace, with a calming flow.

Through every rally, every victory and each stumble we embrace, we're bound by a love, in tennis's sacred grace.

— Adam Del Deo

Head of Documentary, Netflix

If you ask me which is my favourite tennis court, my mind leaps back decades to the red clay of the Imperial Country Club in Tehran, where I first learned to play, where I was ball-girl for my dad and his friends and where occasionally we would watch an international tournament between Iranian players and whichever medium seeds Tehran could tempt over from around the world. This was all pre-Islamic Revolution: I played in shorts and a T-shirt, no hijab. At the same time, I became a fervent fan, besotted in the 1970s with the hunky Australian champ, John Newcombe, later admiring Billie Jean King for her brilliance on and off court, and likewise now Rafael Nadal.

— Christiane Amanpour

Journalist and broadcaster

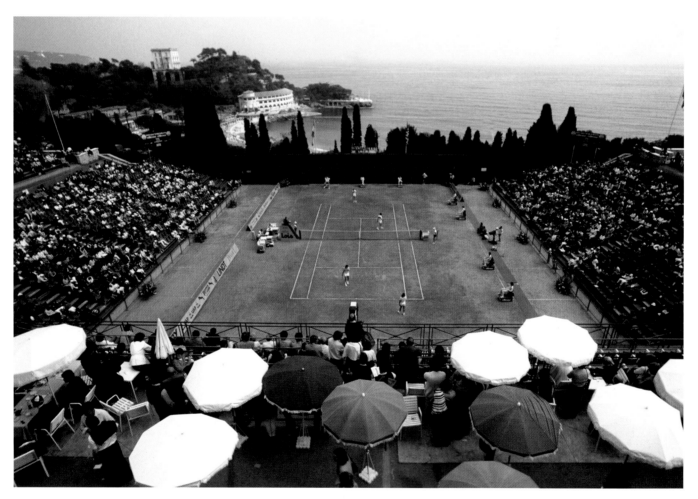

The central court at Monte-Carlo Country Club, Monaco, 1982

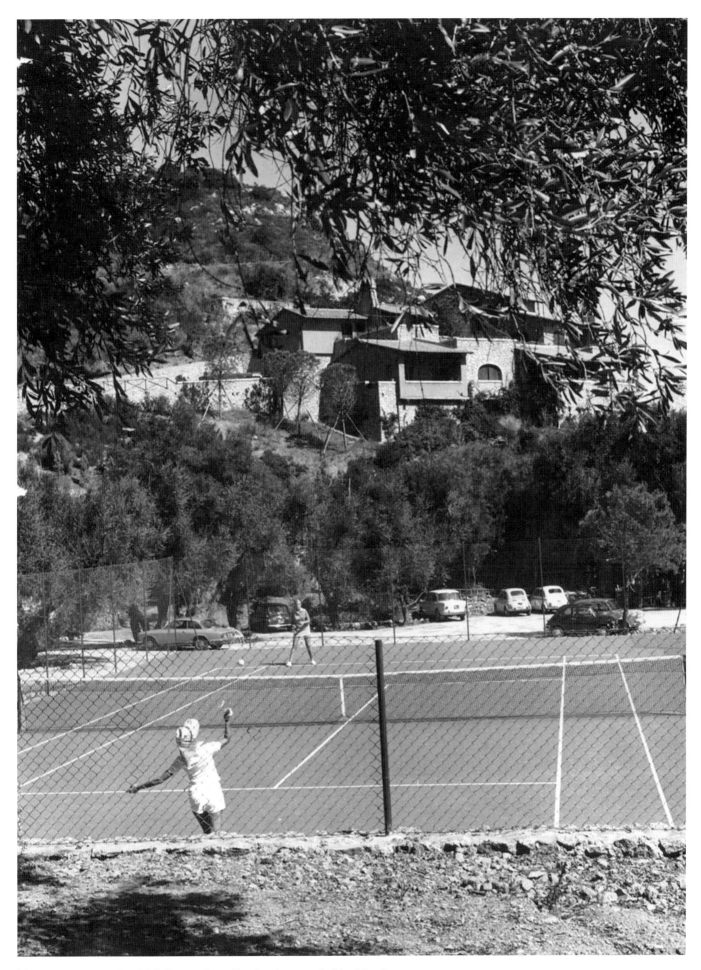

The tennis court at Hotel Il Pellicano, Porto Ercole, photographed by John Swope

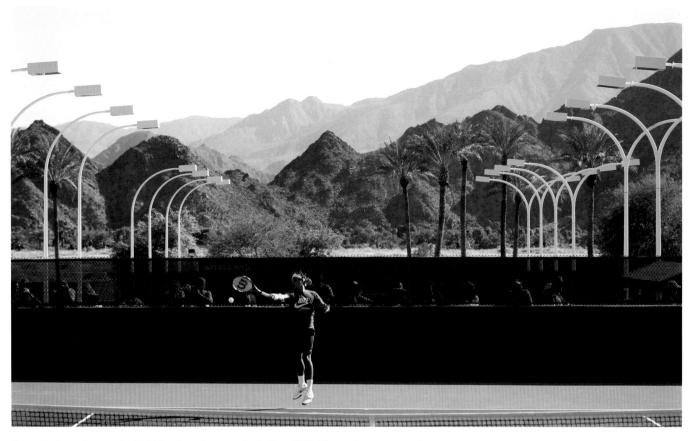

Roger Federer during the BNP Paribas Open at the Indian Wells Tennis Garden in Indian Wells, California, 2011

'Come on Tim'.

My tennis hero growing up was Tim Henman, the housewives' favourite with his toothy smile and championship whites. I was at the same school as him. He was its most famous alumnus; well, I think technically John Betjeman was, but I'd never seen him on *A Question of Sport*. I was a tennis nut but had never been to Wimbledon, and my parents' complete lack of interest in sport meant I might never get to see the great Tiger Tim in his pomp. Then, one particularly washed-out British summer (are there any others?) I heard that there was a chance to get centre court tickets by joining something called the Wimbledon Queue, which sounds so quintessentially British you'd think it must have been made up, our nation's two great passions being freebies and standing in a line.

Most of my friends at that stage were camping at music festivals, but I managed to find another friend, who, like me, was a genteel middle-Englander trapped in the body of an awkward teenager. We pitched a tent, loaded up on supplies and, buoyed with blitz spirit and a thermos of tea, pulled an all-nighter. We got our reward: the best seats in the house (other than Princess Anne's in the royal box). We were close enough to see the beads of sweat on the players' brows; you could practically smell Tim's Robinsons squash from our vantage point. I was so cool I even brought a hand-drawn 'Come on Tim' sign with me. I ended up on the TV holding it aloft. My school friends all saw it, which I think contributed to my not losing my virginity for several more years. Tim was marvellous as he doggedly saw off an Eastern European serving cannon, thundering towards another disappointing semi.

Tim will always be my favourite. Not a relentless, all-conquering machine like Novak Djokovic, or a ripped preening peacock like Cristiano Ronaldo, but a dogged, fist-pumping, dictionary definition of a bloody good chap. My kind of sportsman.

— Jack Whitehall

Comedian

Growing up, I was never more than a few feet from a tennis court. People think I am being modest when I say I am very bad at tennis, but after countless lessons, access to a private all-weather court and having been given plenty of encouragement, I remain a dud. I can't do backhands nor top spins nor volleys. I am proof that practice makes imperfect, that talent is innate and that I should remain off court where I belong, clapping from the stands.

— Jemima Khan

Writer and film producer

I am newly obsessed with tennis. It's addictive. Through this discovery – one made later in life – a whole world has opened up to me, a world with its own ways of doing things, its own social codes and, of course, its own style. I now seek out courts on my travels. I love that I can – and do – play anywhere. Because of tennis I discover new sides to the cities that I visit. It's an amazing way to get under the skin of a place.

— Amelia Warner

Composer

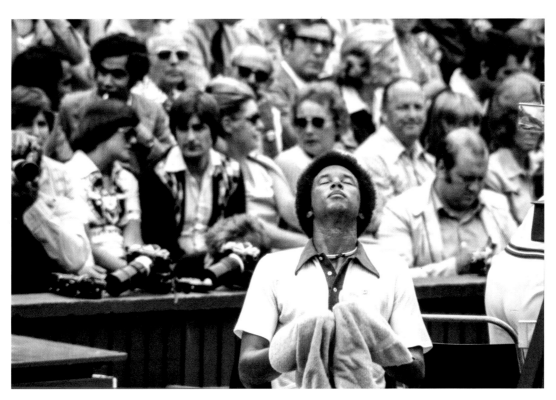

Arthur Ashe during the Gentlemen's Singles Final at the Wimbledon Championships, 1975

I have loved tennis since I was a small boy.
Football may have been my first passion,
but tennis has always held an appeal for
me: the characters, the style, the drama
of the great matches ... we would watch
it on television as a family, and enjoy the
spectacle of the big tournaments.

The great players of my childhood
inspired me. Andre Agassi, Björn Borg,
John McEnroe – huge characters with
incredible talent, and such strong
personal style. I loved it all – the play, the
competitive spirit ... and, of course, the
haircuts. These guys were icons of not just
their own sport but all sport.

As an adult I've become a regular at
Wimbledon, and it's one of my favourite
days of the year: deciding what to wear,
taking my mum for a special day out,
enjoying the traditions and the spectacle
of this most English of events. It's such
a special tournament, with incredible
history and a unique atmosphere. I've
always enjoyed playing tennis with family
and friends. Winning or losing, there's
nothing like it on a hot summer's day.

— David Beckham

Football champion, UNICEF Ambassador
and co-owner, Inter Miami CF

I have this image in my head from a recent
trip to Hong Kong of three beautiful tennis
courts nestled high up between the Hong
Kong skyline and the rolling mountains.
For me, it perfectly encapsulates the city's
dynamic blend of urban and outdoor
spaces. It's a spectacular city.

— Emma Raducanu

US Open Champion 2021; Team GB

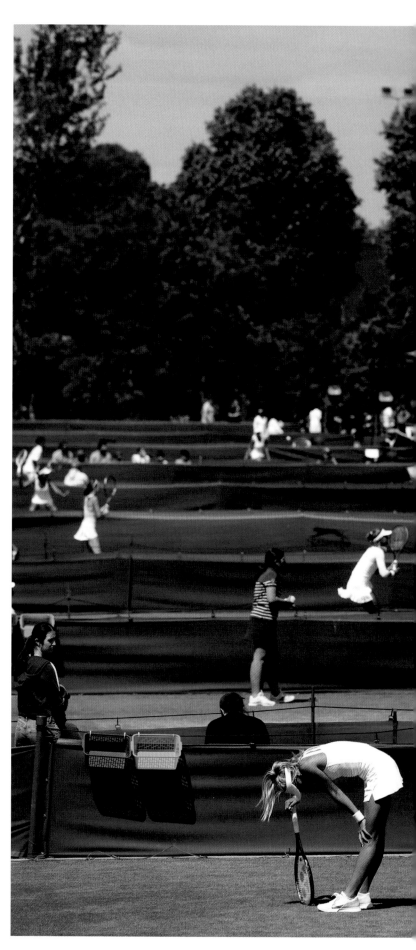

The Lexus British Open Roehampton at Wimbledon Qualifying
and Community Sports Centre, London, 2024

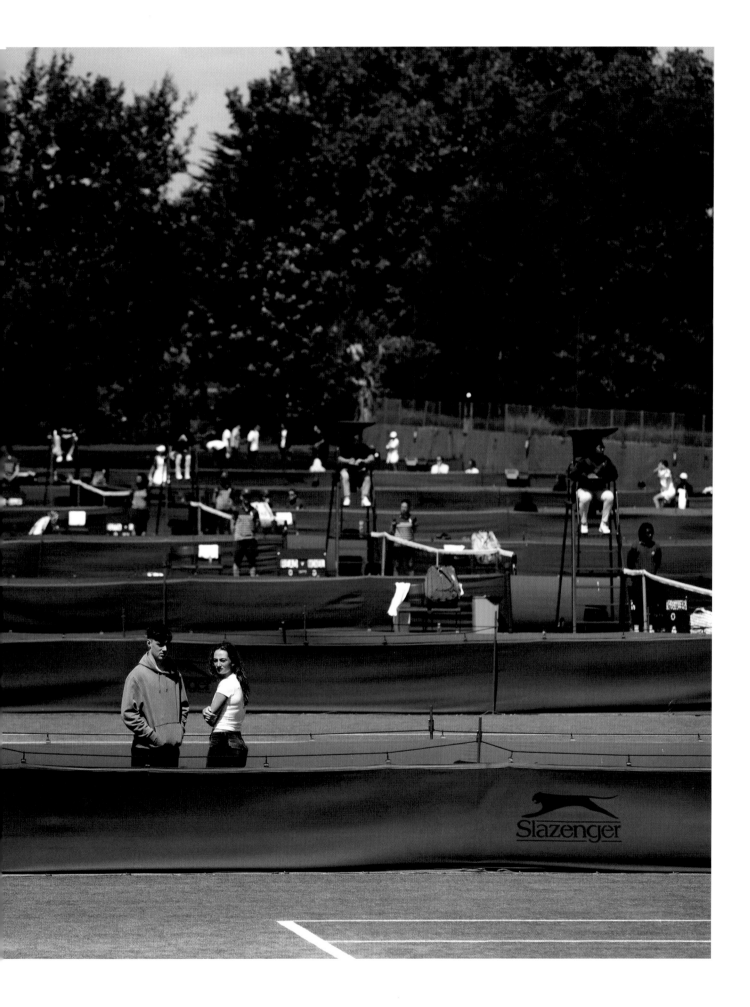

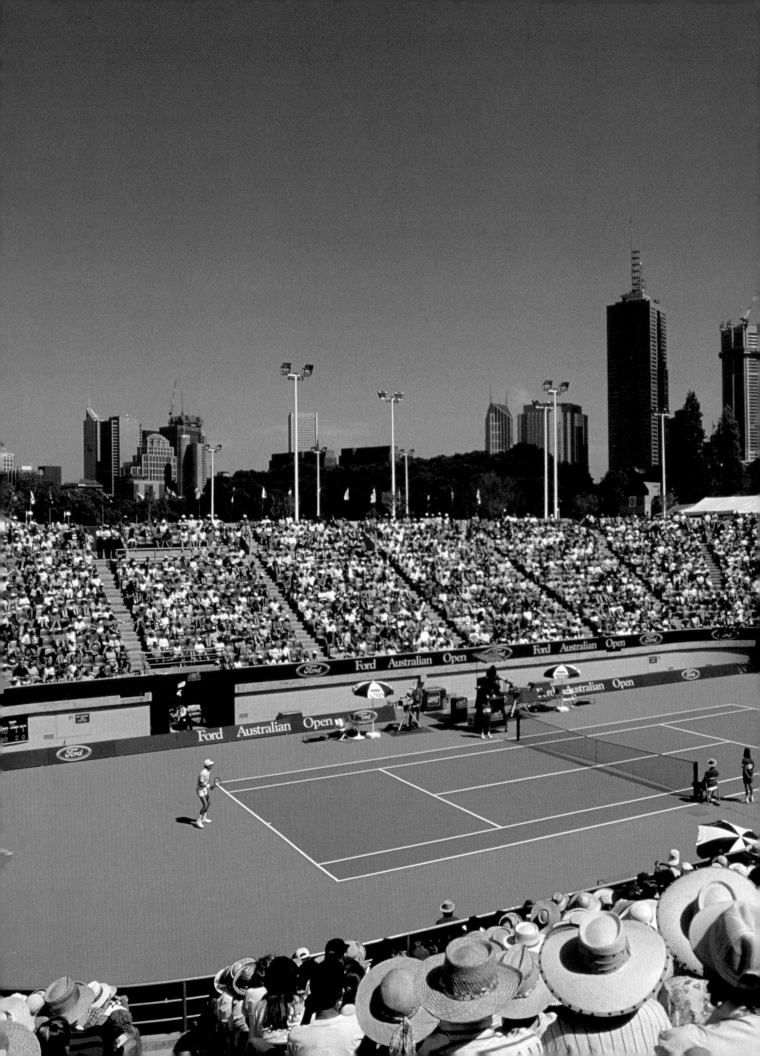

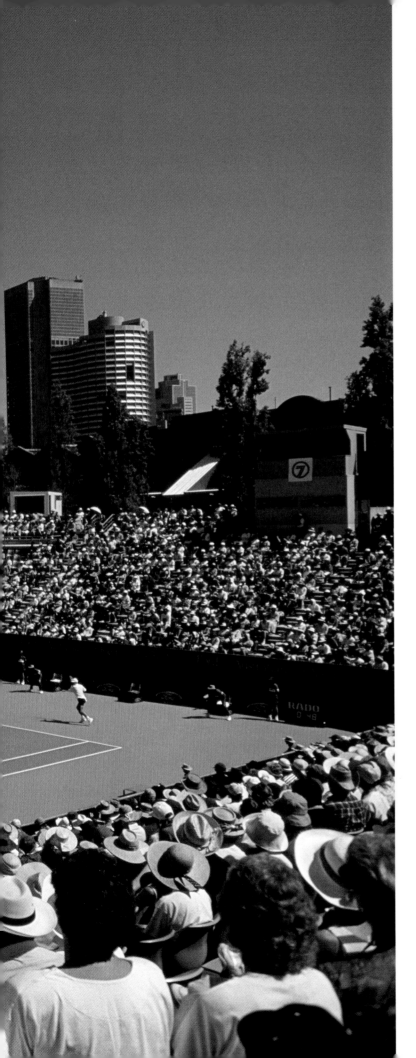

There are two 'courts of dreams' that live in my head. Both involve family. The first was at the farmhouse in which I grew up. I can picture my father on the tractor, adding a chunk of one of the fields of our dairy farm to the garden, loading it with sand and flattening it with a heavy roller. My main jobs were creating the white lines, which were as straight as I could make them, and the annual installation of the big net, which prevented the balls from disappearing into the garden or the ditch. It was not a perfect tennis court, but it's where I learnt to play and had so many wonderful summer afternoons and evenings with my sister, my mum and dad and my friends.

The other court is in part a re-creation of the first, but in our beautiful piece of paradise by the sea in Sardinia. If we chop down the tops of the fast-growing bushes and the trees that help to stop the court sliding into the sea, we can see the water and the Mediterranean sunsets. I love to play there now with my wife, Meabh, with all my kids and now with my grandkids. King of the Court is the game we play whenever there are more than four of us. It's a carpeted court, merciful to older knees and in need of renewal, just like me, really. We added some lighting last year, and these days often finish off a meal with a run round the court. So much pleasure, fun, focus and release. Tennis does the same job for me on tour: I always bring a racquet, and this last tour had another tennis fan in the form of the wonderful trumpet player Josh Shpak.

Who knew little yellow balls could bring so much happiness?

— Peter Gabriel

Singer, songwriter and musician

The Australian Open at Flinders Park, Melbourne, 1992

Growing up in South Africa, before events were televised, Wimbledon was the one event that had all the prestige. I remember at a young age anxiously awaiting the time of year when I could sit next to the radio and listen to the broadcast. In those days, the Wimbledon champion was widely regarded as the number one player in the world.

I dedicated my childhood to training long hours to have the chance to play at Wimbledon one day. In 1972 my dream came true as I was accepted into the Junior Tournament as an unseeded player representing South Africa. As I progressed through the draw, I learned that the Junior finals were to be played on Court One at Wimbledon, where the legends of the sport had won some of the greatest matches of all time. After winning my semi-finals match, I thought about the significance of this moment and the sacrifice that others had made to help me get to this point. I felt a sense of pride and gratitude for all of those who had helped me on my journey, including my parents, sister, coaches and too many others to thank. However, fate had another plan for me as that year in particular there was a fair amount of rain throughout the tournament (Wimbledon didn't get a roof over centre court until 2009), and due to the backlog of matches to be played, the Girls' Finals was moved to Court Two. While this development may have discouraged others, it gave me a new appreciation for a court that usually does not get the love it deserves. Court Two famously had the distinction of being known as the 'Graveyard Court', a place where numerous upsets occurred.

After winning the 1972 Wimbledon Girls' Singles title, Court Two for me will always hold a special place in my heart. Every year since then, I stop by to take a minute to appreciate what tennis has done for me. As someone close to me, Billie Jean King, says, 'dream big' and 'champions adjust'.

— Ilana Kloss

Champion junior and doubles tennis professional; activist and organiser

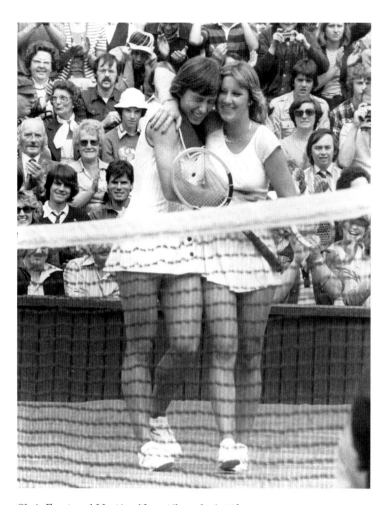

Chris Evert and Martina Navratilova during the Wimbledon Championships, 1978

In 2006, my friend Rebecca told me that she wanted to set me up with a great friend of hers, a fellow documentarian. Rebecca was convinced we would be a great match, or, at the very least, maybe we could somehow work together. So, she set up a dinner with her and her friend at a Japanese restaurant in SoHo in New York. I ended up bringing my friend Omar because I had double-booked and thought I could slip out and leave him with the girls. Kind of an asshole move, looking back.

I apologised for leaving early, and somehow managed to convince Rebecca's intelligent and beautiful friend to come to my office for a coffee a few days later so we could have a proper chat.

She came to meet me in my Tribeca office, an impressive-looking place until you entered my workspace, which was a complete mess. Piles of newspapers, half-read scripts, pens, drawings, books, and, buried under a pile of *New Yorker* magazines, was a tennis racquet. She asked me if I played and I said yes. 'Do you?', I asked, and she said, 'Yeah, I play a little bit'. So she accepted another date. Not drinks or dinner this time, but a game of tennis.

We agreed to meet at an indoor court. I loved to play, despite having had very little training. When we arrived at the court, she was in her tennis whites, and I looked like I was going to a Beastie Boys concert. I really did not want to lose to this woman. And I really *did* want to at least have another chance to take her to dinner.

As soon as we started hitting, I knew I could be in trouble. She started picking me apart on that court. Running me around, forehand, backhand ... She had obviously started playing at a young age, and had incredible consistency and power in her groundstrokes. I kept wondering if she would eventually tire, or start playing unforced errors, but she didn't, which made her even more attractive.

In any case, the attraction was outweighed by the growing fury I was feeling. After losing the third game, I started yelling, 'Christ! Christ! Christ!' and threw my racquet at the back of the court in a fit of rage.

When the match ended, we shook hands like good sports, both pretending that what had just happened hadn't happened. I offered her a ride home. I had

just purchased a brand-new Lexus hybrid. I mentioned 'hybrid' several times to emphasise my environmental bona fides.

I then asked if I could just make a quick stop to pick up my prescription – Synthroid, for my thyroid condition. We got coffees on the way. I pulled up in front of the drugstore, and somehow managed to spill my coffee all over my new Lexus, my tennis shoes, and it even ended up on my battered tennis racquet.

Any normal person would think that this would have been the first and last date. But thankfully I persevered and asked her to give me another chance. This time, I asked if we could have the date as far away from a tennis court as possible. She said yes.

Today, we have two beautiful children and a wonderful home. Somehow, that tennis game was the most honest date any two people could have. I guess I showed her the most authentic insight into what life with me would be like. And, fortunately, she was okay with it.

— Fisher Stevens

Director, writer, producer and actor

Andre Agassi during the French Open Tennis Championship at Roland Garros, Paris, 1990

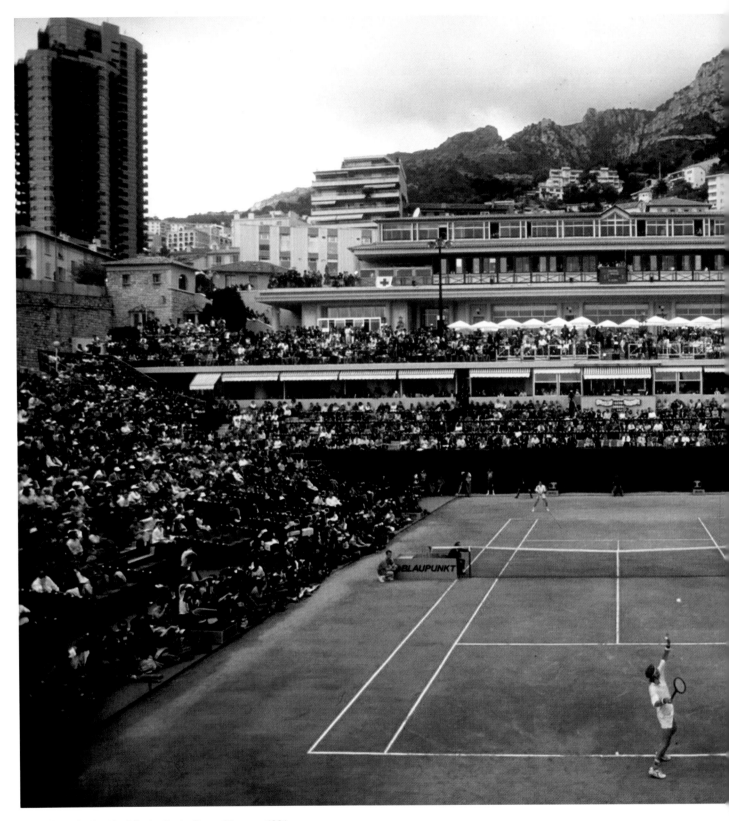

Björn Borg during the Monte-Carlo Open, Monaco, 1991

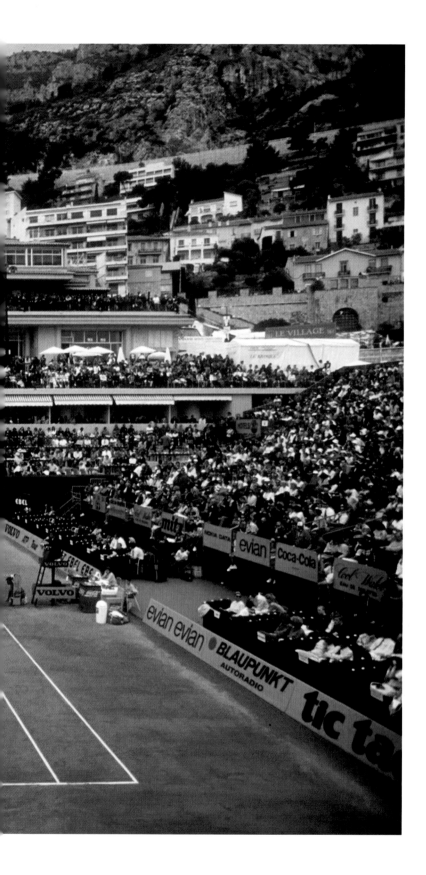

Tennis, you are my obsession, passion, first love and heartbreak.

As I reflect on our multi-decade relationship, I see the bond we created between the natural and metaphysical worlds. I relish the memories of learning your craft while connecting with the elements, a sadistic preference for playing through whirling winds, drenching rain, lightning and thunderstorms. All of which encompass our first lesson together. Your ability to create opportunities, to navigate loss and not to define 'self' based on an outcome is unique. I am fortunate to have found a refuge through our relationship, enabling confrontation and management of my anxieties and insecurities. With time you have guided me to a greater level of psychological growth than I could ever have imagined.

You have also provided me with a holistic connection to others, many of whom I believe would be happy to be called your 'disciples'. These people range from immediate family (particularly my younger brother: we share fond memories of our trip to Tenerife conversing through your craft on the picturesque courts of the Santa Barbara Tennis Club overlooking the Atlantic), to the community of your devotees found at a variety of clubs (or shrines) across the world, to physics classrooms, benches in Paris, and hospital wards on occasion. Within all of this you have assisted me in connecting to individuals and relinquishing antique social constructs, showing that you are here for us all. I will be forever grateful.

Tennis, you provided me with more than enough joy for one lifetime. I will continue to share your message with all I meet.

— Dr Ben Zuckerman

Resident doctor

211

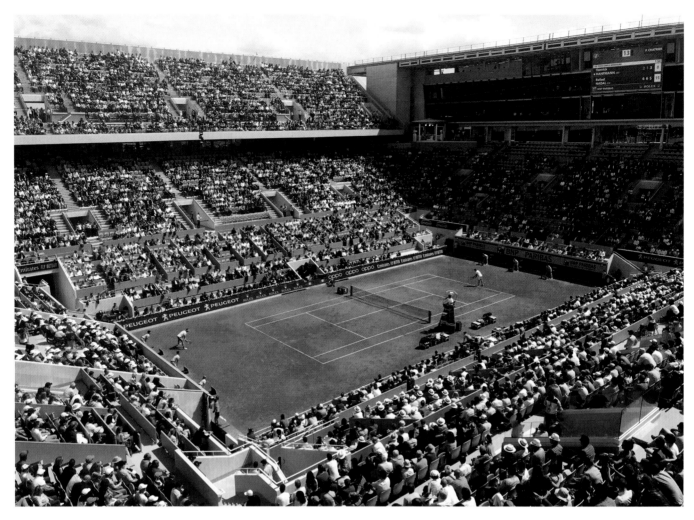

Court Philippe-Chatrier during the French Open at Roland Garros, Paris, 2019

My best win was against Stefan Edberg in 1994 in the third round of the US Open. I was a newcomer on the tour. I'd had the privilege of being Stefan's hitting partner for a couple of years when I was between seventeen and eighteen years old. He was my mentor and idol, so to win against him on the centre court under the lights of a night session with a full stadium was so unexpected. He beat me probably fifty times at practice during those years when we trained together, but we only played each other once officially, so our head-to-head is 1-0 to me, which is funny. I know it still frustrates him when we speak about it.

— Jonas Björkman

Tennis champion; former world number one
in doubles, number four in singles; Swedish hero
of the game

The tennis court is the heart of our summer. It's the place where everyone gathers, where guests behave impeccably or appallingly. You learn a lot about people on the tennis court.

Our annual friends-and-family tennis tournament takes place in mid-August: the Mastic Doubles Open, the Mastic Juniors and the Super Juniors. These are all highly competitive. One year we put out a rumour that Rafael Nadal's cousin was coming and the anxiety among our guests ran exceptionally high. In fact, he did come and play, but he disputed a line call by one of our most respected and veteran umpires and was never asked back.

We like to give our youngest Super Juniors – sometimes as young as two – a walkover. The more advanced Juniors draw is usually round-robin doubles; parents, of course, are strictly banned from playing. They compete loudly from the benches. Speaking of the draws, artist friends spend days creating and decorating them. One year a very talented young man stayed up all night to finish his work, and I made sure to have it framed because it was so beautiful. Guests wait with enormous excitement for the reveal of the seeding at dinner. The tournament director is habitually offered bribes.

Some guests focus more on their tennis outfits than their tennis game and tend to be knocked out in the early rounds. Others dress for the court with less imagination – in our annual message T-shirts ('Mastic Unchained' one year, 'Mastic In Love' another – a wedding summer). Who do we watch out for? Anyone who claims not to have played 'since school' and to be 'terrible'. The tournaments last the weekend, and we always have Disco Night the evening before the finals. Guests take the Disco Night dress code very seriously and pile together into cars for trips to Party City and Kohl's to prepare. Silver feathers and glitter abound. And we work hard to keep the finalists up very late.

We have hardcore Mastic players who have competed for decades, and newcomers who shake up the field. One of my very talented tennis-playing nephews is invariably a winner. One has had his name on the trophy seven times.

There is wisteria in the spring that climbs high above the court, as well as wild roses and wonderful morning glories – and if we are all very lucky, Roger comes for lunch and generously hits with everyone …

— Dame Anna Wintour

Editor-in-Chief, *Vogue*

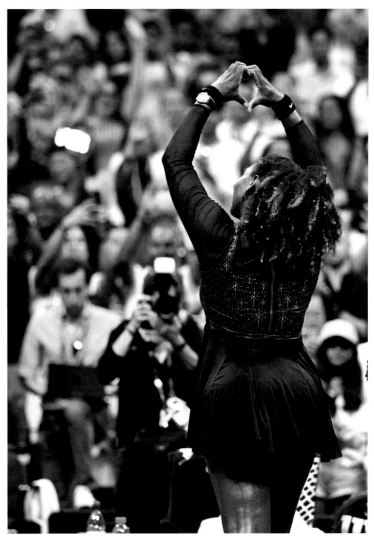

Serena Williams during the US Open at Arthur Ashe Stadium, Flushing, New York, 2022

There's an amazing tennis court in the Scottish Highlands, on the Isle of Harris. It's in the middle of nowhere, beside an unmarked road and surrounded by stunning rural scenery. The backdrop is phenomenal: hills, a small loch and lots of sheep.

The court itself is artificial grass and luckily there's fencing to keep the sheep out and the ball in. There's a tiny wooden pavilion, which a local enthusiast opens and closes daily. It's unmanned and there's an honesty box should you wish to have a hit.

Plan your trip carefully to avoid the dreaded Scottish midges, horrible little insects that come out in droves when the weather is warm and humid. Otherwise, this must be the most peaceful and remote court in the world.

— Judy Murray

Coach, philanthropist and mother

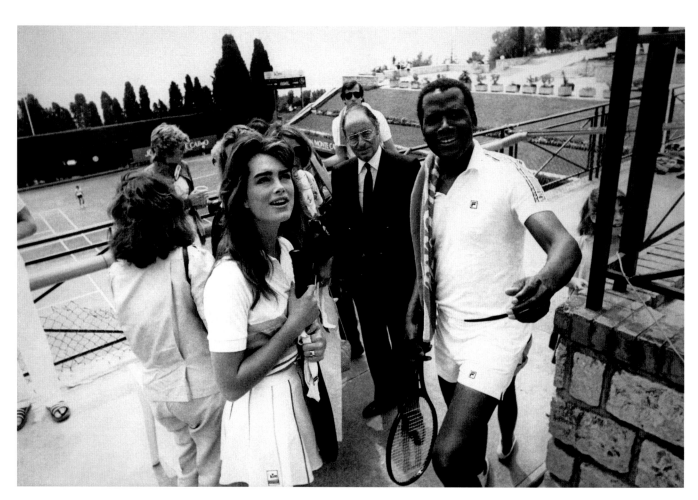

Brooke Shields and Sidney Poitier at the Monte-Carlo celebrity tennis tournament, Monaco, 1983

By fourteen I was burned out on competitive tennis. Although I started picking up casual games again in my late twenties, I didn't truly fall back in love with tennis until I played at the Maharashtra State Lawn Tennis Club, in Mumbai. I was taken there by Jitendra Shinde – known to me now as just 'Boss' – after he collected me from my hotel lobby on the first of a thousand mornings in Mumbai.

The club, insofar as it is a 'club', is located in the Colaba neighbourhood of South Mumbai, a short walk from our pink Art Deco apartment building, in an area characterised by basalt and limestone colonial buildings, honking car horns, the shade of banyan and peepul trees and, in the evening, the sweet smell of the *raat rani* – 'queen of the night' (known in English as tuberose) – bush. There were six lightning-fast hard courts, players shouting on every one of them.

Jitendra, known as Jeetu to everyone at the club, was five foot six, roughly my age, with a facial hairstyle in constant flux and an aggressive centre parting that called to mind the 1980s quiff of Mike Score, lead singer of A Flock of Seagulls. Often, he called me 'Dabaang', after Salman Khan's moustachioed Bollywood cop of the same name. ('Don't angry me!' was his tagline, and soon became mine, too.) Mainly though, he called me 'Boss'. He does to this day, texting me on Diwali, Christmas and New Year's Day to say, 'Happy holidays, Boss'. In Mumbai, all men call each other 'Boss'.

Jeetu made few errors, had insane racquet-head speed and an uncanny ability to run as little as possible whilst humbling me on the tennis court, a crucial skill in the stifling Mumbai heat. His classic move: a passel of drop-shot and lob combinations, usually in the first minutes of our game, ensuring I was too exhausted to put up much of a fight from then on.

Jeetu came with a ball-boy, Manoj. I am at peace with Manoj, but it took a minute. Manoj was a jittery presence, quick with an unsolicited and often incorrect line call.

His most enduring gift, however, might be teaching me not only to score a tennis game in Marathi, but also to curse out my opponent or a loud player on an adjacent court in his mother tongue. For this ability, I am confident I am still remembered at the MSLTC more than a decade later.

For 1,200 rupees (about 22 dollars at the time), I would get an hour with Jeetu and Manoj, two cans of 'new' balls and, if I wanted, a fresh lime soda on ice after our games, presented lovingly by Manoj – though I didn't like to abuse this last privilege.

After a while we started playing in the intense daytime sunshine, presumably so Jeetu could save a few rupees on the fees required to keep the court lit at night and, certainly, so he could fleece tourists during the more sought-after (and expensive) evening slot. It didn't matter. By that point tennis had taken precedence over my productivity as a writer, so I was happy to keep my mornings free.

He'd slot me in at 10 am several times a week, when everyone else had left for work, having played in the warm golden light and more reasonable temperatures of a Mumbai morning, except on the rare occasions when he couldn't. 'Sorry Boss, not possible', he'd say on those days. This was the end of the conversation.

I beat him exactly once, not counting the time when he called off our game, down match point, due to the presence on the court of one single large raindrop.

After we'd play, he'd put the six slightly weathered balls back in their cans, to present to some other foreigner as new, and amble off to his next lesson, singing a tuneless song that contained some version of the line, 'Boss, Boss, Boss, you are my Boooosssssss'.

He is the only boss I'll ever have.

— David Shaftel

Co-founder, *Racquet* magazine; founder, *The Second Serve*; writer and editor

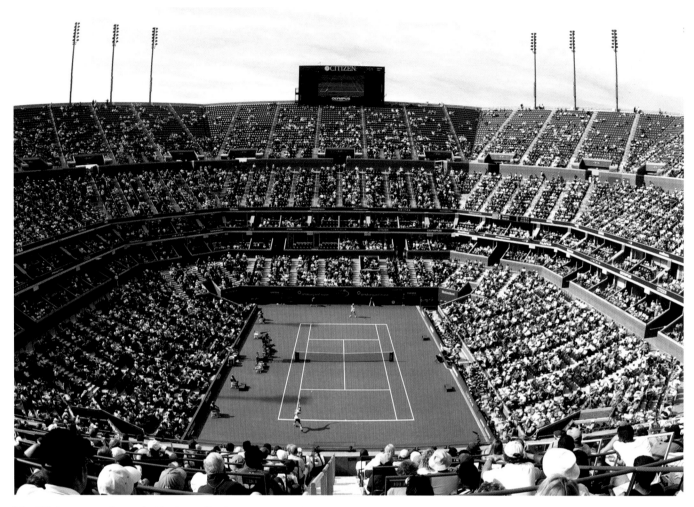

The US Open at Arthur Ashe Stadium, Flushing, New York, 2003

Sacrifices often need to be made to accomplish one's goals in tennis. Nazrah (aged eight) started on our bursary program when she was five. Since then, she has made it quite clear that she wants to become a professional tennis player as great as the Williams sisters and Coco Gauff. I am now training Nazrah for free five days a week, two hours a day after school, to help her reach her dreams. This is what it takes.

In the summer of 2023, I took Nazrah and Tito, her training partner, and their parents to Wimbledon for their first time ever to experience the Championships – such an unbelievable experience for the children as they were able to witness the best junior players in the world compete at the best Grand Slam in the world, which is where they plan to be in the next few years. And for their parents, it was something they had always dreamt of doing as children, but had never had the chance. To be able make this happen – encouraging these kids to dream big – was unforgettable.

— Arum Akom

Head Coach, Butterfly Tennis Club, Camberwell Grove; Director of Tennis, Streatham Vale Park, Streatham; founder, Black Tennis Mentors UK Platform

They say you should never meet your heroes. Well, if your hero happens to be a true tennis icon, a seven-time Grand Slam winner, someone you've admired since childhood but who is also known for their impolite on-court manner, then meeting this hero is a big no-no – and playing against them should be well and truly called 'out'. But a few years ago, that's precisely what I did when my wife, Stella, 'lovingly' set up a match for me to take on the legend that is John McEnroe. What should have been a dream come true turned into a nightmare that still haunts me. Just writing these words sends me 'top spinning' into a cold sweat.

Tennis is a true passion of mine, a sport I love dearly, but if I'm honest, I'm an average player at best. Even my absolute 'A' game is erratic, littered with unforced errors, and has enough junk shots to cause an environmental crisis. So, with that in mind, picture the scene: me, head down, reluctantly dragging my Adidas Barricades across the red clay court to face, on the far side of the net, Johnny 'Superbrat' McEnroe. After a very brief warm-up that was, let's just say, not a 'net positive' performance by me, we got down to business. I got down to the business of thoroughly embarrassing myself, while Johnny Mac got down to the business of trying to work out a semi-plausible excuse to get off the court as quickly as he possibly could. Suffice it to say, it wasn't a 'classic', and the few friends who had joined to watch the encounter in the vague hope of seeing a quality spectacle, with just the outside possibility of an upset, discreetly slipped away after witnessing the warm-up.

After what felt like a physically gruelling and psychologically scarring four hours on court (but was in reality forty minutes), we shook hands at the net and called it a day. Head down, red-faced and dripping with sweat, I shuffled off in a state of acute trauma. As I tried to process and come to terms with the utter humiliation of what had just taken place, I heard the voice of my hero empathetically shout, 'Hey Al, it's not a bad forehand you have there – something to work with'.

Now, I don't suppose he really meant it, but I did appreciate the thought, and despite my state, I couldn't help myself turning back and shouting: 'You cannot be serious!'

— Alasdhair Willis

Chief Creative Officer, Adidas

When I was younger, I played at Leicestershire Lawn Tennis Club. It's in a residential area, two minutes from my grandpa's house, so I used to walk over after spending some time with my grandparents. It had real and artificial grass courts, as well as hard courts and clay courts. On the roof there was a stand overlooking the first court, which I will always remember because of the County Championships where everyone used to play – such a big deal back in the day.

It's a beautiful little club with a bar and clubhouse. I spent a lot of time in the clubhouse waiting for my mum when she was coaching. I spent most of my time, however, on the hard court. They had a wall and a net on this court. I'd be there for hours.

— Katie Boulter

Team GB; British number one, 2024

In the 1970s, my family and I would fly
every Christmas from Minnesota to
Ocho Rios, Jamaica, escaping sub-zero
temperatures in search of adventure. We
rented an incredibly romantic house called
Zandunga in the tiny village of Port Maria.
An older refugee from Eastern Europe
had founded the Port Maria Racquet Club
and my father – the one-time captain
of the University of Minnesota Tennis
Team and an avid player still – became a
visiting member. My brother and I hung
around the adorable grass court, sipped
exotic almost-chilled vanilla cream sodas
in the shade and waited for our turn. The
court was maintained by two unusual
employees: a handsome thirteen-year-
old boy who wanted to learn how to hit
(Jean, the founder, needed partners for
sure) and meet American girls (I was very
game!), and the local donkey, who was
led around the court, up and down, by
the boy, nibbling the grass and keeping it
the perfect turf. There was a heavy metal
roller they both pulled to further flatten
the grass and make it perfect while Jean
and my father directed the two so that
they had the ideal surface. I will never
forget the civility, the camaraderie and
the meeting of the old European world of
Jean, the new world of the upper Midwest
that we brought, and the Caribbean
Jamaican world of the lovely boy.

— Diana Phillips

Film producer

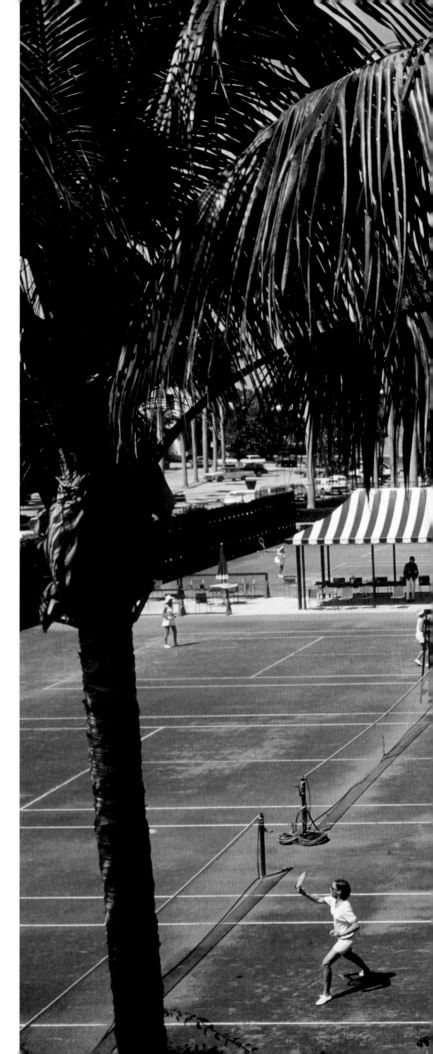

The Everglades Tennis Club in Palm Beach,
Florida, 1968

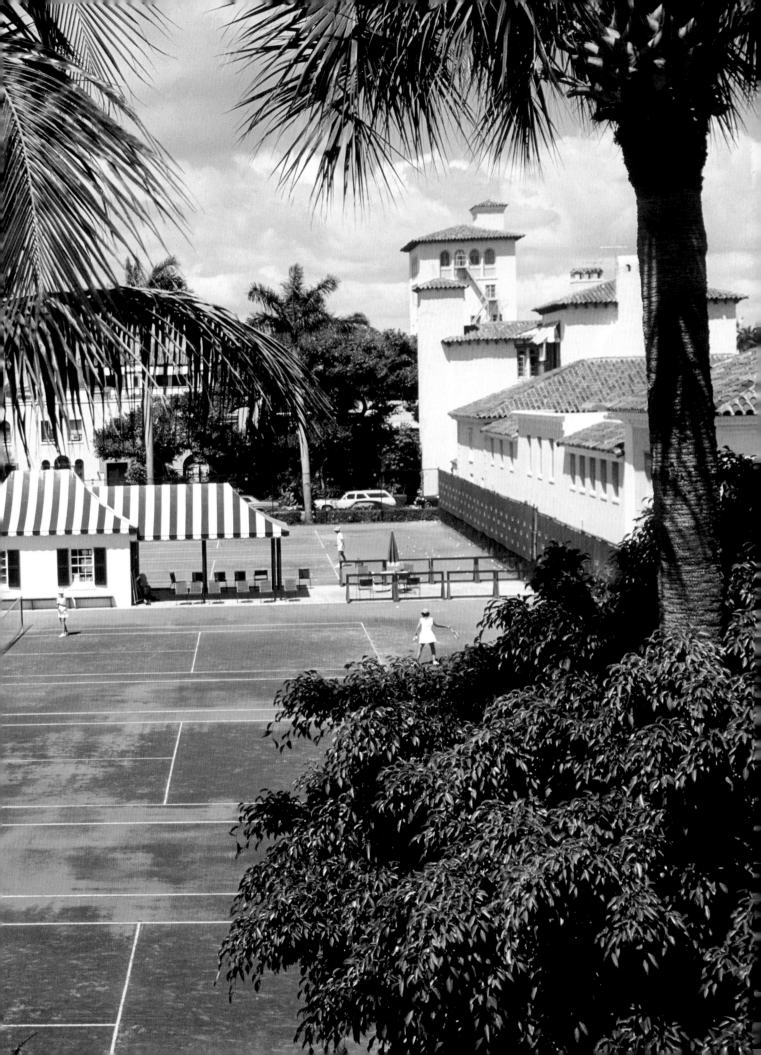

Fabio Testi and Helmut Berger in a scene from *The Garden of the Finzi-Continis* (1970) directed by Vittorio De Sica

The best shrink I ever had was also my tennis coach. His name is Zach Kleiman and he wrote the preface for Tim Gallwey's *The Inner Game of Tennis*. Anyone who plays the game knows there are two opponents: the person across the net, and the voice inside your head. The latter is usually the tougher one to beat. In the twenty years Zach has been my coach, I got married, got divorced, lost friends, made new ones, have been fired, hired, celebrated and panned.

Zach (who looks just like Yoda) had me begin our lessons by telling him whatever was going on in my life at that moment. His 'therapy' – which works remarkably well for tennis – is not just to hit each ball with the intention of where to place it, but to give each stroke its own feeling and personality. Over the past twenty years, Zach has yelled to me from his basket of balls: 'Hit it with the feeling you had the day your daughter was born'; 'Hit it like when your heart was broken'; 'Hit it with gratitude for finding love again'; 'Hit it like when you were betrayed'; 'Now hit it as the betrayer'. It might sound like mumbo-jumbo to some, but if nothing else, it does heighten the concentration. To this day, Zach's voice follows me from court to court. If he were a ball, I'd warmly lob him to the heavens as thanks for helping me find my inner game.

— Griffin Dunne

Actor, writer, director and producer

I like dressing up and losing. I'm not very good, but I always turn up in all whites, with maybe a paisley silk cravat, and all-black racquet, no logo. I have no technique, really; I'm an untaught tennis player – street tennis – but I love defending. My favourite games are against players who are just a little better than I am – and defending. The biggest pleasure is a fourteen-shot rally where your opponent hits you all over the court, you get the one out wide on the right, you race across for the one wide on the left, you come back in and you manage to get the drop-shot, all at full speed. When you get the shot they don't think you'll get. It's the joy of running all out for the sake of the ball that makes you feel like a child again. And you don't think about anything but the ball and the geometry of the lines of the court. The pleasure of tennis is this unique combination of Cartesian geometry and childlike running. Like meditation, it shuts off all the anxieties of life. If I just go running, I think about all the stresses in my life. If I'm chasing a ball, I think about nothing.

My father, a very poor golfer, said that how he looked at it is that he got more fun out of the game than his better opponents because he got to hit the ball more times than they did. And I look at it similarly: if someone is hitting me all over the court I get a better cardio workout than they do. I want to start a tennis club called Saint Jude's Lost Cause Amateur Tennis Club. The only important rules of the club will be to dress well on the court, perhaps with a little flamboyance, and be a good loser.

— Robert Montgomery

Artist

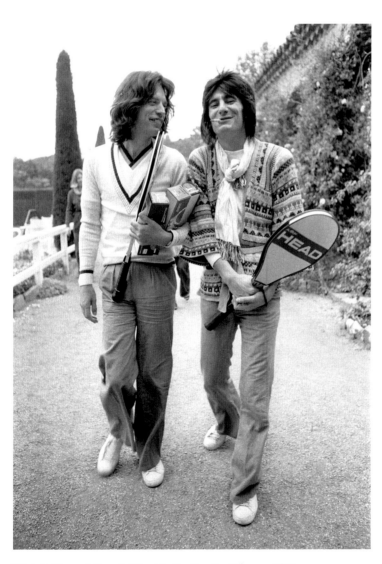

Mick Jagger and Ronnie Wood in the South of France, 1976

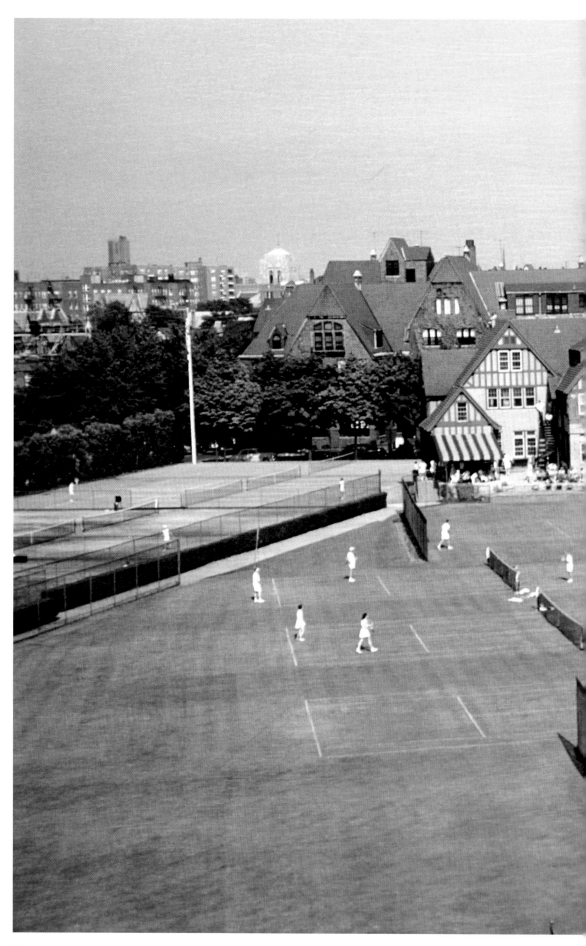

The grass courts and clubhouse at West Side Tennis Club in Forest Hills, New York, 1955

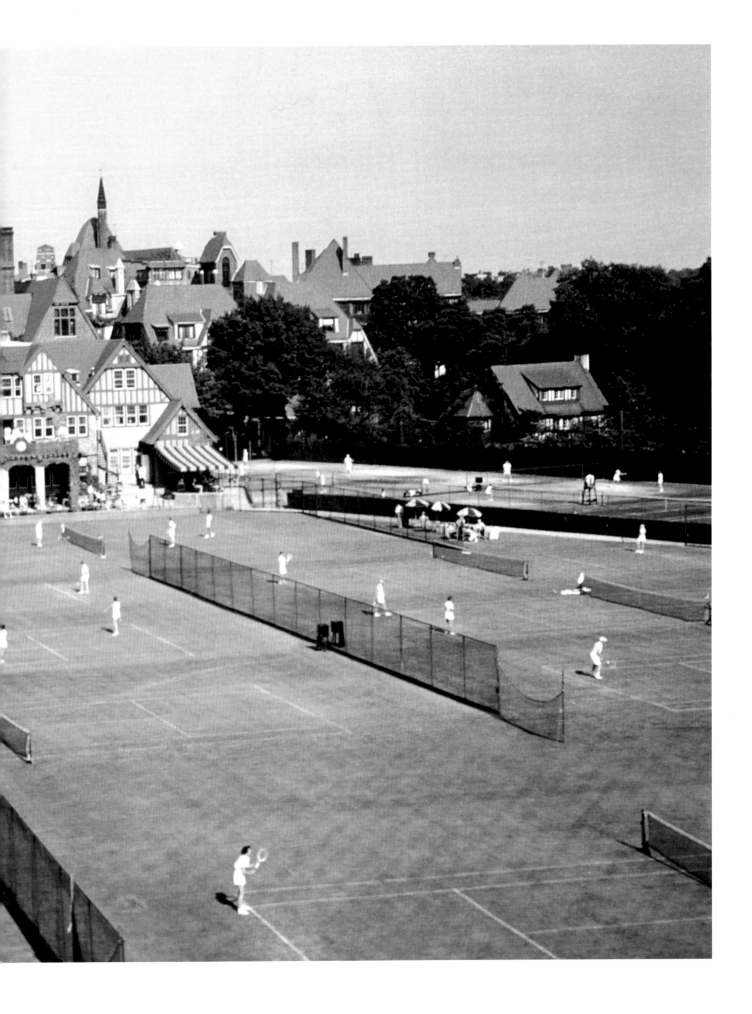

You're the only thing that gets me out of bed before the sun rises.

The only thing that encourages me to tell a white lie to get out of a work meeting or dinner for singles or doubles.

You're unpredictable.

My new non-negotiable as I balance my time as a 'grown-up'.

I never quite know how our game will turn.

An addiction you have become ...

This palpable, tantalising danger of anything going wrong.

The court – a backdrop of stillness where I forget about my worries and the world.

The game – a superpower, stopping time.

The outfits, the gear – an obsession. The comfort I find in the uniform I create.

The hours we put in pay off.

The sense of adventure you give me to discover a court when I arrive in a new city: finding someone to play with, both in our own languages, communicating through our shared passion. You.

The community, the friendship – to which I am forever indebted.

Oh, tennis, the way in which you have now become my number one.

I never will know quite how ... but boy do you give back.

— Gala Gordon

Film producer; co-founder, Parados Pictures

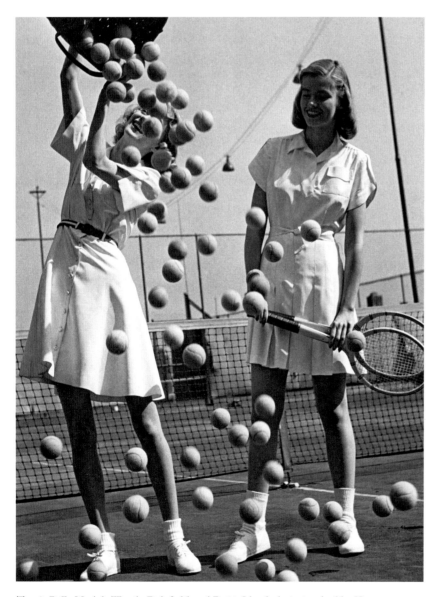

Tennis Balls. Models Wanda Delafield and Peggy Lloyd photographed by Hermann Landshoff for *Harper's Bazaar*, 1946

We moved from Los Angeles to Brooklyn after living on the West Coast for twenty-five years. I had never been a huge fan of LA, but one of its redeeming features is the abundance of tennis courts. They seem to be everywhere in the city, whether they are private, public or in a club. And for a devoted player like me this was a tremendous source of pleasure. Brooklyn Heights was another matter. Urban density is hostile to tennis. The two public courts near us were always booked and there did not seem to be an alternative. Then I found the 'Knick'.

The Knickerbocker Field Club, founded in 1889, is situated in Flatbush, a neighbourhood deep in Brooklyn. I chanced upon it when visiting an old friend who lives nearby. The Knick has five perfectly maintained clay courts and a concrete clubhouse. The clubhouse was built in the late 1980s, replacing what must have been an amazing Victorian structure that included a bowling alley in the basement. Pictures on the walls show tennis greats like Bill Tilden and Jack Crawford playing there in the 1920s and 1930s.

It burned down in the 1980s – supposedly the handiwork of some young kids in the area. It is surrounded on one side by apartment buildings that are occupied mostly by West Indian families and on the other by the B and Q subway that runs above ground in that part of the city, so when you are on the courts you often hear the whistle of a passing train. Adjacent to the clubhouse is an old camper which is occupied in the summer by the groundskeeper, Raymond – who, in the winter, moves back to his home in Aruba. There are 150 members and a five-year waiting list. I was desperate to join.

After much effort I contacted the club president, Ray Habib, and he invited me to play doubles to see whether I had what it took to apply for membership. Ray worked at the Brooklyn Navy Yard, and he was largely responsible for the robust health of the Knick. I walked down Tennis Court Lane into the club and heard loud voices with strong Brooklyn accents yelling from the courts. I was in tennis whites, and instantly realised I had made a mistake. The other players were wearing every manner of T-shirt with logos from various New York sports teams or different brands of beer.

Ray was my partner for the match, and when I got on the court my tennis garb was jokingly ridiculed. They asked me where I had gone to college, and then gave me the nickname 'Harvard'. We were playing against two guys who were both ten years my senior. They appeared to be out of shape and had unconventional strokes. I thought that we could take them easily. I was wrong. What ensued was one of the most competitive games of doubles that I have ever played. Not only were our opponents – and Ray for that matter – better doubles players than me in every way, but they also played to win with a ferocity that I had rarely encountered. Shouting, swearing and trash talk were all part of the game. It went three sets and in the end we lost. I thought that I had failed the test.

We got back up to the clubhouse and grabbed a few beers out of Ray's hidden stash in the fridge. We sat around on folding chairs and talked about tennis, including whether the club could afford to resurface one of the courts, and various physical issues that ailed us. There was no talk of work, politics or the state of the economy. It was an unwritten rule that these topics were not welcome. I was a bit uncertain where I stood with all these folks. I realised that this was a closed circle that had found and cultivated an oasis in the middle of the city, and they were not eager to welcome strangers. Everyone was a native of Brooklyn and I was the furthest thing from that.

Ray walked me out of the club on my way to the subway. We chatted and I tried to appear relaxed but in truth was eager to know how I had done. When we got to the street Ray turned to me and said, 'You fit right in. Turn in the application. I'll make sure it happens quickly'. I was overjoyed.

Since that time, I have played tennis all over New York. Many of the places are quite elaborate with lovely facilities and locker rooms. But none gives me the pleasure and comfort of the Knick. It is my tennis home. My home away from home. And I am so grateful that I have it in my life.

— Michael Lynton

Chair, Snap

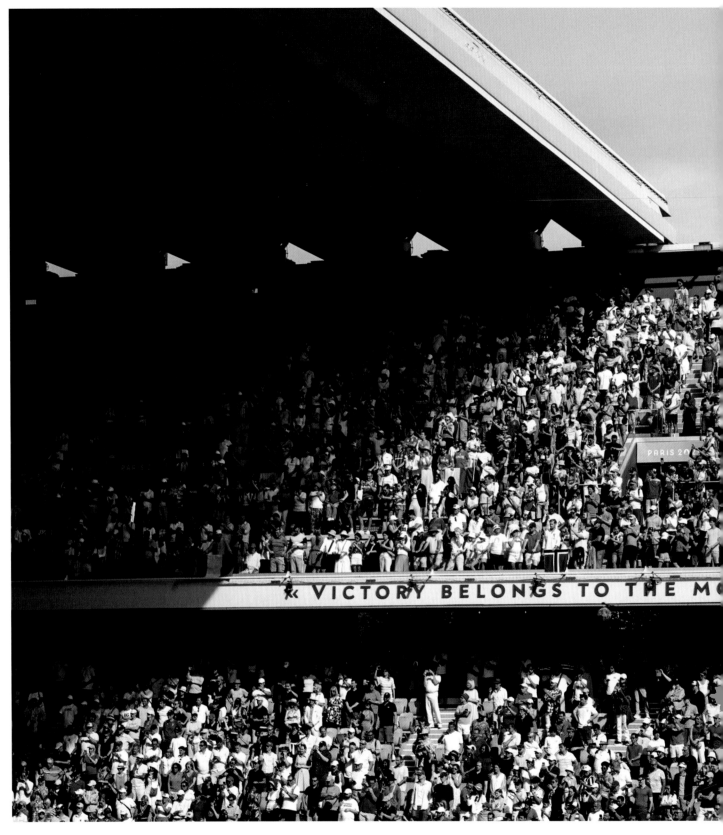

"Victory belongs to the most tenacious," a quote attributed to Napoleon but often used by Roland Garros and inscribed on the stands at Philippe-Chatrier centre court at Roland Garros, Paris

I grew up playing tennis. My first taste of independence was cycling to and from Hartswood Tennis Club on Saturdays with my brother. The club became a great source of cute young boys to have crushes on as I grew up. I also have fond memories of playing on grass courts during my summer holidays in Ireland. Now I play mostly at Oakley Court Hotel in Windsor; it has been special to watch and play there with my kids.

Tennis is such an important feature of our family summer holidays, and we often aim to stay at hotels or houses that have courts, so when we holiday with friends we can pick up a game of doubles or play as a family. Some of my favourite courts are those at Hotel Il Pellicano and Il San Pietro, both in Italy.

What I love about tennis fashion is that it has stayed so consistent over many decades. It is clean, neat, sporty and timeless. Pieces I have designed for my own collection, including our Campden Hill Polo and Skirt, can be worn by schoolkids or members of the Queen's Club alike.

— Alex Eagle

Founder and creative director, Alex Eagle Studio and Alex Eagle Sporting Club

The appeal of a tennis court is all about the lines and the soundscape. The crisp shapes and angles of a court, linear marks and drawings on the ground. It represents performance, like a stage ready with its audience or spectators, an open space waiting to be occupied and played on. And then there are the rhythmic motions of the ball on the court, a back-and-forth like a conversation between friends.

— Charlotte Keates

Artist

227

Farrah Fawcett plays mixed doubles with Vincent Van Patten in a celebrity tennis tournament in Los Angeles, California, c. 1980

Tennis is a great way of fending off loneliness. When I moved to Brazil for a period, I didn't know anyone, couldn't speak Portuguese and was trying to navigate the goliath of a city that is São Paulo. There were clay courts nestled between the skyscrapers (most of them now sites for skyscrapers themselves these days, unfortunately), which became a haven for me: dusty red oases that provided opportunities to meet locals who shared my passion for the game. Mornings of tennis and then long, long lunches at an Argentinean restaurant called 348 are fantastic and cherished memories for me, memories into which tennis is deeply intertwined.

When I travel I always bring a racquet and find that there's an instant connection which can be made at a dinner party or work event when you throw out, 'Does anyone play tennis and want to hit tomorrow?' Someone invariably throws a hand up and the trip becomes so much more enjoyable and somehow real. The global community that the game of tennis has brought to my life is life-affirming, and I'll always be grateful for it.

— Adrian Calvert

Founder, All Court Tennis Club

Tennis on one of the grass courts at Babington House is unrivalled. Nestled in the trees and in the depths of glorious Somerset you have a court with the most verdant surroundings, tucked away from the hubbub of life. In summer it's the floral aromas, the tweeting of the birds and the end-of-day sun on your back to remind you that the simplest of things really lift one's spirits. Then hark to the autumn with woodsmoke wafting through the air, the reassuring coo of a wood pigeon and the rustling of the leaves as they blow off the trees. It's nostalgia, and my very great comfort. And that's before the tennis has even started.

— Martha Ward

Travel editor and stylist

Marion Hargrove photographed by Joseph Leombruno for *Vogue*, 1954

Fabrice Higgins during a Learning Disability Exhibition Singles match at the cinch Championship, Queen's Club, London, 2024
FOLLOWING SPREAD: The Lipton International Players Championships at Boca West Country Club, Boca Raton, Florida, 1986

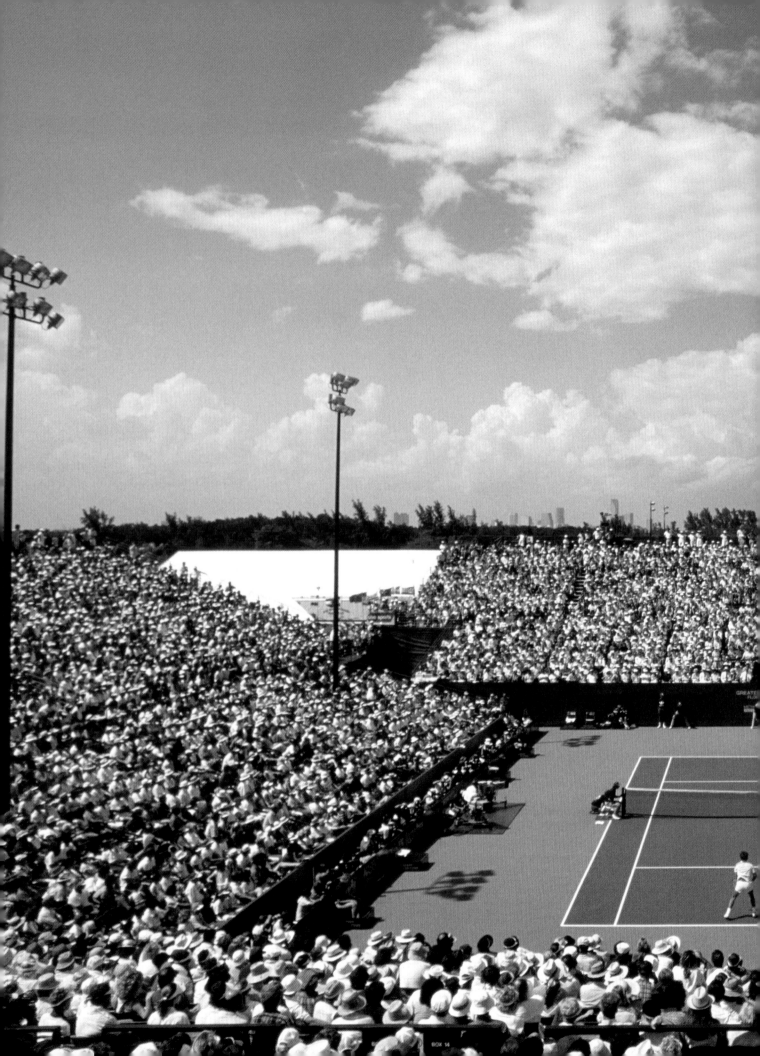

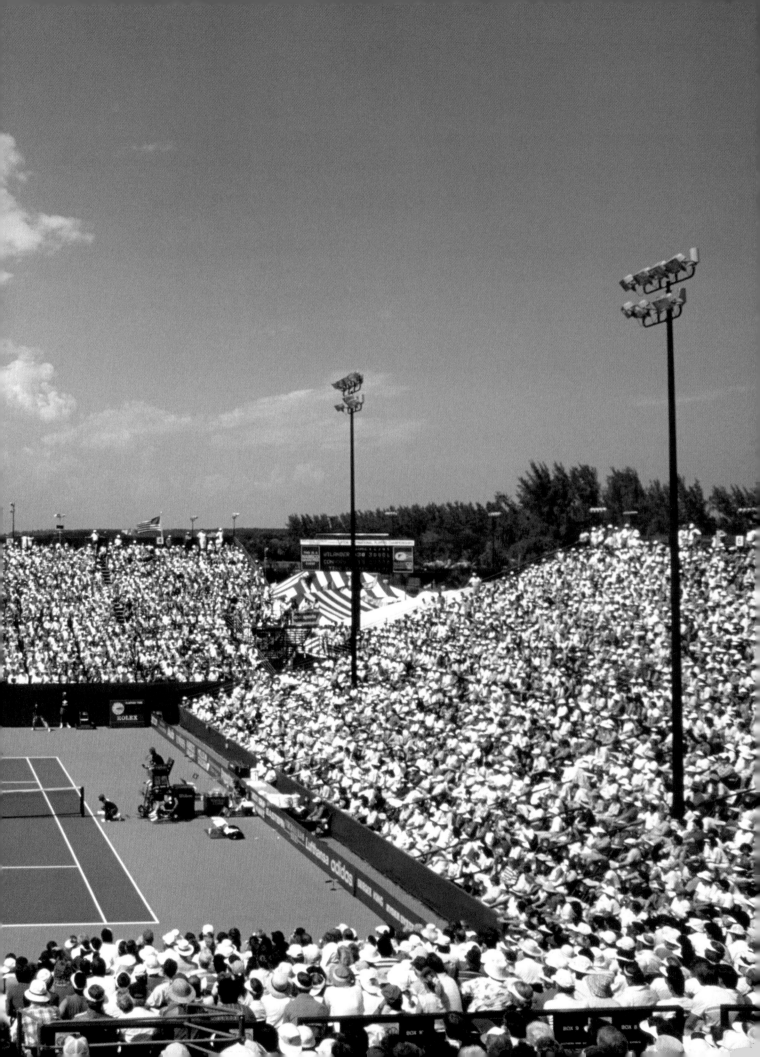

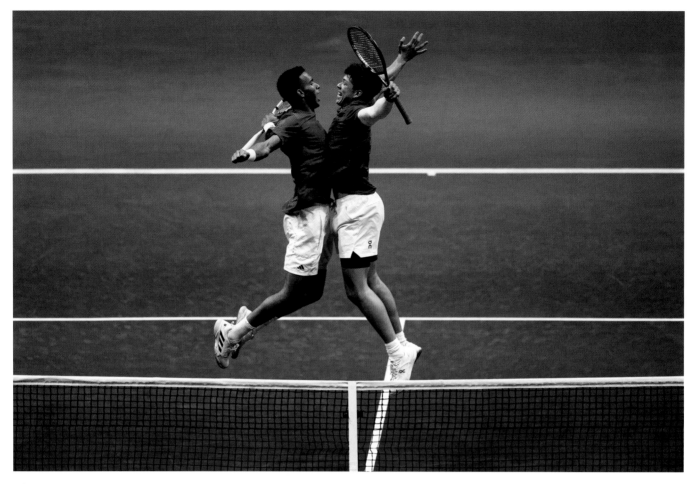

Félix Auger-Aliassime and Ben Shelton during the Laver Cup at Rogers Arena in Vancouver, British Columbia, 2023

That smell ... I swear I could drink it in.
The unmistakeable 'cluck' followed by the
persuasive, elongated hiss. The removal
of the razor-sharp lid, which needs
negotiating with firm, quick confidence
lest you slice yourself – and we all have.
But then the reward, the smell. It's a smell
for the ages. Who knew that a two-piece
rubber shell filled with pressurised gas and
clad in fuzzy yellow stuff could promise so
much? This is the sport.

— Eddie Redmayne

Actor and producer

The court was old school, built in the 1950s, its surface made from loosely compacted gravel which twenty years of winter frost and summer heat had left riven with potholes and cracks. Dandelions sprang out of a rash of tar bumps. Thick moss had colonised the tramlines, and the whole enclosure was surrounded by a moat of nettles – a graveyard for lost tennis balls in varying stages of decomposition. Sunk into the ground at the bottom of two flights of chipped stone steps, the court was at my grandmother's home in the countryside. It smelled of cut grass and fox's piss – but when the wind blew from the east, it smelled of honeysuckle and those big old-fashioned roses that English gardens used to be famous for. I loved playing on it and did so obsessively every June after our New York schools broke up for the holidays.

My father taught me the game. He was a natural athlete, fluid and co-ordinated with an impeccable eye for a ball, irrespective of what sport it belonged to. Though he had nothing against the tradition, tennis whites weren't really his thing. He preferred flared jeans, a denim shirt and a pair of cowboy boots, the heel of which added another inch to his already tall frame. Back then he still enjoyed a sixty-a-day habit, and smoked as he played, a lit cigarette dangling from his mouth and the rest of the pack snapped into his breast pocket. Serve, volley, forehand, backhand, there wasn't a shot he couldn't make or return, and though I realise this can't possibly be true, I swear I never once saw him run for the ball. He could have played with a frying pan and still won, even against my grandmother, who was a vicious cheat. I grew up a passable if erratic player. My greatest skill was hitting a winner off a wayward bounce. Not much of an advantage on today's pristine courts, but a skill well worth honing on the assault course of my childhood.

In our early twenties, my brother and I ran a fashion business together, and one spring we brought a clutch of our Japanese licensors to the house for Sunday lunch. They had arrived from Tokyo determined to visit the Cotswolds, and were entranced by the yellow stone, thatched cottages and roast beef, but when they saw the tennis court they stopped and stared. What new and inexplicable English eccentricity was this?

A further decade of benign neglect had not improved the court. The net, held to rusted posts by string, looked as if it had been swiped off a Scottish fishing trawler. An ancient weeping willow, which had been growing steadily through the chain links of the enclosure, now provided a dense canopy over half the service line. My father was passionate about trees, pocketing seeds from around the world, planting, nurturing, labelling them with their Latin names. He refused point blank to prune the willow, and during the height of summer the only evidence of a fourth player in any match might be a warped racquet poking hopefully through its leaves.

Undeterred, our Japanese friends changed into Ralph Lauren shorts and polos. All six were extremely competitive, and far superior players to my brother and me – but that was without factoring in the home advantage. Marcus and I knew only too well which pothole was likely to snap an ankle, which erupting volcano of gravel lethal to the big toe, and we aimed accordingly. The away team also had to contend with psychological disadvantages. On being sent by his superior to retrieve an unruly lob, Micky, who'd adopted a Beatles haircut, found the ball nestling between a pair of loved-up grass snakes. Osamu quickly became fastidious about the crunch of snails under foot, and Hiroko was nervous of contracting tetanus from the rusted iron roller parked in the corner of the court. Soon, set after set was being chalked up to the Pollens.

My brother and I were twenty-one and twenty-three, respectively. Too young for much tact or business sense. We beat them soundly, and when our licensing agreement wasn't renewed a few months later, we never acknowledged that the fortune we lost in royalties directly correlated to the amount we'd gloated. Besides, we consoled each other through the lean years that were to follow, no proper player would ever throw a game for financial gain.

The house has long since been sold, and though it's wishful thinking I like to imagine that instead of getting beautified, the court has been allowed to continue rotting gently by its new owners who have the wit to appreciate it for what it is: never much of a sports facility but a top class, if accidental, example of early conceptual land art.

— Bella Pollen

Writer and co-founder, 30 Birds Foundation

I walk onto Wimbledon centre court and the crowd's applause is deafening. This is my sixth Wimbledon title. I have been sponsored by Nike for fifteen years, the longest sponsorship they have ever committed to. My family are standing and waving in the box above the score board, and the emotion is overwhelming. I cannot hold the tears back any longer. Every muscle in my body is aching and I know it will soon be time to lay my racquet down and make way for the younger generation. How did I ever get here?

I never got there – but each time I have walked onto a court during my fifty years of loving tennis I have somehow managed to pretend that I am on centre court and I am one of the best players in the world. I do have a Nike skirt and Nike top and shoes and a pair of bobble socks, which I shall never part with. These days Tony, my Chihuahua, will sit courtside, watching my every move, and that is enough for me. To him I am the best player in the world, so I suppose there are parts of my dream that have come true.

I am open to sponsorship if anyone is interested.

— Kim Sion

Creative director

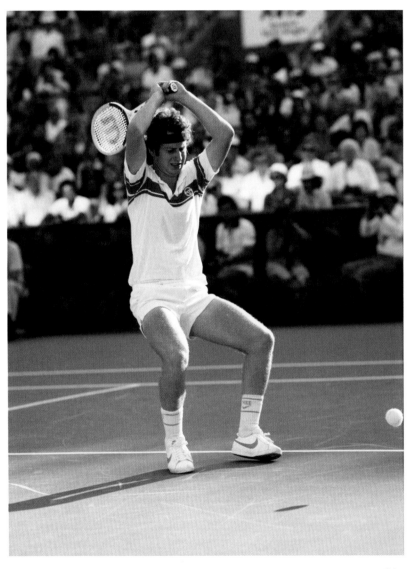

John McEnroe during the US Open Men's Singles tennis tournament at the USTA National Tennis Center at Flushing Meadows, New York, 1980

234

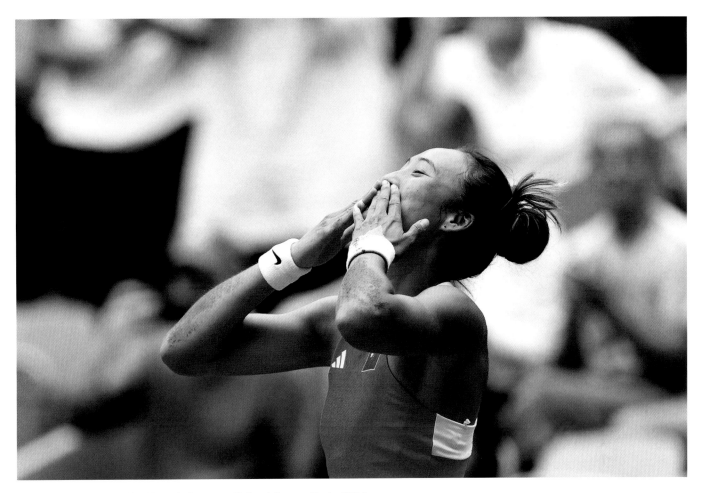

Qinwen Zheng during the Olympic Games at Roland Garros, Paris, 2024

It's more than tennis. Black Girls Tennis Club transcends the boundaries of sport, forging a pathway to empowerment and liberation for Black women and girls through the simple act of play. On the court and beyond, tennis becomes a beacon of community, joy and radical wellness. It's not just about swinging racquets; it's about igniting a movement. From advocacy to education, content, real estate, sport, fashion and entertainment, politics and social impact, Black Girls Tennis Club sits at the intersection of it all. Working across these various sectors and collaborating with numerous allies empowers us to uplift countless lives.

What began as a desire to simply enjoy more tennis and witness our own reflections has evolved into a vital force for change. BGTC emerged not only to serve up forehands, but to meet an undeniable need in the world. Our mission is clear: to disrupt the sports world with Compassion, Action, Resilience and Empathy (CARE). We aim to reshape the cultural landscape, breaking barriers to access, amplifying representation and exposing under-represented voices. Our approach is multifaceted, but our goal remains: to inspire others to embrace their own magic and step onto the court of life, ready to play their hearts out.

— Kimberley Seldon

Founder, Black Girls Tennis Club

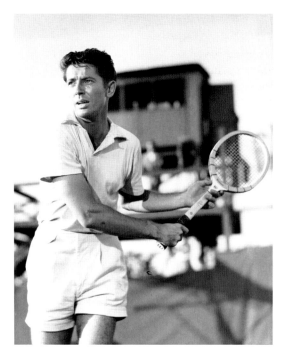

Farley Granger as tennis pro Guy Haines in Alfred Hitchcock's *Strangers on a Train* (1951)

Tennis was a sport I wasn't exactly invited into. I grew up just outside of New York City where tennis was, more or less, a sport that you played if you belonged to a club, which I definitely did not. Joining a tennis club was probably the furthest thing from my parents' mind. Then, one summer (I think I was about twelve years old) I was attending the town summer camp when I picked up a racquet for the first time. Tennis instantly grabbed me. I became obsessive and focused – which I wasn't terribly good at being elsewhere in life. I was an average student, smart but not on the honour roll. I wasn't the 'focused' type, and here I was entering the precarity of adolescence.

When I came home from camp that day, I told my mom how much I loved playing tennis and how badly I wanted to do it again. She and my father managed to get the money together to send me to take lessons at the local tennis club. It was quickly apparent to my instructors that my obsession was real to the point that I'd do whatever it took to get on the court and play. I even started working at the club so I could spend more time there.

I became absolutely obsessed with Andre Agassi. I mimicked his swing, his return, his footwork ... I even dressed like him. And I became better and better – but, as any avid tennis player knows, the game is not just physical. The physical part of tennis in your teens is almost an afterthought. You're young, and barely feel the fatigue. The difference between the winners and losers was entirely down to mind power, emotional control and poise. Tennis exposed parts of me to myself (and my opponents) that I didn't or couldn't have known otherwise. It made me confront myself, made me feel confident some days and feel worthless on others. It broke me down and eventually forced me to acknowledge that what kept me from being a Wimbledon champion was not how big, strong or fast I was, but my fears, insecurities and emotions.

Now I'm a lot slower. I can't get to balls like I used to, a shoulder injury has ruined my serve, and yet I can't help but think about the paradox of this wonderful game and how it gave me a process that allowed me to learn about myself.

To this day, as I teach my kids how to play tennis, it gives me as much joy as it ever did.

— Dan Martensen

Photographer

236

For me, playing tennis and watching and listening to birds have always been intrinsically linked. From my earliest childhood memories of competing in Kent, at school or in my local park, practice seemed always to be accompanied by the presence and sound of birds. As with tennis, lift, drag, thrust and gravity are the fundamentals of bird flight; and the birds and birdsong that accompanied my every game – at home and abroad – have always been my most appreciated audience and commentary.

In my eyes, the athletic displays of birds mirror the sparring partners and players of sport and tournament like mythological winged gods, and the messengers of Greek mythology. The ear sharpens and the eye focuses on hearing the volleying retort of two territorial wrens, machine-gunning back and forth as they compete for space next to an English park court; and muscles tighten watching the mesmeric spiralling dance of two bateleur eagles, claws locked in combat above a red earth court in northern Kenya.

Competition, contemplation and courtship: tennis is a relationship, a language and a seduction like all the best games. It is an education, a learning as curved and aerodynamic as the arc of a swift. It is paired or grouped, and each player struts and parades their power, their precision and their personal plumage on this bare, netted stage.

Two jays, courtly and confident, cleave the skeletal arbour of chestnut trees in the Jardin du Luxembourg in Paris, alighting on an adjacent park bench as we dip and dive in furtive, cautious play across a hard, glistening, leaf strewn surface in the cold autumn morning light. A gang of unruly raucous myna birds sit on high metal fences and mimic and mock us as we battle the humidity and dust on a heat-shimmering court in the urban chaos of Chiang Mai in northern Thailand. A magical twilight silhouettes the aerial precision of two black, fork-tailed raptors, gliding over a grass terrain in Marrakech, each updraft of warm air teasing us to play on into the night. We are awed by their elegance and cruel determination. Bee-eaters, hoopoes and serins in Provence; red-winged blackbirds, whimbrels and piping plovers in an old whaling port on Cape Cod; oystercatchers and red-breasted mergansers in a Victorian seaside spa on the Scottish East Coast – all heard or seen in flight over local public tennis courts where we as players aspire to a similar elegance and economy of movement.

In the game of tennis, the desire to hover, swoop, glide, coast, ascend, achieve feather-like weightlessness as one moves across the court, and yet remain firmly anchored to the ground, reminds me of Brancusi's joyful words: 'All my life, I have only sought the essence of flight. Flight – what bliss!'

— Jerry Stafford

Creative director, curator and stylist

Gérard Falconetti and Laurence de Monaghan in a scene from *Claire's Knee* (1970), directed by Éric Rohmer

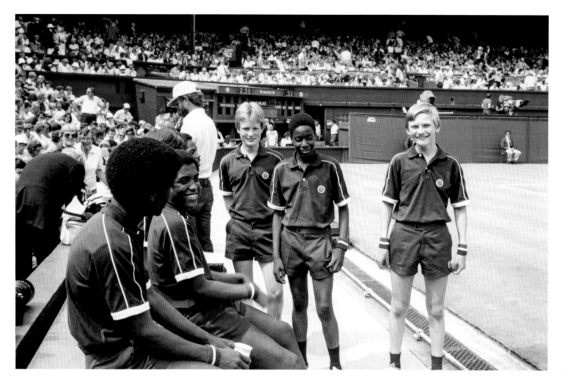

Ballboys on Centre Court before a match at the Wimbledon Championships, 1981

It's Monday, 22 June 1981. I am six years old and my mum is taking me to the Wimbledon Championships for the first time. To this day I can tell you what I wore, where we sat; I still have the ticket. Centre court in all its glory. The immaculate green grass, the Royal Box. Then Björn Borg walks out: the five-time defending champion. He is my idol. Still is. A couple of hours later, Borg has won his first-round match, and I have made my one and only career decision: I'm going to be a professional tennis player and play on centre court at Wimbledon.

Fast forward fifteen years and it's Tuesday, 25 June 1996. I'm twenty-one years old, and ranked number sixty-two in the world. I have been drawn to play against Yevgeny Kafelnikov, the French Open champion, in the first round of the Championships. This is what I have been dreaming of. This is what I have been preparing for. My chance on centre court. As we walk out to play, I'm nervous and excited.

In my professional career on tour, I played 770 matches. My opponents and I warmed up for five minutes before each of those matches. I don't remember any of those warm-ups – except this one. I remember virtually every shot. My groundstrokes, volleys, smashes and then serves – I hardly miss a shot. I'm ready to play and break Kafelnikov's serve in the first game.

Playing some of the best tennis of my life, I win the first two sets. The finish line is near. Kafelnikov, however, has other ideas. He wins the third set on a tie-break. The fourth 6-4. Suddenly I'm down 3-5, 15-40. Two match points against me on my serve. This wasn't in the script. Time to attack.

A couple of aces save the match points and I hold serve. The pressure is back on him and this time he falters. I break serve. It's 5-5 all in the fifth set. Easy hold for me and suddenly from match point down, I'm a game away from winning. We get to 30-30 and a rally follows when I eventually hit one of the best and sweetest running forehand cross shots of my life. Match point.

I can't take much more of this. Please let me finish it here. And I do ... My first victory on centre court at Wimbledon! It was 7-6, 6-3, 6-7, 4-6, 7-5 after three hours and thirty-eight minutes. Looking back now, it was worth the endurance. One of my favourite victories.

— Tim Henman

Champion of British tennis, Chairman of Wimbledon LTC and founder of the Tim Henman Foundation; commentator and activist

Some people were talking the other day about tennis court surfaces. Speed, grass, hard, clay, heat and bounce. I thought, but didn't venture: 'What about gravel?'

At the junior school of my school, a Lendl-lovin' PE teacher commandeered a bit of playground and strung a tennis net across it. This was my first experience of something not necessarily being a thing just because someone says it is. I still don't know what gravel is good for, but in the 1980s, councils and schools alike decided: schools.

I learnt to play tennis – and not just play, but fall in love with it – on gravel. The first thing this surface teaches you is that you cannot intend a ball to do something through placement, drive or practice, because it is always the gravel that decides. The one guarantee in a gravellish world of unpredictability is that you will always skin your knees. I took to wearing knee pads, and sometimes they stayed in place. The greatest lesson gravel gave me, however, came in all these following years of playing tennis: if you learn to do something you love in conditions that are less than ideal, when those conditions change and improve, you are ten times as good as you were when things were harder.

I don't love gravel, but it's part of my backbone – and there's still some in my knees.

— Minnie Driver

Actor, producer, podcaster and musician

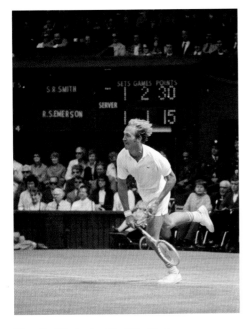

Stan Smith during the Wimbledon Championships, 1971

As a child who struggled with low self-esteem and negative self-image, I became a self-proclaimed 'prolific PE-dodger' in school, which means that I don't have much in the way of early memories of tennis, nor did I really have any reason to follow the sport as I was growing up.

Sport at school never really included or inspired me, being a larger kid with vision impairment, so when Wendy Glasper persistently hounded me to try Visually Impaired Tennis (VI Tennis) at the age of twenty, I decided that rather than avoiding her calls and texts it'd be easier to try it and then politely decline thereafter; but the problem was that tennis captivated me the way it did Wendy, and it has truly transformed my life.

Blind and Visually Impaired Tennis was invented by Takei Miyoshi. Had he not had the passion and ingenuity to invent a tennis ball that would enable blind and partially sighted people to try the sport, then bring his passion for Blind and VI Tennis to London in 2006, I may not have had the fortune of crossing paths with Wendy Glasper and Barbara Borwell, who drove VI Tennis in England's North East; of meeting Jo Cunliffe in her role as the LTA's Regional Participation Manager, who saw something in me and went on to help create a Sport Development role for me; of going on to represent my country at three International VI Tennis Tournaments and of being able to pay forward the passion, energy and enthusiasm for our wonderful sport that knows no bounds of language, culture, ability or disability, ethnicity, race or religion.

For me, tennis is the universal language of connection, and the discipline of tennis that we play harnesses our community, our identity and what makes us uniquely us.

— Rosie Pybus

Team GB, Visually Impaired Tennis

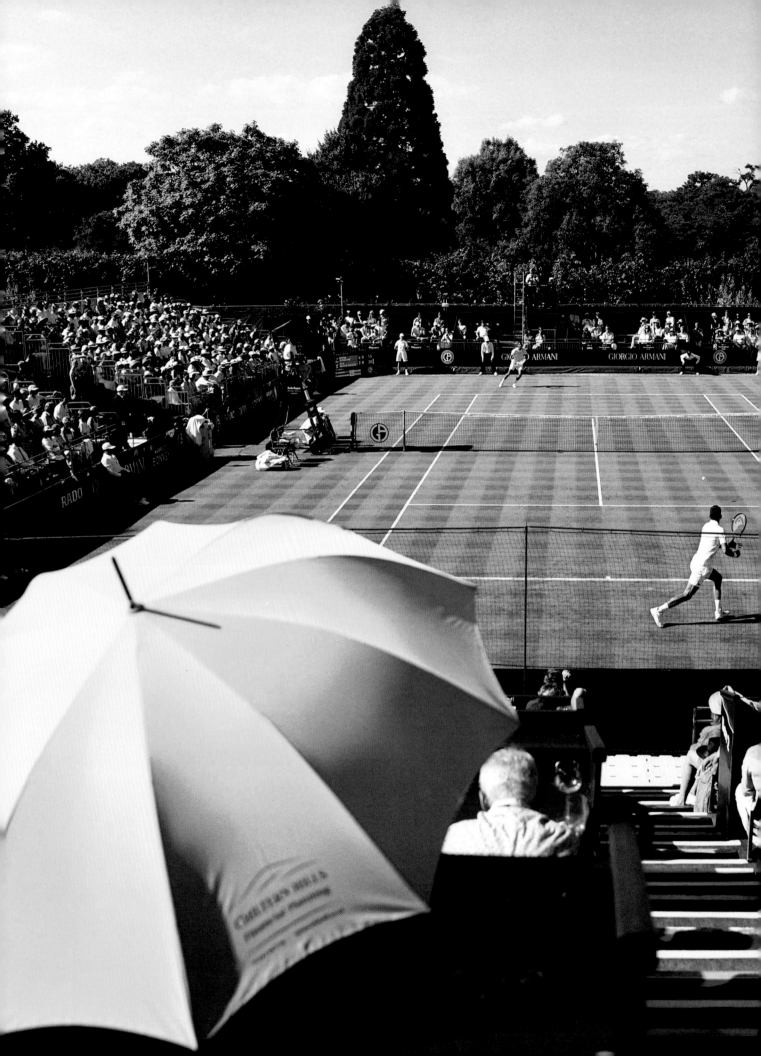

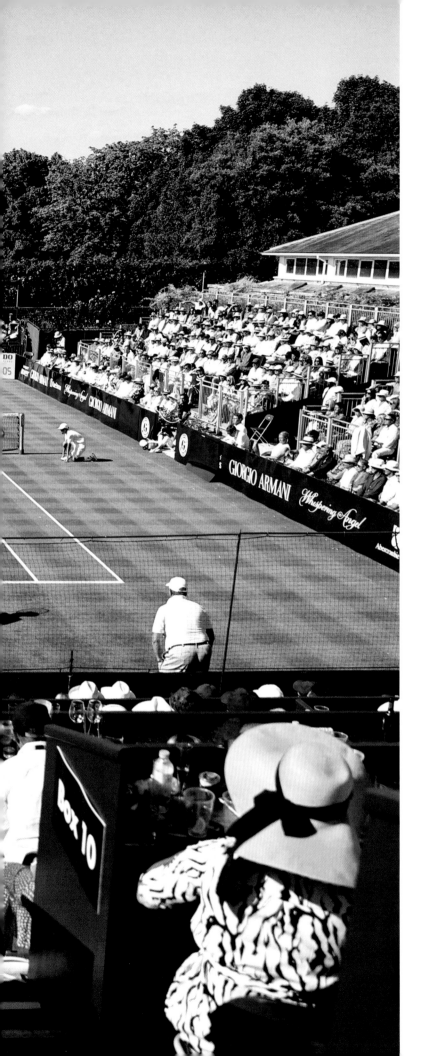

I love tennis. Ask anyone who knows me well and they'll say, she loves tennis. I'm not good at it, I don't get to play enough of it, but I'm there for it, spiritually and mentally. I love to ritualise my time before I play. In every other arena of my life my socks don't go on first. For tennis, they do. Tennis socks are important. They've got to be just right – the right length, the right thickness, the right colour depending on the dress I choose to wear. Olive green: pink socks; white dress: orange socks; black dress: black socks. Yes, it's as much about the look as the game. Gotta go feel strong out there; I need to feel powerful. Gotta feel like I can hit the ball back. Not necessarily beat my opponent, but just get it over the net. A good coach is a life coach too: put the world to rights, talk scripts and movies. ('Keep your eye on the ball, Sam!') Jump in the air and feel alive, hold the game in my heart, some strategy in my head, look into the eyes of my fellow player and know it's all good, I'm in great socks.

— Sam Taylor-Johnson

Film director, artist and photographer

Dear tennis: I love you, I love you not, I love you.

— Naomi Osaka

Four-time Grand Slam champion and former world number one

The Giorgio Armani Tennis Classic at the Hurlingham Club, London, 2022

241

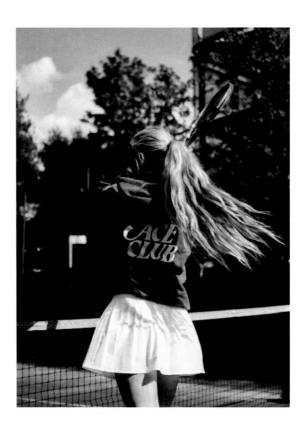

This book, and my tennis journey, owes
much to the sporting community and the
kindness of strangers. But from Day 1,
I wanted to find a way to give back and
ensure that more people had the chance to
enjoy the many benefits that sport brings.
Therefore, I am proud to be supporting the
LTA Tennis Foundation, whose incredible
work quite simply transforms lives, especially
by welcoming children and young adults
into a sport that has the power to develop
diverse life skills, confidence, health and
mental strength. As I continue to witness
the inspiring initiatives of the LTA Tennis
Foundation, it is both a passion and a
privilege to be able to commit 10 percent
of my royalties to support their work.

Sport saved and changed my life.
Everyone deserves that chance and joy.

— Laura Bailey

www.ltatennisfoundation.org.uk

Acknowledgements

Laura Bailey and Mark Arrigo wish to express special thanks to the following individuals and organizations whose collaboration and support have made this publication possible.

Abigail Bergstrom
Alfie Martin
Anya Szykitka
Campden Hill Lawn Tennis Club
Caroline Michel
Charles Miers
Charlotte Keates
Cilla Klaus
Colin Hough Trapp
Gabrielle Didier
Giulia Di Filippo
Giulia Garbin
Labyrinth Photographic
Michael Lynton
Nicole Hiebner
Preston Thompson
Rozalyn Bandres
Scott Lloyd, Tom Gibbons, Caroline Lacy
 and Hannah Simpson at the LTA
Stillking Productions
Thomas Phongsathorn
Tim Henman
Working Title Films

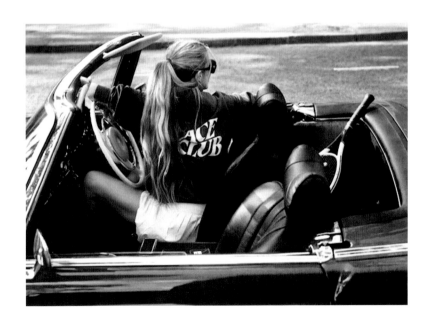

pp. 1, 2, 247, 248: Artwork by
Charlotte Keates, Ink on paper
© Charlotte Keates

p. 196: © Simon Michou/Paris
Match via Getty Images

p. 198: © Terry O'Neill/Iconic
Images 2024

p. 199: © Slim Aarons/Hulton
Archive/Getty Images

p. 200: © Jean-Marc Loubat/
Gamma-Rapho via
Getty Images

p. 201: © John Swope
Photographs, Margaret Herrick
Library, Academy of Motion
Picture Arts and Sciences

p. 202: © Ezra Shaw/Getty
Images

pp. 203, 238: © AELTC/Michael
Cole

pp. 204–5: © Luke Walker/Getty
Images for LTA

pp. 206–7: © Professional Sport/
Popperfoto via Getty Images/
Getty Images

p. 208: © Rob Taggart/Central
Press/Getty Images

p. 209: © Bob Martin/Getty
Images

pp. 210–11: © Simon Bruty/
ALLSPORT

p. 212: © littlemisslux/Stockimo/
Alamy Stock Photo

p. 213: © Corinne Dubreuil

p. 214: © GARCIA/STILLS/
Gamma-Rapho via Getty
Images

p. 216: © Photo by A.
Messerschmidt/Getty Images

pp. 218–19: © Slim Aarons/
Hulton Archive/Getty Images

p. 220: © Michael Ochs Archives/
Cinema 5/Getty Images

p. 221: © Trinity Mirror/
Mirrorpix/Alamy Stock Photo

pp. 222–23: © Jerry Cooke/Sports
Illustrated via Getty Images/
Getty Images

p. 224: © bpk Bildagentur/
Münchner Stadtmuseum/
Munich/Germany/Hermann
Landshoff/Art Resource, NY

pp. 226–27: © Luca Castro/Foto
Arena LTDA/Alamy Stock
Photo

p. 228 (top): © Nik Wheeler/
Corbis via Getty Images

p. 228 (bottom): © Joseph
Leombruno/Condé Nast via
Getty Images

p. 229: © Luke Walker/Getty
Images for LTA

pp. 230–31: © Professional Sport/
Popperfoto via Getty Images/
Getty Images

p. 232: © Clive Brunskill/Getty
Images for Laver Cup

p. 234: © Leo Mason/Popperfoto
via Getty Images

p. 235: © Matthew Stockman/
Getty Images

p. 236: © John Springer
Collection/CORBIS/Corbis via
Getty Images

p. 237: © Les Films du Losange

p. 239: © Rolls Press/Popperfoto
via Getty Images/Getty Images

pp. 240–41: © Adrian Dennis/
AFP via Getty Images

pp. 242–43: © Laura Bailey

Additional captions

Front cover: Santa Agnese,
Rome, Italy

Back Cover: Hotel Cap-Estel,
Èze, France

p. 4: Hotel Il San Pietro
di Positano, Positano, Italy

pp. 6–7: The British Embassy,
Paris, France

p. 8: Ballymaloe House
Hotel, Shanagarry, Ireland

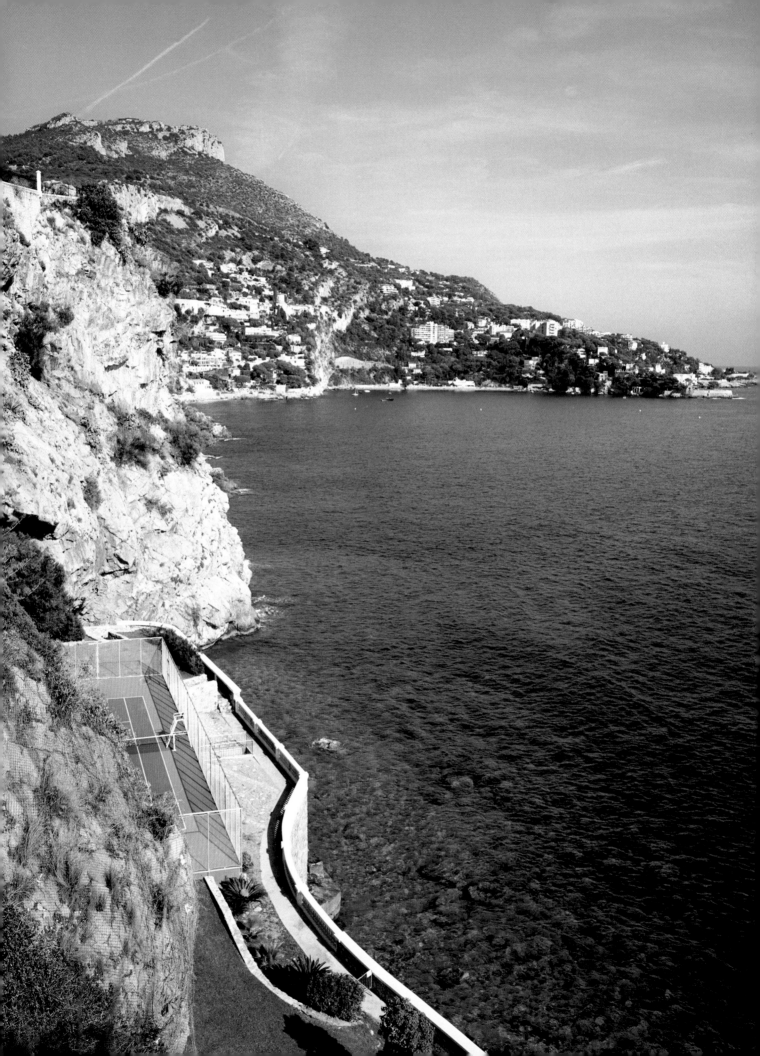

First published in the
United States of America in 2025 by
Rizzoli International Publications, Inc.
49 West 27th Street
New York, NY 10001
www.rizzoliusa.com

Publication copyright © 2025 Rizzoli
International Publications, Inc.
Texts copyright © 2025 individual authors
Photography copyright © 2025 Mark Arrigo,
unless otherwise specified

Publisher: Charles Miers
Senior Editor: Giulia Di Filippo
Production Manager: Colin Hough Trapp
Picture Researcher: Josefine Skomars

Art Direction and Book Design: Giulia Garbin
Assisted by Juliet Ramsden

ISBN: 978-0-8478-4420-3
Library of Congress Control Number:
2024949050

Printed in Singapore

2025 2026 2027 2028 / 10 9 8 7 6 5 4 3 2 1

Visit us online:
Instagram.com/RizzoliBooks
Facebook.com/RizzoliNewYork
X: @Rizzoli_Books
Youtube.com/user/RizzoliNY

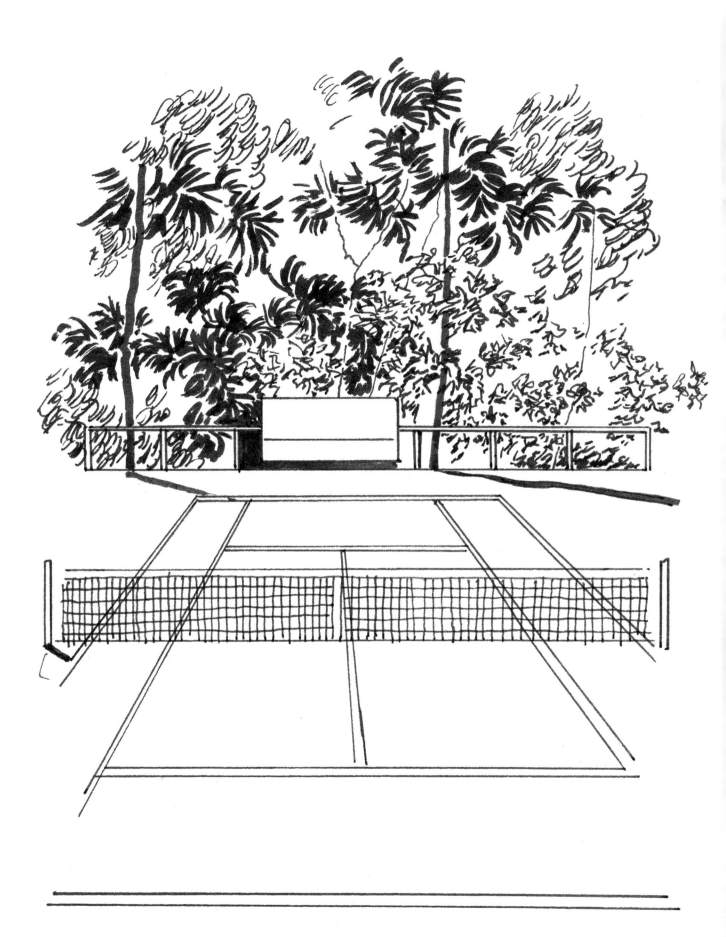